CONTEMPORARY
JAPANESE SCULPTURE

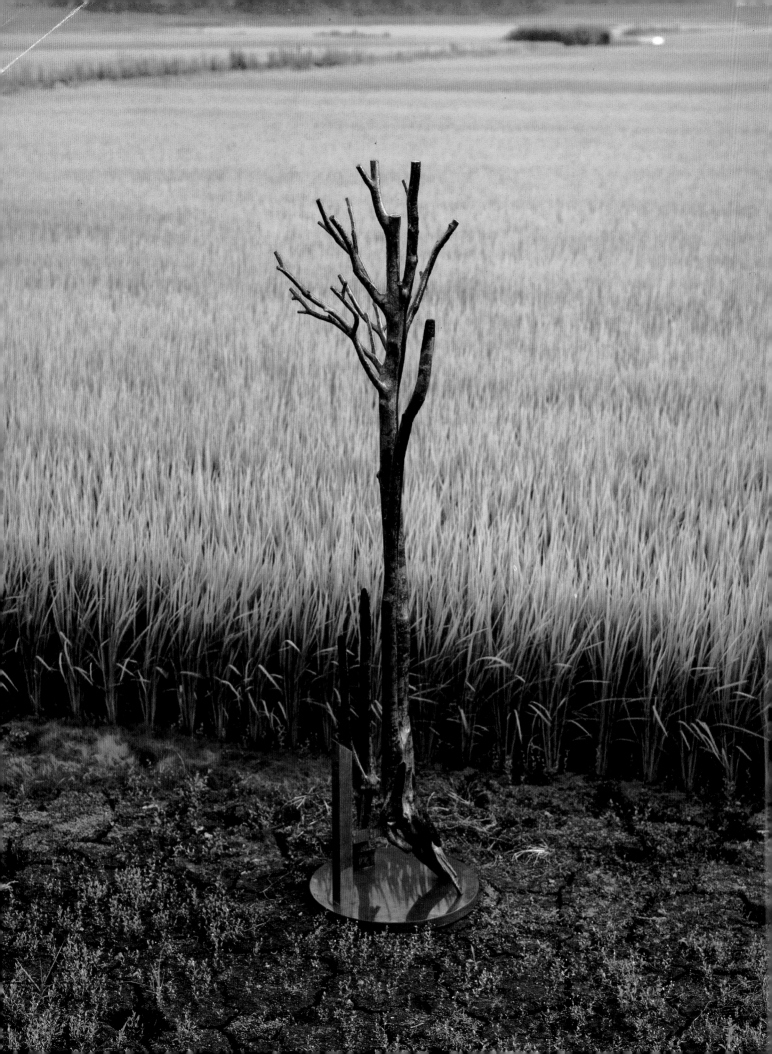

CONTEMPORARY JAPANESE SCULPTURE

JANET KOPLOS

ABBEVILLE MODERN ART MOVEMENTS

ABBEVILLE PRESS PUBLISHERS

NEW YORK LONDON PARIS

To
Alta Rose Golden Edwards,
more of an influence than I realized;
and to T.J.G.H., with gratitude.

EDITOR: Nancy Grubb
DESIGNER: Nai Chang
PRODUCTION SUPERVISOR: Howard Theile
PRODUCTION EDITOR: Philip Reynolds

FRONT COVER: Hideho Takasu (born 1946). *Homage to Soseki,* 1986. Colored stones; 78¾ x 9¾ x 18⅞ in. (200 x 25 x 48 cm).
BACK COVER: Takashi Fukai. *Dissipating Thoughts,* 1986. See plate 125.
FRONTISPIECE: Hisayuki Shima (born 1953). *Orientierung No. 5,* 1985. Wood, copper; 94½ x 35⅜ x 35⅜ in. (240 x 90 x 90 cm).

Library of Congress Cataloging-in-Publication Data

Koplos, Janet.
 Contemporary Japanese sculpture / Janet Koplos.
 p. cm.—(Abbeville modern art movements)
 Includes bibliographical references (p.) and index.
 ISBN 1-55859-012-9
 1. Sculpture, Japanese—Themes, motives.
 2. Sculpture, Modern—20th century—Japan—Themes, motives.
I. Title.
II. Series.
NB1055.K66 1991
730C.952C09045—dc20 90-27482
 CIP

CONTENTS

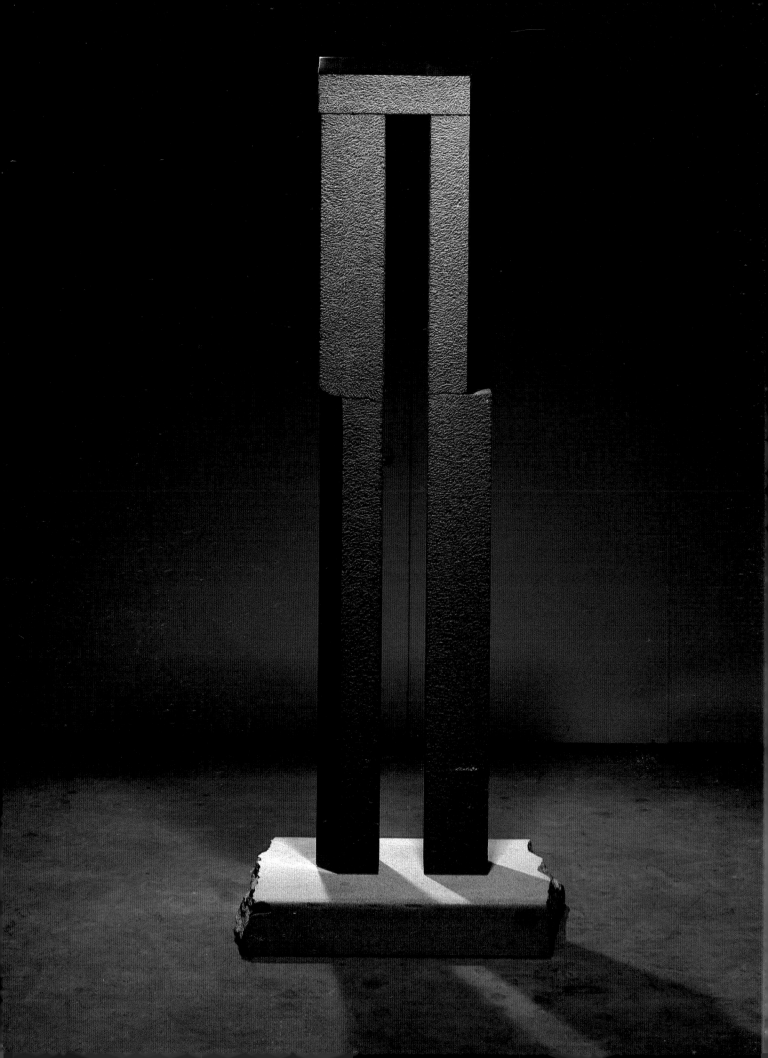

In the summer of 1989 *Against Nature: Japanese Art in the Eighties* opened in San Francisco and began a tour of the United States that ended in Houston eighteen months later. In the summer of 1990, in Los Angeles, *A Primal Spirit: Ten Contemporary Japanese Sculptors* initiated a continental tour scheduled to end in Ottawa eighteen months after that. These exhibitions marked the first attention given to Japanese contemporary art by American art institutions in two decades.[1]

Visitors to these two exhibitions would notice that most of the twenty artists whose work was included create sculptures and installations. One show consisted entirely of three-dimensional work, and in the other only the photographer Yasumasa Morimura showed solely two-dimensional work. In addition to what we would think of as standard forms of sculpture and installation, *Against Nature* included a performance set, a drawing installation, costume sculptures, and paintings that pushed into the third dimension by means of added wood relief. Viewers might conclude that the artistic energy in Japan today takes primarily three-dimensional forms, and such a conclusion would be correct.

Little more than twenty years ago, that was not the case. The Museum of Modern Art's examination of Japanese work in 1966 and the Solomon R. Guggenheim Museum's show of Japanese art in 1970 included both painting and sculpture, but the curatorial choices emphasized two-dimensional work. That preference was consistent with the dominance of painting in America and also reflected the situation in Japan, which was so unequivocal that William S. Lieberman could write in the catalog for the MoMA show that quality was not being realized in sculpture as rapidly as in painting.[2] Clearly, the preeminence of sculpture in Japan is a recent occurrence.

And it is a very surprising occurrence, for the history of sculpture in Japan has traced a broken line. Until now, every book about Japanese sculpture has ended its coverage with work made about seven hundred years ago. The term "Japanese sculpture" has been limited in application to the Chinese- and Korean-influenced Buddhist figures of the

1.
Keiji Ujiie (born 1951)
Rising and Falling 180 Degrees,
1985
Black marble; 81⅞ × 31½ × 23⅝ in. (208 × 80 × 60 cm)

Nara, Heian, and Kamakura periods (seventh through fourteenth centuries). After that time, the Buddhist faith and the urge to give expression to it weakened, and sculpture ossified. In the following centuries standard forms persisted, but sculptural creativity found other channels. Figural depiction continued on a miniature scale, in the form of decorative objects such as dolls and netsuke (carved belt toggles). Anomalous and interesting religious sculpture appeared occasionally, notably modest-scale work by unschooled itinerant Buddhist monks such as Enku (1632–1695)[3] and Mokujiki (1728–1810), the former known for his expressionism and the latter for his humor.

Western sculpture was introduced to Japan with the country's opening to the West in the mid-nineteenth century. An Italian sculptor named Vicenzo Ragusa taught at the Technological Art School in Tokyo from 1876 to 1882. His program was discontinued and he returned to Italy, but he left behind his work and a few motivated students. By the last decades of the century ambitious young men were going abroad to study, most often in Paris and most often in the ateliers of academic painters and sculptors, but they brought back home with them knowledge of not just Emile-Antoine Bourdelle but Auguste Rodin and Aristide Maillol. By the turn of the century foreign works were being brought to Japan to impress Japanese artists and audiences, and Rodin's works arrived early in the twentieth century.

For the most part, Rodin's example was not followed. The conservative, classicized, academic figural style became the norm in Japan and remained so until after World War II. It became entrenched in the schools, ateliers, and art associations that followed the Japanese apprenticeship pattern: the *sensei* (teacher or master) propounded the rules and the students followed them scrupulously; status accrued with the development of manual skill and with seniority, rather than according to Western measures of originality. Thus, advanced European styles such as expressionism, Cubism, and Constructivism were slow to come to Japan, if they came at all. Figural sculpture was prestigious because it had been the dominant mode when Japanese artists first looked avidly to Western art. And perhaps figures were easier for the Japanese to like because of that ancient history of Buddhist statuary. Yet even conventional Western figures presented problems. One major difficulty was that Japan lacked traditions of allegorizing or public memorializing to give meaning to the figures. And second, Japan had no experience of nudity in art, not even in the erotic ukiyo-e prints. Nudes were considered avant-garde in the Japanese context, and they continued to be seen that way until after World War II.

The first century of modern sculpture in Japan shows a

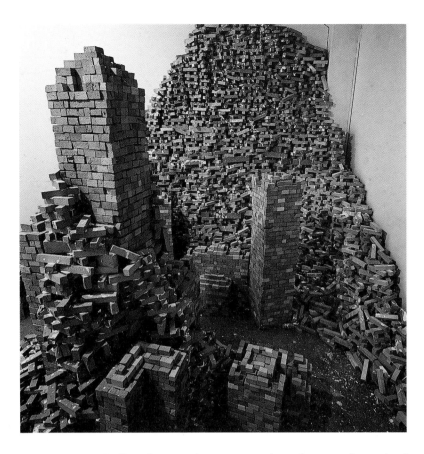

2.
Takamasa Kuniyasu (born 1957)
'87 Crossing, installation at
Kaneko G1, Tokyo, 1987
Clay brick; 10½ ft. × 13 ft. 1½ in.
× 19 ft. 8¼ in. (3.2 × 4 × 6 m)

pattern of imitation, increasing comprehension, and gradual reinterpretation, much like earlier adaptations by the Japanese from the Chinese and Korean cultures, but more rapid. That first century included several reactionary swings as the Japanese attempted to maintain (or recover) their own traditions and identities, which often seemed to be vanishing under the onslaught of Western styles, techniques, and information in all fields. Japanese intellectuals in the Meiji era (1868–1912) used the phrase *wakon yosai* (Japanese spirit, Western know-how) in an effort to claim some native constants amid all the change.

Despite its revitalization with this transfusion from the West, sculpture would not seem to be the most likely form of art for Japan. The most prestigious visual arts in Japan were ink painting, calligraphy, and ceramics, and of the "imported" forms, painting was embraced with more fervor than sculpture.[4] Westerners assumed that "the Japanese sensibility" (as if there were only one) predisposed Japanese artists to pursue two-dimensional arts. This misapprehension arose because of the success of Japanese prints, which were received with great enthusiasm in the West. Ukiyo-e prints (then a popular, not a fine, art in Japan, equivalent to rock posters today) became widely known to Impressionist and Post-Impressionist artists in Europe, who were fascinated by the prints' planes of color and descriptive outlines. In

theory, this aesthetic of flatness continues to this day in prints and in *nihonga*, the traditional painting using water-based mineral pigments. According to the Western stereotype, the Japanese linear aptitude would preclude sculpture's becoming a dominant form. But the stereotype overlooks the fact that many Japanese arts require spatial and sculptural considerations—among them, architecture, garden design, and ikebana (flower arranging).

In Japan, as in the United States, abstract sculpture flourished only after World War II. The history of the development of modern Japanese sculpture—from the nineteenth-century introduction through the decades of figural domination to the eventual rise of abstraction and the expansion of the art in recent decades—has not yet been written in English, or even in Japanese. But a rough outline of the postwar development can be sketched. In the 1950s, during the resettling of society and culture following the loss of the war and the first occupation by a foreign army in Japanese history, rules began to be broken. The artists' associations that had rigidly controlled exhibition opportunities very gradually began to lose power, and it became possible for an artist to function outside the associations. In the early 1950s an informal group of young artists that became known by the name Gutai began to try out unconventional art materials, to create ephemeral art objects, and to stage artistic events. These experiments were continued and expanded by others in the late 1950s and

3.
Fusako Tsuzuki (born 1949)
Animal, 1985
Wood, bolts; 9 ft. 10⅛ in. × 18 ft. × 5 ft. 3 in. (3 × 5.5 × 1.6 m)

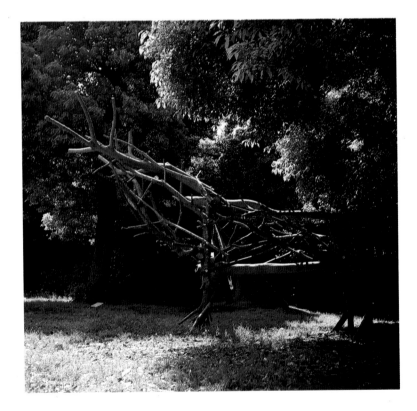

throughout the 1960s, during the time when Western art modes such as kinetic art, light sculpture, and various forms of Pop art were embraced. At the end of the 1960s several artists to whom the term Mono-ha was later applied struggled to develop an Asian contemporary art based on Buddhist and other ideas; these men asserted that art was not created, fixed, or independent of its surroundings, and that every material had its own intrinsic value. Mono-ha rejected illusion and emphasized contrasts of materials, so the resulting work was inevitably three-dimensional. The proliferation of sculpture of all types followed from this breakthrough philosophy.

Today in Japan the Western idea of sculpture has been investigated and assimilated. International concepts and forms of contemporary sculpture abound. But the most exciting work is that which has synthesized the international and the East Asian. Occasionally this Easternness is turned against the West: there are some who will claim that Japan's mystical, nonverbal, and abstruse cultural forms can be understood only by the Japanese. This position is untenable. With the expanding venues for Japanese art in Europe and more recently in the United States, contemporary Japanese works are being presented to other cultures, and there is no question that they speak to the West as well as to Japan.

Still, Japanese sculpture arises in a largely non-Western context. It draws on its own religious, aesthetic, and social sources, and our understanding of it is enriched by recognizing and appreciating these cultural foundations. Various East Asian concepts and practices that infuse contemporary sculpture are briefly outlined in the first chapter of this book, which is intended to help explain relevant differences between Japanese and Western work. From there the book proceeds to a discussion of two influential postwar movements—Gutai and Mono-ha—and the work of Yoshi-shige Saito, an influential forebear of the current sculptural vitality. It then moves on to present recent work by nearly one hundred contemporary sculptors, grouping them in categories that reflect loose affinities but should not be seen as fixed or decisive; there are no movements today. The sculptors included here were chosen on the basis of my evaluation of work shown publicly, mostly in Tokyo, over the last half of the 1980s. I judged on the basis of contemporary interest and ignored traditional measures of importance, such as school attended, group affiliation, or seniority. The selection, though far from exhaustive, is representative of active, serious contemporary work. It does, however, exclude a few sculptors who established a style and a body of work before this period and who now work largely outside the gallery circuit. For example, neither Masayuki Nagare nor Susumu Shingu is included. In the 1970s Nagare was

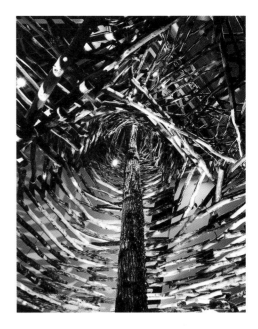

4.
Jae-Eun Choi (born 1953)
Tree (detail, interior view),
installation at Spiral Garden,
Wacoal Art Center, Tokyo, 1987
See plate 112

probably the Japanese sculptor best known in the United States, with works in such prominent locations as New York's Lincoln Center; Shingu has exhibited his kinetic sculptures internationally. The artists included range from beginner to senior in Japan but have not yet moved into the smooth groove of international celebrity and so might be regarded as "emerging."

For, in fact, the market for Japanese contemporary art is still very weak. In Japan collectors of Western art pursue the prestigious names of the past (Vincent van Gogh) or present (David Hockney). Collectors of Japanese art spend most of their money on *nihonga* and ceramics. Contemporary Japanese art remains at the bottom of the list.

To get around the poor sales prospects, the majority of galleries handling this work are rental spaces. There is no stigma attached to renting a space for an exhibition; it is a routine practice and even has certain advantages in that young artists can begin with solo shows, artists can show as often as they wish, and if there are sales, the gallery takes no commission. As one owner of a rental gallery put it, artists in Japan act as their own patrons.[5] Yet the situation is not completely unstructured. Directors of the better rental galleries screen slides of applicants' work to maintain a certain quality level, and many of them offer free shows to a few favored artists each year. There are also regular commission-taking commercial galleries of the sort familiar in the West, with stables of artists. Most of these show both Western and Japanese art. In Japan very few galleries have the large loft-type spaces favored in New York. Most are located in conventional low-ceilinged office buildings and, given the extremely high cost of land and consequently steep cost of building space, most are quite small.

Japanese museums typically have plenty of space. In the last several decades prefectures, municipalities, and even wards of cities have indulged in a spree of museum building as a demonstration of their affluence and sophistication. The results are often multipurpose museums. Only in the late 1980s was the first public museum dedicated to contemporary art (in Hiroshima). National museums include specialty institutions devoted to modern art (in Tokyo, Kamakura, Osaka, and Kyoto) as well as to Western art (in Tokyo). In addition, Japan has an exceptional number of private museums, including the Hara Museum of Contemporary Art in Tokyo, established a decade ago as the first contemporary art museum in Japan.

Japanese museum programming tends to be conservative. Retrospective exhibitions at the national museums are usually limited to the geriatric; Isamu Wakabayashi, at the age of fifty-one, was the youngest artist ever given a solo exhibition at the National Museum of Modern Art in Tokyo.

While the Hara Museum has successfully established an "Annual" in which about ten young artists—or older artists who have never quite gotten their due—are featured, group exhibitions in most museums typically choose broad topics (such as "space" or "movement") and back them up with vague (or impossibly abstruse) catalog essays. The nature of these essays is not surprising, considering that Japan has no tradition of criticism.

What criticism there is—in newspapers, several art magazines, books, plus museum and gallery catalogs—serves somewhat different purposes than such writing in the West. In general, both writers and artists in Japan are reluctant to be specific about artworks. In gallery catalog essays, it is not uncommon for the work never to be specifically described or analyzed. The essay approaches the details of the work indirectly or not at all. Readers are expected to encounter the work itself through their senses and sensibilities rather than through verbal description or prescription.

The major art magazines do not focus exclusively on contemporary art, and those that give it the most consideration are characterized by brevity. Newspapers are likely to cover major museum shows and the annual shows of the huge traditional art associations. Books are likely to address historical topics or Western art. Many senior Japanese critics have established their reputations by introducing Western art movements, such as Pop art, to Japan, and surveys of contemporary Japanese work are rare. Monographs on contemporary artists are often self-published. Still, the drift is now toward Western-style criticism, especially as the growing interest from the West encourages translations and since the existing criticism is poorly received abroad.

Yet if criticism is forced into a Western mold, one hopes that the artwork won't be. Contemporary sculpture in Japan presently follows Japanese preferences, adopting from the West only selectively, assimilating influences to make a distinctive hybrid (just as any Western artist does). Of course, contemporary sculpture in Japan is not one thing; every imaginable type of artwork is made, from pieces that recapitulate traditional styles to pieces that are so neutrally internationalist that they could be made anywhere. A still-common type of Japanese sculpture, which is not included in this book, consists of unimaginative bronze or marble figurative works that are no more than exercises in craftsmanship—holdovers from the nineteenth century.

Today, nonfigurative sculpture predominates. Contemporary sculpture in Japan can be characterized as being moderate in scale, showing a preference for wood and stone, and concentrating on details of surface and texture as much as on overall composition. Sculpture tends to

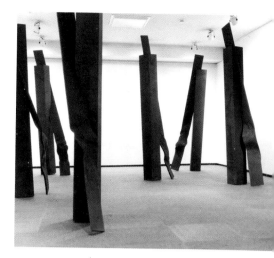

5.
Takio Nakamura (born 1952)
Release, 1987
Cor-ten steel; height: 90⅝ in. (230 cm)
The Museum of Modern Art, Toyama, Japan

6.
Hachiro Iizuka (born 1928)
Variable Construction, installation at Nakanobu Gakuen,
Japan, 1989
Painted wood

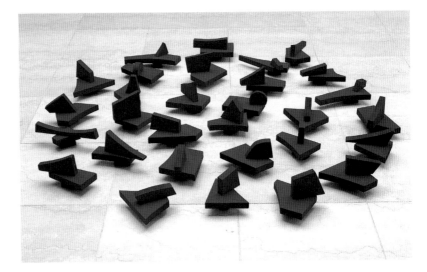

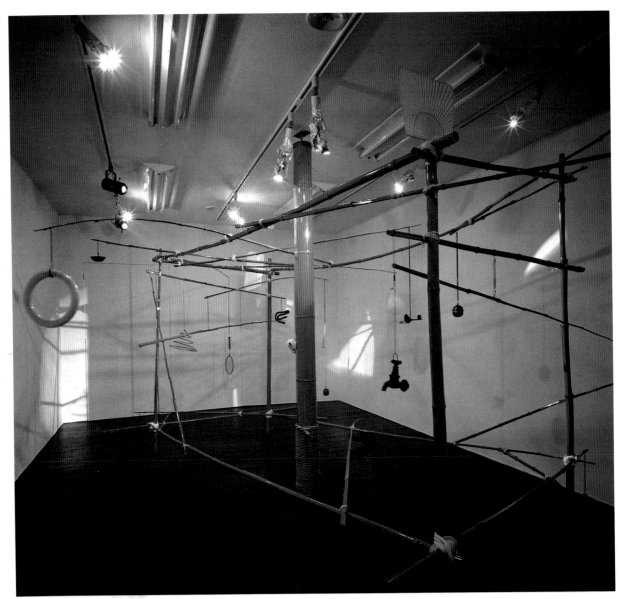

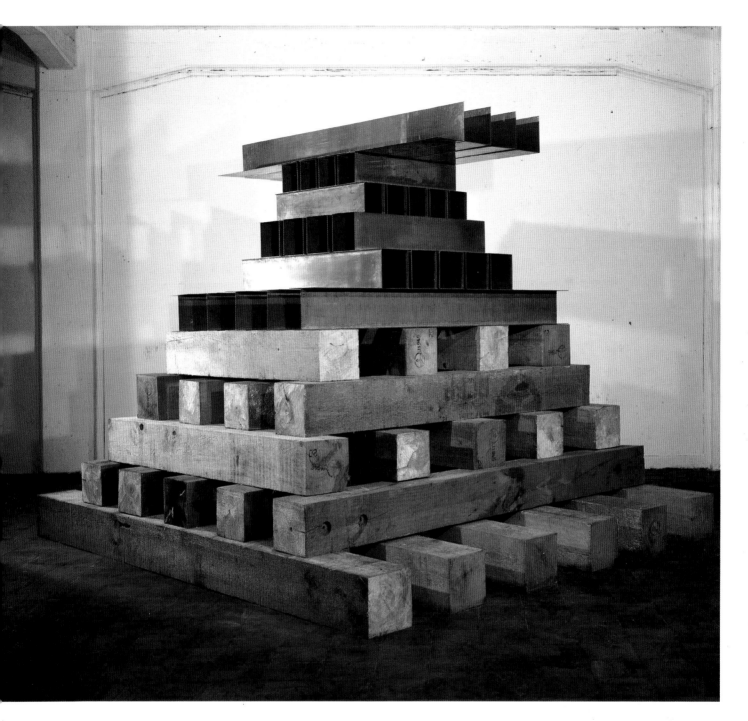

OPPOSITE
7.
Yoji Matsumura (born 1950)
Festival or Politics, installation
at Gallery White Art, Tokyo, 1987
Bamboo, found objects; 7 ft.
2⅝ in. × 18 ft. ½ in. × 11 ft.
5¾ in. (2.2 × 5.5 × 3.5 m)

ABOVE
8.
Noriyuki Haraguchi (born 1946)
100; Revised, 1985–86
Copper, wood; 9 ft. 9⅛ in. ×
12 ft. 9½ in. × 11 ft. 4¼ in.
(2.97 × 3.9 × 3.5 m)

communicate a positive attitude, without hints of angst. A surprising number of works achieve an almost living presence, a numinous power. At the same time, inexpensive, easily available, and disposable materials are common in the many temporary installations consisting of multiple parts.

Not one of these characteristics is unique to Japanese work. Sculptures by a number of British artists, in particular, show similarities. For example, "relational" sculptures made by Bruce McLean in the 1960s predate Japanese relational works of the 1970s. Richard Long's attitude toward nature and his practice of intruding very gently in the landscape are admired in Japan. The sculptures of David Nash fit easily within what I identify as the Japanese materials aesthetic, and Barry Flanagan seems close to the Mono-ha movement.

There are American parallels as well. Much of the medium-centered sculpture originating in the crafts since the early 1960s, particularly that using clay and fiber, shares the Japanese sensitivity to materials. There are also kinships between Japanese work and the anti-illusion of Minimal art (Richard Serra is admired in Japan) and some Process art (much of Jackie Winsor's sculpture looks like Japanese work of the same period). More currently, Martin Puryear's sculpture would be at home in Japan.

There are also differences. For one thing, although much outdoor work is created in Japan, none of it is gargantuan—unlike much American public sculpture. When it is tall, it is in a few multiples of human height; when it is broad, it tends to be an accretion of objects, much like gardens or natural landscapes. There is little constructed "industrial" sculpture like that by Mark di Suvero or by Anthony Caro and his followers. And where industrial materials are adopted, they do not express feelings of raw energy or power; their physicality is that of a touch, not a punch. Industry is accepted but neither celebrated nor mourned. Expressionistic work is uncommon, and when it occurs it avoids the solely personal or autobiographical; the occasional work that is emotionally expressive points beyond the individual or even the culture, addressing shared human problems and experiences. Currently there is little polychrome sculpture, and the few examples are mostly planar works that might be described as painting in space (however, young sculptors increasingly seem to be interested in color). While reductiveness is common, there is no Donald Judd–type Minimalism. The works retain individuality and evidence of touch, even in the most apparently minimal forms. One sees almost no political work. Although some sculptors concentrate on social reality, they do not use the world as a source of data, and they do not make polemical statements. There is no Japanese Hans Haacke, no Japanese Adrian Piper.

In general, Japanese sculpture is concerned with parts rather than wholes and with momentary conditions rather than fixity. Often these preferences result in installations rather than central-mass vertical sculpture. Japanese artists may be comfortable with temporary installations because of the traditional practice of keeping rooms like empty stages and "dressing" them with furniture, decorations, or other items as required for each occasion. Emphasis on the moment, and on savoring a brief experience, also figures in the tea ceremony, and ikebana offers some precedent for the "arrangement" emphasis of installations. Practical matters undoubtedly encourage installations as well. The high rents in Japan—the effect of which on gallery size has already been noted—also limits artists' studio and storage space. The frustrations over lack of space and the pressures of the one-week exhibition schedule common to rental galleries in Tokyo may result in an overcompensation through scale and complexity: elaborate installations can be substituted for other approaches to large scale because the installation can be created in bits in an artist's studio and then put together in the gallery. The fact that such installations cannot readily be sold is unimportant because the market is so anemic anyway.

The fascination with parts and the lack of concern with permanence are also revealed in more conventional object sculptures. They seem to be manifestations of two large themes that run through much contemporary Japanese sculpture: the web of relationships that bind each aspect of existence to every other aspect, and the inexorable passage of time. Both are ultimately spiritual themes, derived from Buddhism. These meanings underlie even works that appear to be flatly formalist: the literal reality of the sculpture as form, substance, texture, etc., is nearly always important, but this reality almost invariably coexists with an abstract, often spiritual, meaning. The work points beyond itself; like a literary synecdoche, it is an individual that stands for the whole, because in the Buddhist philosophy nothing can be isolated or independent of the whole. Thus Japanese sculpture, as individual examples will show, emphasizes the concrete and the material but is not limited to that. The spiritual values derive from the culture and from the era, but the expressions are personal and open-ended. The old Buddhist sculptures, from the enormous *daibutsu* statues at Nara and Kamakura to the tiny votive figures, are powerful works of art that communicate their intensity even to nonbelievers. Contemporary sculpture in Japan has abandoned the figural specificity but kept the aesthetic power and its spiritual base. It is time that this work emerged from the tiny, tucked-away rental galleries and took its place on a larger stage.

9.
Tomoaki Ajiki (born 1950)
Tan Tan, 1985
Bamboo; 98⅜ × 47¼ × 43⅜ in. (250 × 120 × 110 m)

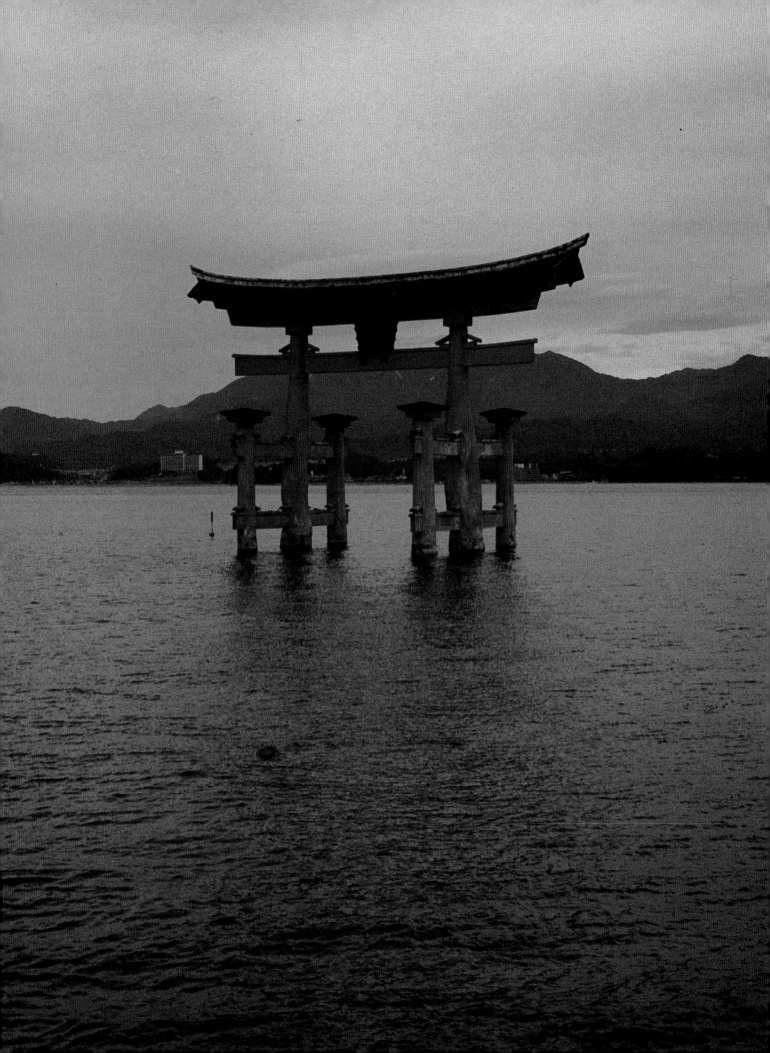

Religion as a cultural force influences the meaning of contemporary artworks in Japan. Buddhism and Shinto infuse the arts there just as Greek and Roman myths and Christian Bible stories provide Western artists with symbolic characters and events. The Japanese are often described as unreligious or as religious only when it suits them, the chief times being weddings and funerals. Yet millions of people make seasonal visits to Shinto shrines, and many leave money before religious icons (the coins piled in front of Buddhist statues in art exhibitions have taken many a Westerner by surprise). Surveys show that about 50 percent of the families in Tokyo and as high as 80 percent of those in rural areas have Buddhist altars in their homes.[1] It is impossible to travel anywhere in rural or urban Japan without seeing shrines and temples (100,000 of the former and 70,000 of the latter, by one count[2]). Even more striking are the multitudes of well-maintained roadside or yard altars. Such prevalence of religious structures demonstrates practice, and in Japan practice is more important than profession.

Shinto is the indigenous Japanese faith. It had no founder, it has no written dogma, and it did not even have a name until the introduction of Buddhism in the sixth century made a distinction necessary. Shinto, which bears some kinship to Taoism and East Asian folk beliefs, is animistic and is based in agricultural rites and ancestor worship. The sun goddess, Amaterasu, is paramount, as one would expect in a farming culture. But there is no absolute deity. And there is almost no religious iconography. Although performing arts have been important at Shinto shrines, the visual arts have never found the kind of patronage that Buddhist and Christian institutions have provided. Nevertheless, Shinto can be perceived as an element of contemporary sculpture in Japan—as a deep and often unconscious cultural attitude rather than as a professed faith.

An optimistic emphasis on the value of wordly life is central to Shinto, and traditionally the Shinto deities, or *kami*, are far from transcendent. Folktales describe their lust, humor, and various other human traits, characterizations

10.
The torii of the Itsukushima shrine, on the island of Miya-jima near Hiroshima, stands in the Inland Sea.

closer to Greek gods than to the thundering Jehovah. *Kami* are everywhere, believed to inhabit mountains, rocks, and trees. Such natural objects are not themselves gods but are honored as their dwelling places and often are designated by sacred rice-straw ropes. Offerings may be placed before [14] them. The potential of natural objects to house the *kami* gives them a numinous vitality and a sculptural individuality. The straw rope sets apart a sacred object just as clearly as a pedestal sets apart an art object. The spiritual power of some contemporary sculpture of stone or wood may derive from the artist's perception of the *kami* in nature.

Shinto has been described as "a nature worship of which the mainspring is appreciation rather than fear."[3] Nature is seen as essentially like man, even sharing man's emotions. In the nineteenth century, when Japan was importing foreign concepts, a new Japanese word had to be devised to accommodate the Western concept, derived from Greek philosophy, of a nature separate from man.[4]

Shinto has also contributed to the Japanese aesthetic sense through its emphasis on purity (which has an isolating and focusing effect) and through its reverence for natural beauty. The Japanese, like the peoples of many other nations, believe themselves to have a special relationship to nature, one simultaneously religious and aesthetic. At the turn of the century Lafcadio Hearn wrote, "Religion, indeed, is everywhere associated with famous scenery."[5] Recently, when young Japanese were surveyed about their sense of religiosity, most identified it with the beauty of scenic views and saw atmosphere as the key to spirituality—a feeling consistent with the Shinto viewpoint and one that may indicate that the traditional inclination persists.[6]

Buddhism has been credited as the source of Japanese painting and sculpture, which originated with objects of worship for temple and personal use. In traditional painting, landscape was used as a metaphor for the path to spiritual enlightenment. It has also expressed the position of man within nature, implied cosmic distances, and exemplified a kind of longing for natural purity. All art, even the most "realistic," simplifies, but the brief, fragmentary, reductive approach of some Japanese (and Chinese) art was believed to capture from the flux of life an essence more real than any specific, individualized, literal depiction of a particular view could provide, rendering a truth of spirit rather than one of scientific perception.

Practitioners of Zen (which has come to be regarded in the West as the quintessentially Japanese form of Buddhism) dismissed the value of religious statues, for its purpose was to break with the world. Nonetheless, some aesthetic forms, including ink painting, the rituals of the tea ceremony, and garden design—all of which have been important models

for contemporary work—were seen as beneficial practices or as providing a meditative environment or as having some other redeeming aspect.

Sculpture today does not reflect the much-vaunted Japanese appreciation of the seasons, but it may reflect cyclicality, which can be traced to Shinto's association of change with renewal rather than deterioration, as well as to the Buddhist notion of the cycle of death and rebirth, from which nirvana is the release. What has been called the Zen attitude of "transparency" toward nature—no separation of subject and object, no dualism[7]—has left its mark on contemporary sculpture.

In the Buddhist cosmology, life and self are illusions. Life is seen as brief, discontinuous, unpredictable. In medieval times this was expressed in the attitude of *mono no aware* (the poignance of things)—the awareness of beauty's relentless decay. This emphasis on transience permeates such practices as ephemeral architecture (designed to serve short-term needs without regard for the future) and narrative art (emphasizing sequences of vanishing moments). The tendency to view reality as fluid rather than fixed, as a process, gives a cultural rationale to certain kinds of contemporary sculpture that are similar to the Process art made in the West during the 1960s and '70s.

Other Buddhist beliefs underlie the absence of central mass, the ubiquity of the circle, and the multiplicity in contemporary artworks. One is the notion that life is only a moment in the void. But the void holds no terror; nothingness has infinite creative possibilities. Whatever its source—the empty innermost sacred precinct of Shinto shrines, the Zen demand for simplification, the influence of Chinese painting—empty space has become identified with Japanese aesthetics. Another belief relates to parts and wholes. Traditionally, the Buddhist sees his body and spirit as identical with the "Six Great Elements" (earth, water, fire, wind, space, and consciousness), and these elements are visually equated with certain body parts and with certain Buddhist symbols.[8] Everything is part of the whole, the whole is constituted of parts, and the whole can be understood by means of any part.

The Japanese *do* (ways) have been called a secularization of the Buddhist spiritual aim of achieving fulfillment through every thought and every gesture; they are disciplines for developing mental and physical concentration as well as intuition.[9] These "ways" include the tea ceremony, swordsmanship, archery, calligraphy, and ikebana.

The Way of Tea *(chado)* influenced a style of architecture, utensils, and gardening, and although it hardly exists in its original form today, its legacy affects many Japanese arts. The elements of tea are said to be harmony, reverence,

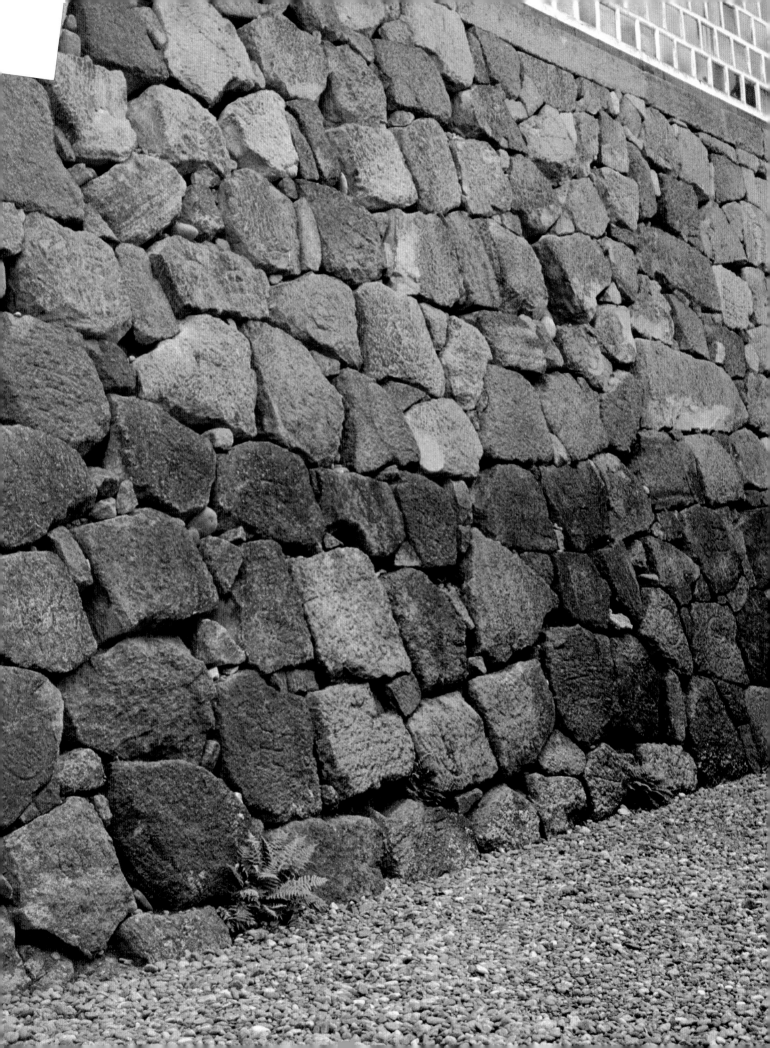

OPPOSITE
11.
The Ishikawa Gate in Kana-
zawa is an example of the
mortarless stone bases of
medieval castles.

12.
A teahouse in the garden of
the Nezu Art Museum, Tokyo.

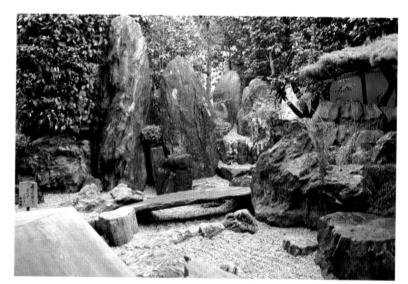

13.
A *karesansui* garden at the
Daisen-in (a subtemple of the
Daitoku-ji in Kyoto), "depict-
ing" a bridge over a mountain
stream.

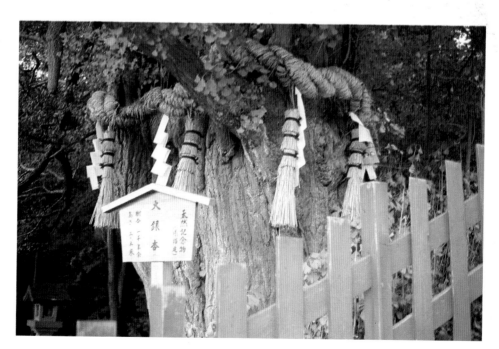

14.
Rice-straw ropes honoring a
magnificent tree on the
grounds of the Hachiman
Shrine, Kamakura.

purity, and tranquility. Encompassed in the philosophic principles are such aesthetic principles as the balance of opposites and suggestion rather than pronouncement.

The teahouse was the center of a consciously created world entered at a measured pace—through gates and through a specifically designated tea garden. Like an art gallery, the tiny but orderly teahouse encouraged focus. All distractions (except, perhaps, a controlled view of nature) were eliminated to direct attention to the ritual and the objects used in it. As an almost theatrical performance involving a temporary confluence of elements, the tea ceremony was an expression of transience. Each particular combination of season, weather, guests, and implements would never recur. The tea ceremony became an art, and the teahouse has been described as "a kind of inside-out sculpture in planes, lines, and textures, understandable only when the observer is in his proper place inside it, feeling its enclosure around his body."[10] The teahouse is occasionally the subject of contemporary sculpture, and much installation art establishes a carefully controlled environment that can be compared with a teahouse.

As an island nation, Japan has a strong sense of geographical integrity. It has no artificial political boundaries interrupting the continuity of its landscape, people, and language. Even more to the point, as an island nation it has unmistakable edges. No one in Japan, not even residents of the most remote mountain villages, is more than seventy miles from the sea, seventy miles from an edge. The fact that Japan is both mountainous and heavily forested means that usable land is at a premium and space is precious, even in rural areas. Only on the less-populated northern island of Hokkaido might a Japanese experience a sense of wide-open spaces. The forests do not supply an image of boundlessness because they are interrupted by natural and man-made features and because they are contained by those encircling edges.

Because Japan has the highest ratio of population to habitable land of any nation, space is a constant consideration. In many rural areas cohesive communities are surrounded by rice paddies. The village spatial organization conserves precious land and responds to extremes of topography. Irregular lots and irregular building relationships are the norm. In the cities the density of the population shapes the environment. The streets are narrow and seem to wander. Broad boulevards and regular blocks are relatively uncommon. Far more typical, even in the nation's capital city, are narrow two-lane streets with no on-street parking, and even more characteristic are the tiny, twisting one-way residential passages.

City blocks in most of Tokyo are nongeometrical, and

unlike America, where most communities have laws requiring a minimum street frontage for every structure, in Japan the center of a block may be occupied by a house that has only a long and twisting pedestrian path connecting it with the street. On maps of neighborhoods, residential lots look like shards of glass. Space and spatial relationships in Japan are unstandardized and unpredictable, as in most of the high-population areas of East Asia.

Residential streetscapes are defined not only by gates and walls but by hedges, and also by guardrails and painted lines that set aside space for pedestrians. The streets are complicated by plantings and by intrusive utility poles, which take up precious space needed for the multitudes on foot. The result is that nowhere, from the tiniest village street to the parks of major urban areas, does the streetscape open up. Its boundedness can create a heightened consciousness of space, because every inch is so precious.

Traditional Japanese architecture shows a distinctive attitude toward space in the placement of the house on the lot, in the room relationships within the house, and in the order within a single room. The traditional room was most striking in its emptiness and simplicity. Given the practice of living at floor level, a minimum of furniture was used. When Japan was opened to the West in 1854 and visitors such as the architect Ralph Adams Cram arrived, they were stunned by the bareness, so different from the Victorian clutter back home. Cram may have been the first Westerner to note in print how the emptiness called attention to the few elements that were present, whether decoration, furniture, or inhabitants.[11] As in the teahouse, when objects are few, they acquire an almost sculptural power and presence.

Japan's architecture is based on the distance between pillars in a room and, in residential architecture, on the unit of the tatami mat as well. This modular construction yields a harmony of proportion that is the logical consequence of building according to a system of order. The traditional arrangement of both secular and sacred space began with a center. In shrines the center was both the figurative and literal focus, and the innermost sacred space was never penetrated. The great shrines such as Ise, in Mie Prefecture, are apprehended from the outside only, and even in more accessible shrines the sacred center is often a separate building, viewed from across a courtyard. Because the innermost core is inviolable, "it has, in spatial terms, the same meaning as a piece of sculpture or an obelisk."[12] Even secular architecture often focused on a sacred center pillar (derived from the "pillar of heaven" associated with the gods), which can still be found in some *minka* (traditional rural houses).

Another feature of Japanese architecture is flexibility of

space. Aristocratic houses featured relatively large and multipurpose rooms. The same room might be used for living and sleeping (although the larger the house, the more likely that such functions would be separated). Even in recent times and more modest houses, the interior sliding paper doors could be removed to make the house into a single large room for a special occasion. When a house had to be expanded, rooms were added without regard for a regular overall shape and access to a new room by means of the veranda or through another room was acceptable. Most important was the relationship of one room to another. This emphasis was served by the sequential connection of rooms, in a spatial organization that the architectural historian Mitsuo Inoue calls "movement space."[13]

In movement space, which occurred in aristocratic feudal-era architecture (but not in other traditions such as the *minka* or the city rowhouse, the *nagaya*), the whole is not seen, only a sequence of aspects that must be mentally assembled to extrapolate a whole. Space is exposed gradually, arousing a sense of anticipation, in contrast to a Western form such as the Georgian center-hall plan, which allows an understanding of the whole from a privileged vantage point. Inoue compares movement space with the narrative sequences of Japanese picture scrolls.

Experiencing the streets of Tokyo is similar. Despite the rolling landscape, there are few high perspectives from which pedestrians can get their bearings, and only with the skyscrapers of recent years have any buildings been available as distant landmarks. Traditional buildings are low: shrines are hidden among trees and great residences concealed behind walls. Without an ordering grid to help identify one's position, the meandering streets are perceived as almost cinematic sequences of changing particulars that cannot be predicted; like Japanese novels, they are chains of appearances usually lacking any Western sort of development and climax. And the absence of concern for a larger sense of order is reflected in the fact that the ubiquitous public street maps, so necessary to find anything, do not routinely put north at the top. One must find one's place on the map and look at the sequential relationships of streets. This orientation toward detail rather than overview has made Tokyo a beautiful city when seen in tiny, close-up surprises (one finds doorstep gardens in the tiniest places, niches that would only collect dust and litter in America), although as a whole it is a neon-and-concrete horror.

Japan has its baroque—the Toshogu Shrine at Nikko is the quintessential example—just as the West has its austere beauty (the Cistercian churches and Shaker style, for example). Nevertheless, Japan can be described as a culture with a tendency toward reduction. In some cases, simplifying

is a way of seeking purity. It is also a way to make space. Interest in empty space coincided with the rise of Zen. Inoue and others have noted that feudal-era Zen ink paintings celebrated the beauty of empty space at the same time that architecture reached its classic state of austerity and literature emphasized the insubstantiality of clouds, dreams, and shadows.[14]

Other Japanese approaches to space are seen in gardens, the place where geography meets architecture. In historic gardens, and in modern large public gardens that continue traditions, sequential movement like the movement space described by Inoue is intended. The garden is arranged to present a series of brief views, both immediate and distant, and the speed of movement is determined by the nature of the path. This "stroll garden" most often plots movement around a pond or lake. Its significant features are its alternation of far views with close-at-hand interests such as foliage or stones, and the irregularity of the path. The layout is never geometric and there are no orderly *allées*; the garden is not seen whole. It is a chain of experiences unified by physical and visual memory. Distant views may be incorporated into the garden pictorially, as "borrowed scenery" (a notion that was itself borrowed from China) that is framed by closer elements such as trees or walls. The garden exists within a larger world.

Connections between a building and its garden are crucial. Each is a part of the whole, and the space of one flows inseparably into the other. Because both topography and tradition limit the kind of powerful sweep of space from the residence that is exemplified in Western tradition by Versailles or by the English "picturesque" landscaping style, the relationship between building and grounds in Japanese aristocratic architecture seems more intimate. The intimacy allows nuances of spatial interplay and may provide a model for the spatial subtleties in contemporary sculpture, in which relationships are not merely intellectual, but sensual.

The eminent architect Kenzo Tange has noted: "Buildings . . . are not always the most important part of this [Japanese] tradition. Often the more impressive qualities are in the semi-confined open-air spaces between them; spaces which usually have been planned with the same care and skill as the forms. The main fascination here is quite apart from the gardening, that formal concentration of natural beauty. It is also quite apart from the constant delights of color, the warm grays of thatch and bare timber, merging with the white stones, green leaves, and water. The important thing is the space itself."[15]

The garden was important for its ability to create various illusions of space. A garden designed as an approach to a teahouse would contract the features of a stroll garden,

16

27

with gates interrupting the space in order to give a feeling of depth and of passage. The residential garden, physically limited within walls, was metaphysically limitless: the selection, placement, and shaping of elements could evoke a universe. This psychological expansion of space has a particular poignance today, with the compression of urban living and with the distancing from nature caused by industrialism.

The Japanese-American sculptor Isamu Noguchi—whose work, especially beginning in the 1950s, adumbrated many of the currents of contemporary Japanese sculpture—spoke and wrote a number of times about the meaning of Japanese gardens as "a total sculpture space experienced beyond individual sculptures. A man may enter such a space: it is in scale with him; it is real."[16] The garden is both an articulated space and a system of relationships between objects, and between objects and people.

Conventional sculpture is not used in Japanese gardens, but certain garden objects have a sculptural presence and authority. These include pruned trees or shrubs, individual stones, and man-made elements such as lanterns and gates. They compel attention formally and symbolically. In particular, the torii of Shinto shrines, which define the outer limits and the precincts within the shrine, have a remarkably sculptural presence.

Japanese landscape gardening, a highly controlled and cultivated approach to nature, was also symbolic. Landscape painting and landscape gardening developed in tandem, with similar meanings. In the Edo period (sixteenth to nineteenth centuries), gardens re-created famous scenic landscapes, and even in the Muromachi period (fifteenth to sixteenth centuries) some were designed to look like paintings, such as those of the painter Sesshu, who chose to portray sharp-planed rocks that mimicked his distinctive brush strokes.

The Muromachi-period Zen dry landscape garden, or *karesansui* garden, depicted either a natural landscape (sand representing the sea, rocks representing islands) or a theme such as the crane and tortoise associated with longevity, the islands of the Immortals from Chinese myth, or various aspects of the paradise of Amida Buddha. These gardens were like landscape pictures, intended for contemplation leading to enlightenment. Such gardens—like contemporary sculpture—employed the physical to point to the metaphysical. The idea that nature is an expression of Buddhist law and that Buddha is immanent in the landscape can be expressed in a single stone. According to the Buddhist concept of the cosmos, a stone may not only stand for the universe but may *be* the universe.

Designers of the *karesansui* treated the stones with a

13

reverence in keeping with Shinto attitudes. When the garden became secular, the practice of changing nature as little as possible largely continued. The personality of an individual stone was studied and respected. The stone was placed to take the best advantage of its beauty and character. From the Japanese point of view nature doesn't need idealizing, just selection. So the garden is a matter of clarity, simplicity, and concrete presentation. Rigorous selection for the purpose of achieving deliberate contrasts or dissonances results in a kind of formal tenseness—a quality that is also evident in other Japanese arts, such as crests and textile patterns.

In addition to architecture and gardens another traditional art that may be a source of contemporary sculpture is ikebana. Derived from the same religious impulse as the tea ceremony, ikebana can be of grand scale and dramatic configuration, interpenetrating with space in a very sculptural way. The founder of one of the major modern schools of ikebana made sculpture in bronze as well as in flowers, and several sculptors active today—often concerned with installations rather than single objects—have studied or taught ikebana.

A striking characteristic of much Japanese sculpture is its respect for natural materials, particularly stone and wood. This may be a carryover from religious and cultural traditions such as the Shinto reverence for nature, the garden as a highly developed art form, and the use of undisguised natural materials in the traditional house. Another meaning of materials is found in Zen's recognition of the "thusness" of things as they are: "Not their goodness or badness, beauty or ugliness, usefulness or uselessness nor even their abstract Isness or Being, but rather their very concrete Thinginess."[17] Even purely formalist artworks have meaning inherent in their materials according to this concept of existence.

Kakuzo Okakura, the turn-of-the-century aesthetician who played an important role in introducing Japanese art to America, wrote that the balance of mind and matter—which was weighted toward mind in Indian metaphysicality and in the Christian goal of heaven—in Japan centered in the material. Shinto considered the physical, present world as the ideal world.[18] Okakura cited the concreteness and sensuousness of Japanese arts as evidence.

The Japanese attitude toward materials was articulated by Noguchi, who wrote (in a 1926 application for a Guggenheim fellowship) that it was important for sculptors to recognize the importance of matter and not to be too engrossed with symbolism. "It is my desire to view nature through nature's eyes, and to ignore man as an object for special veneration," he wrote.[19] In the 1930s and again in the '50s, when he studied pottery in Japan, he thought of himself as seeking identity with primal matter, something irreducible,

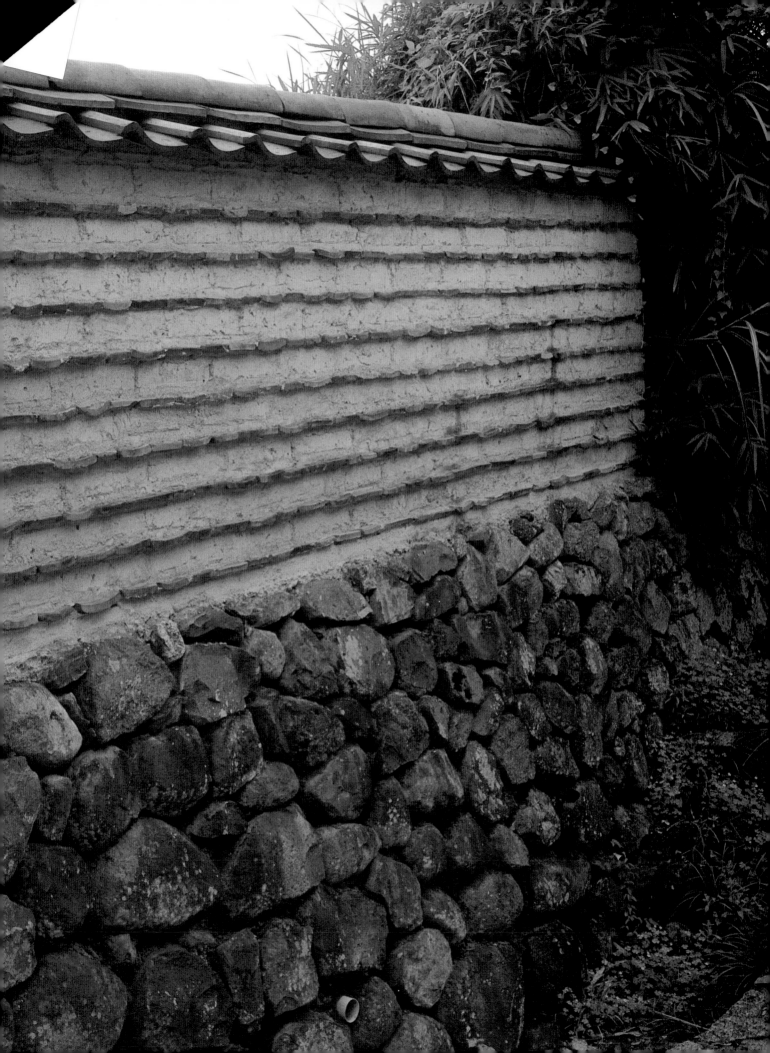

OPPOSITE
15.
A highly textured wall defines the street space near the Todai-ji complex in Nara.

RIGHT
16.
An example of "borrowed scenery": the garden of the Murin-an, Kyoto, incorporates the view of a distant mountain.

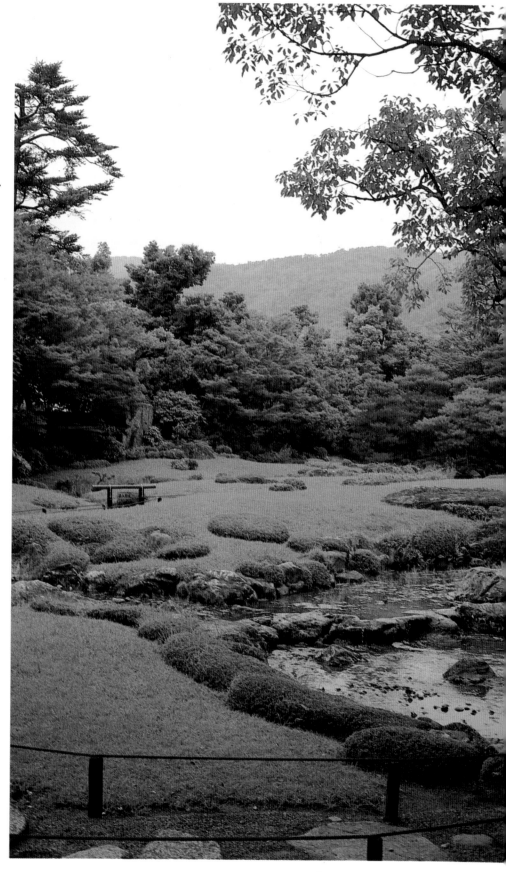

17.
Narrow—and crowded—shopping streets are found even in contemporary parts of modern cities, such as this one in the Harajuku district of Tokyo.

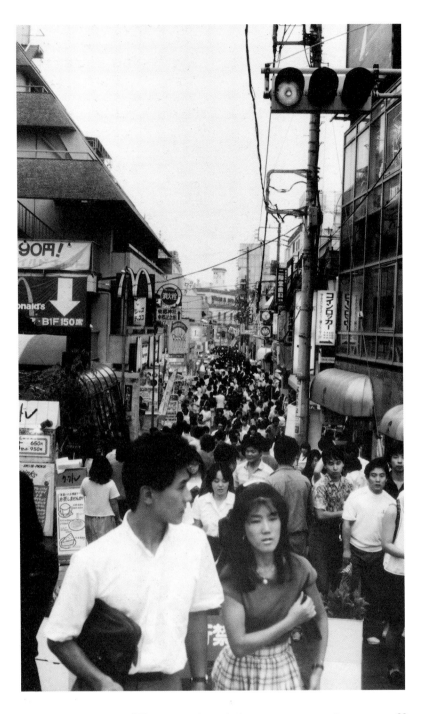

beyond personalities or gimmickry or mere cleverness.[20] Such a primal focus is recognized in contemporary sculpture and even in the title of the exhibition *The Primal Spirit*.

Japan's traditional architecture centers on wood, just as the West's centers on masonry. One early visitor noted: "In domestic work a Japanese builder shrinks from anything that would draw attention from the beauty of his varied woods. He treats them as we do precious marbles, and one is forced to confess that under his hand wood is found to be quite as wonderful a material...."[21] In classic Japanese

architecture the contrast between wood, straw or reed matting, and paper walls is valued for its aesthetic impact.

Sensory and visual interest in texture is still widespread. As a new expression of this interest, one might note that Japanese women who wear Western-style clothing are attracted to a mix of textures (traditional clothing would mix patterns but not so much substances or surfaces). The Japanese proclivity for wrapping things also results in contrasts of surface. Wrapping is a tactile process that distinguishes the natural surface from the protective one.

Interaction with natural materials is a constant of everyday life in Japan. For example, although plastic and fast food are making inroads, traditional eating practices still involve manipulating unfinished or lacquered wooden chopsticks. Food is served in glossy lacquered containers, on bamboo or basketry platters, or on ceramics, which are as likely to be textured folk pottery as smooth porcelain. Each offers a distinct tactile experience. And Japanese eating style requires handling the containers far more than Western style does. Bowls are held in the hand while eating, and tea is served in cups or low bowls without handles; one must grasp the foot and the rim of the container.

It may be that the material interest in Japanese sculpture today owes at least a small debt to the centrality of craftsmanship and the pervasiveness of crafts training. Throughout history many artists began as craftsmen working in fields in which material and technique are the most important aspects, and such attitudes may have carried over into art. Moreover, virtually all Japanese participate in some creative hobby, so that the general level of appreciation of subtleties of materials is high.

Of course, attention to materials is not exclusive to the East. One of the things that Noguchi admired about Constantin Brancusi, for instance, was his practice of leaving axe marks in some works as the record of "direct contact of man and matter."[22] This was a tribute to the material as well as to the process of working it; the material did not need to be neutralized in order to become sculpture.

Contemporary sculpture began during the postwar era with a leap away from figural sculpture (which followed both Japan's ancient traditions of Buddhist sculpture and the nineteenth-century Western figural style) to abstraction. One might postulate that abstraction, by ceasing to impose a subject on the sculptural substance, allowed the renewed expression of a traditional sensitivity to materials previously conveyed in gardens, architecture, landscape painting, and other aspects of Japanese life.

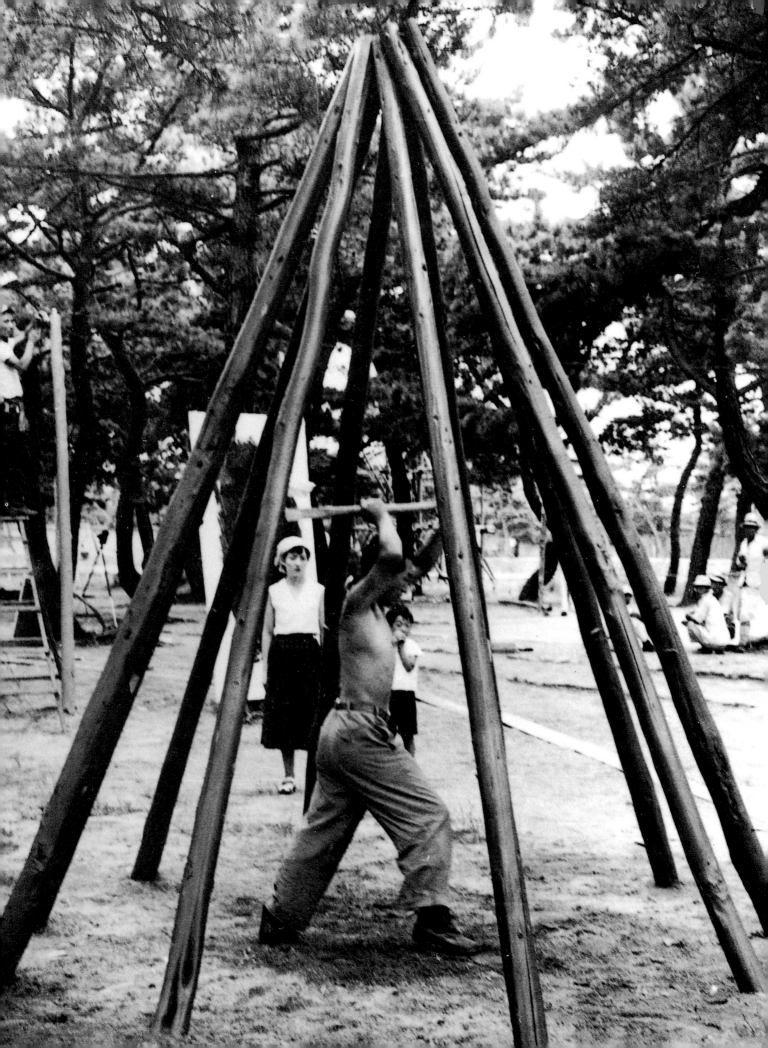

CHAPTER TWO
PRECURSORS

Contemporary Japanese sculpture has been shaped by the innovations of the Gutai group of the 1950s and by the philosophy of the Mono-ha movement of the late 1960s. In comparison with usual Japanese art groups, even those considering themselves modern, Gutai was nearly anarchic in the forms and presentation of its avant-garde art. Mono-ha was a looser association of artists but a tighter concept, yielding sculpture and installations that conformed to international modes in form but were distinctly Japanese in motivation. Painting previously had been the premier art form in Japan, as in the West, but the synthesis of contemporary art with Asian traditions begun by Gutai and brought to intellectual maturity by Mono-ha made sculpture preeminent. Undoubtedly, as many artists have rejected Mono-ha ideas as have embraced them, yet it is from the base of Mono-ha achievement that today's vitality springs.

In 1954, in the Kansai district of western Japan, centered on the cities of Kobe and Osaka, a group of about fifteen young and unknown artists gathered in the studio of an established painter to discuss new concepts in art. The next year they began publishing a Japanese-English newsletter titled *Gutai* ("concrete" or "materialist"), the name by which they themselves came to be known. Gutai owed its existence to the well-known painter Jiro Yoshihara, who also happened to be a wealthy businessman.[1] In an era when "independent artist" was still an oxymoron in Japan, Yoshihara filled the role of *sensei* (teacher or master) and was the theorist, promoter, and banker for the group as well.

The group was open to anyone, participants shifted over time, and their work changed constantly. The emphasis was on innovation—a radical stance in an art world still hierarchical and rule-bound. Gutai artists concentrated on performances, kinetic sculpture, environments, and other ephemeral forms of art in addition to making paintings by novel means. Some of their activities have been described as the first Happenings, predating those in the United States.

Among the Gutai artists was Kazuo Shiraga, who created paintings by laying a canvas on the floor, swinging

18.
Kazuo Shiraga (born 1924)
Challenging Red Log, Gutai
performance, 1955
Wood; height: 137¾ in. (350 cm)

from a rope above it, and painting with his feet. Believing that the spiritual and physical were one (he later qualified for the Buddhist priesthood), Shiraga was as interested in the act as in the result. During one Gutai event he created a sculpture by setting up a conical framework of peeled logs and hacking at it with an axe. In another he painted with his body on a "ground" of mud and concrete. Another Gutai artist, Saburo Murakami, made a practice of leaping through paper "canvases." Atsuko Tanaka became widely known for her performance costumes made of light bulbs as well as for her paintings inspired by electric circuitry.

Gutai held events both in galleries and outdoors, on-stage and in the air. In 1955 the *Experimental Outdoor Exhibition Challenging the Midsummer Sun* included Sadamasa Motonaga's vinyl packages of water and Toshio Yoshida's sixty-meter line of wooden stakes driven into the ground. A 1960 *Sky Festival* displayed paintings suspended from advertising balloons. The group opened its own museum, the Gutai Pinacotheca in Osaka, in 1962. A typical Gutai stage performance included dance, slide projections, original music, balloons, smoke, kinetic sculpture, and once even an actual marriage ceremony, in which the bride and groom were cocooned in a strip of white cloth. One of Yoshihara's own works (seldom cited in the accounts of Gutai activities he wrote) was a 1957 performance called *Two Spaces*. When the curtain was raised, the stage was in darkness and the audience strained to see whoever was talking, making noise, and shining flashlight beams from the stage, but when the lights came up, nothing and nobody was on stage.

Gutai events have been called Dadaist, but Yoshihara specifically denied this, asserting that their activities were never destructive and never lost connection with materials. Despite the Gutai artists' acceptance of modern technology and emphasis on newness and change, their attitude toward materials might be described as traditional. An early statement by Yoshihara read: "Gutai Art does not alter materials. Gutai Art provides materials with life. Gutai Art does not cheat materials. In Gutai Art, the human spirit and materials, though still in antagonism, shake hands with each other. Materials never assimilate themselves into the spirit; the spirit does not subjugate materials. Materials start telling stories when their innate characteristics are exposed as they really are; they even give a cry. To make the fullest use of materials is also the way to make the best of the spirit. Enhancing the spirit is giving materials their nobility."[2]

The action of the Gutai artist *was* the artwork or was recorded in the artwork. The work was tense, active, and direct. This physical approach was understood and appreciated by the American Abstract Expressionists and the Euro-

pean Informel artists and theorists, notably Michel Tapié. No one, however, paid much attention to the ways that Gutai behavior paralleled Zen practices.

About a dozen issues of the *Gutai* newsletter were published between 1955 and 1964, with artists' statements, photographs, and interviews with leaders of the international art world. Officially, the group was disbanded only after Yoshihara's death in 1972, but by then it had sputtered out into mild-mannered painting and had lost its avant-garde position to several anarchic and short-lived groups of the late 1950s and early '60s, the best known of which are the Neo-Dada Organizers and High-Red-Center. The attitude toward art promoted by the Gutai group is probably its most valuable legacy. Their individual works of art have been less significant to later artists than the Gutai idea of inclusiveness—particularly its acceptance of ordinary, everyday materials—and its experimental intent, which loosened the grip of Western and Japanese conventions on sculpture as well as on painting. After the shock of Gutai, art became less predictable in Japan.

For all their significance, the Gutai artists were not the first creators of abstract sculpture in Japan. Yoshishige Saito, a seminal painter and sculptor as well as an important teacher and mentor to the Mono-ha artists of the late 1960s, has been called the link between the prewar avant-garde and the postwar radicals.[3] He was one of the few Japanese artists with some knowledge of Russian Constructivism. As a youth he had seen the works of the Russian Futurist David Burliuk, who came to Japan in 1920 (ironically, exposure to Burliuk's work led to the first of Saito's several abandonments of art). Saito's constructions and reliefs of wood and silk thread and his first wood collages were destroyed during World War II, but in the 1970s he re-created a group of them from memory and photographs, and themes from those early works have continued to occupy him.

Saito has followed an unorthodox course, periodically shifting from painting to installations and often working in an uncategorizable "in between." In the 1930s he tried to exhibit three-dimensional collages at an artists' association group exhibition, but the painters said the works were sculpture and the sculptors said the works were paintings, and ultimately he was excluded from the show. His plywood collages—fitted together like puzzle pieces of varying thicknesses—were intended to reject the illusionistic space of painting. Early paintings introduced motifs such as a balancing doll (an unstable object that moves on a fulcrum) that have been reworked in drawings, reliefs, and most recently in installations.

For a time in the 1920s Saito concentrated on literature. During the early 1950s he stopped exhibiting his art and

19.
Yoshishige Saito (born 1904)
Complex #101, 1983
Oil on wood; 12 ft. 11½ in. ×
13 ft. 3½ in. × 15 ft. 5 in.
(3.95 × 4.05 × 4.7 m)

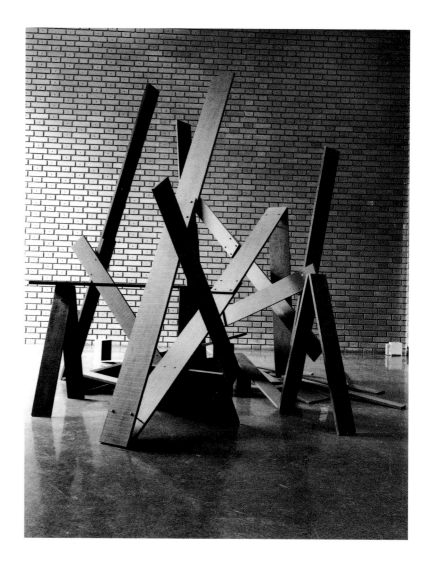

disappeared from view for several years. When he resumed exhibiting in 1957, his Informel-style paintings were honored with prizes in the Fourth International Art Exhibition of Japan and in Tokyo's New Artists 1957. In the latter he was designated as the best "new" artist of the year. He was past fifty at the time. This was the beginning of his participation in a run of important exhibitions, including the Carnegie International, the São Paulo and Venice biennials, and the Guggenheim International, in many of which he took prizes. During the late 1950s he was painting in high relief and sometimes making relief works with moving parts. In 1960 he began flatly painting wooden boards and "drawing" on these grounds with an electric drill.

In the mid-1970s Saito made reliefs consisting of boards lined up side by side, then crossed by diagonal boards. In the 1980s these compact compositions were dispersed into installations consisting of black-painted boards cutting diagonally through space in loose, open arrangements. Because the parts are standardized in thickness as well as

19

color (he uses ordinary lengths of wood purchased from lumberyards), the main visual device is rhythm.

The boards overlap to articulate space in various ways. Saito asserts that there are no perpendiculars in his installations because perpendicularity implies a stability that he does not want.[4] The arrangements are not continuous; elements are connected like a chain, he says, and can be rearranged to suit any location. He thinks of this as an example of simultaneously perceived space and time *(ma)*. Relationships within an installation are not fixed, and the number of elements can be changed. The boards, being linear and short, create a sketchlike effect and imply, as sketches often do, that what we see is not complete. Saito thinks of an installation as the entire room, not just the parts he has placed, so that each time it is exhibited, it is a new work. Rejecting both monumentality and permanence, he makes work that embodies a view of existence as a series of accidents and events.

Saito uses wood because he can work it by hand relatively easily, and he paints it to suppress its material identity as much as possible and to make the elements function as silhouettes. He notes that he started as a painter and that he is still conscious of the presence and the effect of walls. His works retain a frontal emphasis (which Japanese critics have called a Japanese aesthetic) that to some degree reiterates the planes of walls.

These works deal with space in more than one way. They occupy the literal space of relief, but their blackness makes a visual vacuum and also suggests the space of shadows. Because of their openness, which makes the space and things around them visible through the work, they encompass a much larger space than they physically inhabit. Because of their complicated and sometimes contradictory spatial character, the critic Shigeo Chiba has called these works "anti-spaces."[5]

Saito was one of a number of artists making abstract sculpture in the 1950s and '60s. Masayuki Nagare, Shu Eguchi, and Kakuzo Tatehata took part in the 1966 exhibition *New Japanese Painting and Sculpture* at New York's Museum of Modern Art. Another of that generation, Masakazu Horiuchi, has made a great many excellent public sculptures. Each of these men, in his own particular style, mastered the Western form of single-object, centralized-mass abstract sculptures. But Saito's work was far more avant-garde. In addition, he has a special place in this narrative because, as a teacher at Tama Art University from 1964 to 1973, he taught many of the Mono-ha artists (with the major exception of U-Fan Lee). Kishio Suga said of Saito, "Without him, I wouldn't be doing what I'm doing."[6] Nobuo Sekine wrote a tribute to Saito, calling him a force of nature that could

not be interpreted or rationalized. He described Saito as extremely influential yet able to discourage imitation by always taking an opposite position, no matter what the issue.[7] Saito was nonjudgmental and open to change, pushing each student to follow his own interests and to create his own work.

Saito influenced his students' thinking and their way of being artists. The Mono-ha artists emulated his seriousness, although their work did not follow his in form and they took a different attitude toward materials. However, there are several artists who share his constructive sense—the concentration on connections, the suppression of geometric order in favor of organic or intuitive arrangements—among them, Tadashi Kawamata, Yoshio Kitayama, Keiko Yamada, and particularly Hachiro Iizuka, who worked as Saito's assistant. Saito remains an exemplar of independence and vision.

Toshiaki Minemura, the prime chronicler of the Mono-ha movement, says that it developed in reaction against the optical emphasis in Japanese art of the 1960s, specifically the influential "visual manipulation" of Jiro Takamatsu, whose shadow paintings deal with "the discrepancy between vision and real existence, between 'to see' and 'to be.'"[8] Depicting shadows of figures and everyday objects, these paintings seem to question the reality of existence. And in the late 1960s distrust of reality was connected to distrust of established values and systems, both Japanese and Western. It was a time of student unrest and widespread objections to technological culture. Student strikes affected the art schools, and Saito was among the professors who moved their classes away from the schools or suspended them entirely in sympathy with the students.

The recent graduates who later constituted what came to be called the Mono-ha movement (all except one had been in the painting course) began working in three dimensions. Each made sculpture that focused on here-and-now existence by presenting real objects from the real world. Their reaction against the visual tricks of the optical painters—tricks that they had learned in school—was the testimony of Mono-ha, which presented basic things straightforwardly, as they were encountered, without illusion.

Mono-ha can be translated as "the school of things." The movement began in 1968 and by 1972 was past its prime, although the term Mono-ha came into currency only about that time. It was (like most movement titles) derisive, applied by critics to nearly a dozen sculptors doing quite different work. What they had in common was the use of such ordinary materials as earth, stone, wood, metal, cotton, paraffin, and paper. Things—substances as well as objects—were regarded as having an existence and value of their own. The artists used the term *material* rather than

medium to overturn assumptions about the neutrality of substances. In this emphasis on materials, Mono-ha was related to Italy's Arte Povera, America's Minimalism, Earth art, and Process art; the Joseph Beuys circle in Germany; and the artists associated with the St. Martin's School of Art in London.

The intellectual leader of Mono-ha was U-Fan Lee, who was several years older than the others. He had emigrated from Korea in 1956, taken a degree in philosophy at a Japanese university, and become involved in art. He has steadily produced paintings, prints, and sculptures ever since. He became closely associated with several young men from Tama Art University—Nobuo Sekine, Kishio Suga, Katsuro Yoshida, Shingo Honda, Katsuhiko Narita, and Susumu Koshimizu. From other art schools came Koji Enokura, Noboru Takayama, and Noriyuki Haraguchi.

Realizing the futility of attempting to copy or catch up with what was being done elsewhere, Lee sought his own goals. He wanted an art that would present "a candid vision of an undisguised world,"[9] the real world, and would reflect its own time, not recapitulate the past. Mono-ha artists looked at their time as a period of political and commercial propaganda, in which things were obscured by words and representations and the experience of encountering anything directly became increasingly rare. They were determined to respond to this situation with an art that would reflect an East Asian sensibility. By attempting to see things "innocently," they would try to transcend the estranging intellectuality of international art concepts and the burden of art history. They also sought to escape from the anthropocentrism of Western sculpture (as Noguchi had proposed more than forty years earlier) and to replace the adversarial opposition to nature with a partnership.

Japanese aesthetics has been described as being "based upon judicious rearrangements of life's ordinary or daily items into a form that shows their natural beauty and enhances their overall environment. There is less sense of imposed form than in Western art and consequently less sense of artificial delineation...."[10] This description applies equally to Mono-ha. Western sculptural tradition emphasized the independence of the sculpture (and of the artist). The Mono-ha artists emphasized interdependence and relativity, based in part on the Buddhist belief in the relativity of events in a world of flux. Preferring to make each work an integral part of its surroundings, they joined the physical features of the gallery to the work so that sculpture and space were inseparable. Rather than use traditional techniques such as modeling, carving, or construction, they often just stacked their iron plates, charcoal, clay, lead, or whatever in an ephemeral assembly.

The Mono-ha artists rejected the notion of "perfect, finished" objects. The sculptures were merely temporary confluences (that is, a specified combination of materials in a certain configuration) but not "originals" that would increase in monetary value. Rather, like the Great Shrine of Ise, which is reconstructed every twenty years, the essence of a Mono-ha sculpture was the concept rather than the substance. The materials were regarded as generic—tree, stone, rope—or even more broadly as interchangeable representatives of existence itself. A Mono-ha work could be remade from similar materials at any time, just as early works were reconstituted for the *Mono-ha and Post-Mono-ha* exhibition at the Seibu Museum in Tokyo in 1987.

The Mono-ha artists specifically rejected the idea that they were "creating." In Martin Heidegger's terms, the sculptor could "call the object from hiddenness." Lee (who was indirectly influenced by Heidegger through the philosopher Kitaro Nishida) expanded on this idea: "The highest level of expression is not to create something from nothing, but rather to nudge something which already exists so that the world shows up more vividly. An artist's work is shifting the 'as it is' to the 'AS IT IS.' "[11]

The concept of "creating" was also rejected because it assumed a split between sculptor and sculpture, whereas the Mono-ha artists sought a continuity between maker, work, and surroundings. The sculptor would not impress his emotions on the work but would be present only as a "builder," enabling the materials to become an artwork. The focus would not be inward, on the artist's ego, but outward, on the world.

The work that is usually identified as marking the start of the Mono-ha movement is Sekine's *Phase-Mother Earth*. [20] Conceived for an outdoor sculpture exhibition in Kobe, Japan, in October 1968, it was unorthodox because it was not transported to the site but was actually made *of* the site. Sekine dug a cylindrical hole in the earth and piled the excavated dirt into a cylindrical mold of equivalent volume. It was in the course of digging the hole (with the aid of his friends Susumu Koshimizu and Katsuro Yoshida, both Mono-ha artists as well) that he realized that he was not "creating" but merely transferring a material that already existed. His displacement of the earth emphasized both its mutability and its essential changelessness. When the exhibition was over, he filled in the hole.

Phase-Mother Earth can be contrasted with the American sculptor Michael Heizer's earthworks from the same period, such as *Displaced-Replaced Mass* (1969). Heizer's work was in an inaccessible location, Sekine's in a public park. Heizer's work required earthmoving equipment; Sekine needed only a shovel. Heizer's placement of granite masses

in a concrete-lined hole implies man's control of nature through a permanent alteration; Sekine's work was transitory and much smaller in scale. Sekine has derided earthwork artists for dealing only with the physical and for seeing nature and civilization as opposed rather than as aspects of the whole.[12] He has also asserted that the Mono-ha emphasis on the natural, the low tech, the unprocessed, the ordinary, results in the meaning of the work being expressed more clearly.[13] (Despite the preference for natural substances, industrial ones were also used by Mono-ha sculptors from the beginning.)

That *Phase-Mother Earth* dealt with the relationship between two elements (a pile and a hole) in a larger

20.
Nobuo Sekine (born 1942)
Phase-Mother Earth, installation at Suma Rikyu Park, Kobe, Japan, 1968
Earth; 106⅜ × 106⅜ × 86⅝ in. (270 × 270 × 220 cm)

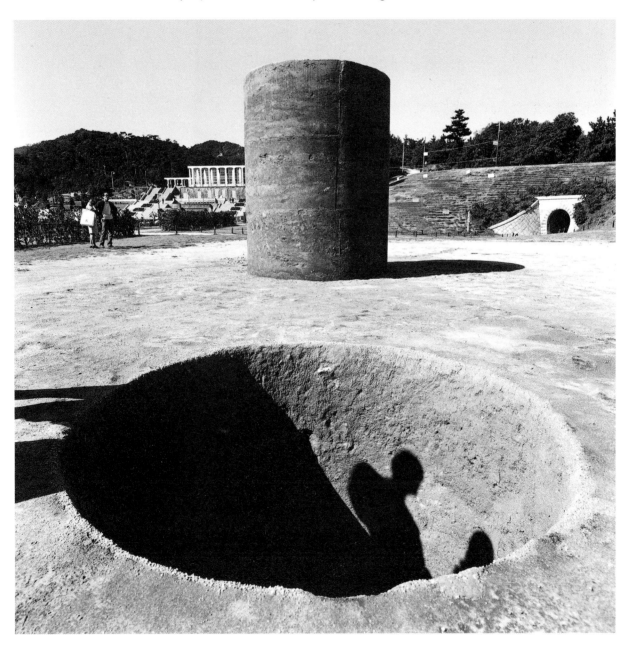

21.
Nobuo Sekine (born 1942)
Phase of Nothingness, 1970
Stone, stainless steel; 14 ft.
9¼ in. × 13 ft. 9⅜ in. ×
4 ft. 3¼ in. (4.5 × 4.2 × 1.3 m)
Louisiana Museum,
Humlebaek, Denmark

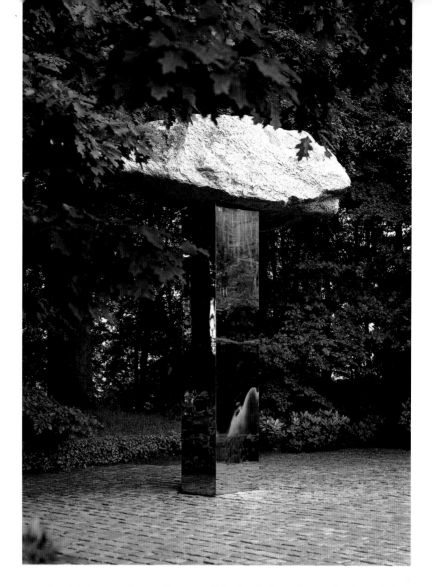

context (the park or the earth), that it acknowledged the preexistence and significance of materials, and that it avoided anthropocentricity made it the first exemplar of the Mono-ha philosophy. Lee met Sekine after seeing the work and they discovered their similar views. To Mono-ha, Sekine contributed elements of topology, Taoism, and Indian philosophy; Lee added Heidegger and Nishida.

As a consequence of making *Phase-Mother Earth*, Sekine became conscious of the difference between things as means ("tools," in his words) and things as ends in themselves. He considered his works to show relationships between separate things or between different aspects of one thing (for example, an indentation in one side of a sheet of metal is simultaneously a protrusion on the other side). To emphasize things as themselves, he did a performance with nonhardening clay that involved recognizing and addressing the clay substance without turning it into a sculpture. In other works he magnified the sense of relationships by setting up striking contrasts, such as a huge sponge with an iron slab on top. He considered that he was "strengthening the presence"[14] of things.

Sekine produced a number of Phase sculptures, the name implying that these were not fixed objects. Among the best known of these—reproduced in several versions and shown at the 1970 Venice Biennale—is *Phase of Nothingness*, a stainless-steel pillar that holds aloft a huge natural stone. In this work the open-ended symbolism seems more intriguing than the formal qualities or the materials, perhaps presaging Sekine's drift away from Mono-ha ideas or perhaps indicating how difficult it is to keep a work free of allusion. The stone can be seen as hovering like a vision or spirit, or it can be seen as displaced and threatening. It might represent Japanese traditional culture or even the Stone Age, when man had a less ambiguous relationship to nature. The stone also alludes to the dry garden, which historically included specific Buddhist symbols. Sekine's approach is close to that of the abstractions conveyed in Kyoto's Ryoan-ji garden, where stones express the harmony of the universe. The pillar, a product of modern technology, stands in a complex relationship to the nature and the culture represented by the stone. The stainless steel reflects its surroundings, which in a sculpture park means reflecting a manicured landscape. In a broader sense it reflects the contemporary environment.

Minemura, the chronicler of Mono-ha, identifies Kishio Suga as the only participant who has continued to be faithful to Mono-ha ideals.[15] Suga titled many of his early works *Situation* and described them as dealing with relationships between object and object or man and object. Seeking to avoid the associations of the established word *sculpture*, he referred to his arrangements of materials as *articulations*. His explorations of existence and materials are based on the "relationality" of Mahayana Buddhism.

Rather than creating isolated objects, Suga generally represents phases or states that contrast with each other. His installations may look simple and straightforward, but they imply dualities such as inside and outside, front and back, vertical and horizontal. One example is his *Half the World* at the 1978 Venice Biennale, in which twenty cedar logs were split vertically; half of each stood at regular intervals throughout the room, and the other half lay on the floor. Thus the work suggested a series of relationships and oppositions. Minemura has noted that even so small a detail as the bark played a role by defining inside and outside, a distinction that would be lost in a more homogenized material.

In *Unlimited Condition*, made for a Kyoto museum exhibition in July 1970, Suga propped open the museum's windows with pieces of scrap lumber. As the critic Shigeo Chiba wrote of the work: "This goes beyond dealing with just a particular thing or the relationship between one thing

21

22

23

22.
Kishio Suga (born 1944)
Half the World, plan for instal-
lation in Japanese Pavilion,
Venice Biennale, 1978

and another. The visual field is a world that extends from the space inside the museum, through the window, to all of the outdoors. . . . The work goes beyond the concept of art and steps into the world."[16] Suga has said that "expanding outward" so that his self disappears into the larger whole is the basic philosophy of his work. Transcendence is possible only as an expansion from the concrete and mundane; it is impossible in the imaginary world of painted illusion, he believes.[17]

Katsuro Yoshida, who is currently working in two dimensions, began his Cut-Off series in 1969. These works adopted an almost baffling variety of forms and materials, the only hint of unity being the consistently unexpected combinations of materials, such as paper and stone, iron and cotton, lumber and electric cord variously wrapped, chained, stuffed, or stacked. *Cut-Off (Hang)* is an enormous square wooden beam wrapped twice with rope and dangled. The rope encircles a stone on the floor and then terminates in indecisive loops. *Cut-Off (Chain)* consists of square posts set in concrete blocks and linked by chains. Some posts lean, asserting individuality and threatening the connections.

Early Mono-ha works tended to favor unprocessed materials, but sooner or later all the artists altered the surfaces of their materials or processed them in some other way. Mono-ha's emphasis on flexible space and on relationships and the preference for untreated materials can still be recognized in contemporary work—for example, in the continuing prevalence of multipart works and in the disinclination to conceal materials.

23.
Kishio Suga (born 1944)
Unlimited Condition, installation in Kyoto, Japan, 1970
Materials: square wood beams, structure of building, outdoor scenery; size: variable

CHAPTER THREE
SCULPTURE AS MATERIAL

Japan is known for its wooden architecture, its textiles, its handmade paper, and its gardens of stones. In what seems to be an extension of the value traditionally placed on such materials, some sculptors take them as their subject as well as their medium. They use the sense of well-being that can derive from direct manipulation of materials to counteract the anxiety caused by pollution, runaway technology, rootlessness, and other ills of contemporary life (art as therapy, in a sense). These sculptors nearly always make their own work rather than having it fabricated—an approach that others may consider old fashioned. For example, at a 1983 symposium held in the Netherlands, some Dutch conceptual artists dismissed participating Japanese sculptors as "typical craftsmen, the stone carvers."[1]

The regard for materials, which may occur in any culture, derives a spiritual depth and vigor in Japan from the animism of Shinto. To find life or soul in natural materials that are cyclically renewed is to find a source of comfort in an otherwise difficult world. The belief that *kami* occupy natural things intimates a harmony quite unlike the intellectual problem solving (or problem making) that cools much advanced art in Europe and America. Such animistic materialism provides a cultural path through the artificiality and trash of contemporary life, enabling sculptors in Japan to make work that is mundane and at the same time mystical.

24 The monumental sculptures of Chuichi Fujii are tree trunks that seem untouched—except that they stand bent in a gallery rather than erect in a forest. They are enormous, a yard or more in diameter, and reveal no evidence of the technique used to bend them. The artist, wisely, will not discuss it, for how he works is not the point. He has said: "I grew up surrounded by wood; it has always been an essential part of my life. Like human beings, trees breathe air, they drink water, they cry. . . . I think there is nothing more beautiful than the form of a tree stretching upwards. But, when I see an especially good tree, I get an uncontrollable urge . . . to start working with it. . . ."[2]

Fujii's perception of trees as nearly human may explain

24.
Chuichi Fujii (born 1941)
Untitled, 1987
Japanese cedar; 10 ft. 6 in. × 13 ft. 1½ in. × 11 ft. 6 in. (3.2 × 4 × 3.5 m)
Otsuka Pharmaceutical Company

the sense of movement, albeit imperceptibly slow, suggested by the relationship of the two huge Japanese cypress trees in his 1985 untitled sculpture. They curve toward each other like lovers or dancers, creating tension and drama that derive from their unrealized embrace more than from the danger inherent in the trees' great weight. Seemingly engaged in a sad, mysterious rite, they command space with their mesmerizing presence. The sculptures induce a feeling of religious awe, and some visitors to Fujii's exhibitions have left coin offerings before the works.

Fujii has said: "In the past I would work with a material and try to change its essential qualities. Since I returned to wood, though, I do not feel the need to do that. Wood is wood, and it should be approached simply; the point of departure should be the A of ABC. I think that if the point of origin is forgotten, one will lose his way. . . . There seems to be a lot of art in which it makes no difference what material it is made from. My attitude is that one should start from an understanding of what a material can do, whatever the material is."[3]

The wood-and-metal sculptures of Hisayuki Shima also p. 2 create meaning with material, using the wood for itself and to symbolize other ephemeral organic matter. Shima has wrapped the slender trunks and branches of saplings with little patches of patinated metal, attached with rivets. He sometimes lays these encased limbs on the floor alongside metal rods. The metal coverings seem an absurd preservation measure for the perishable wood, like preserving the bodies of Han royalty by shrouding them and plugging their orifices with jade. Shima's recapitulation of this concept is modern in its ironic awareness of the symbolic efficacy but actual futility of the encasing gesture.

Other works by Shima suggest material transformations. In sculptural tableaux, he borrows images of art classics of East and West—Michelangelo's Rondanini *Pietà*, Marcel Duchamp's *Nude Descending a Staircase,* and the eighth-century Ashura sculpture from Nara's Kofukuji temple—and recasts them in sharp-edged metal. The material may strike a negative note, suggesting that both humans and gods are turning into machines, but more often Shima conveys a sense that an essence persists no matter what physical transformations a thing is subjected to.

Toshikatsu Endo might be seen as an offspring of Mono-ha in that his works are made of unadorned familiar materials, often brought together in simple and impermanent configurations. They differ from Mono-ha in their stronger sense of mystery. Endo uses primary materials such as earth, fire, and water in simple forms evocative of primordial memory and timeless experience. *Canal I* (1984) is a long wooden trough filled with water; his untitled 1987

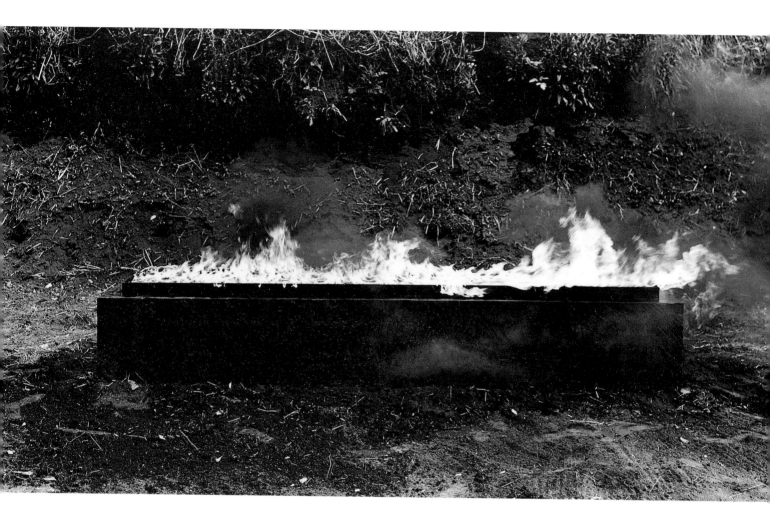

outdoor work at the Hara Museum of Contemporary Art consisted of two hemispherical excavations, one containing a circular pan of water reflecting the sky, the other a circle of gas flame. Other recent work consists of charred coffinlike boxes that are filled with water. Water—a purifier, a solace, a life source—recurs in his works, though often barely visible or not visible at all. The elemental substances and processes that Endo favors retain the mystery of ancient rites, and by means of photo-documentation he shares such pre-exhibition rituals as setting the works aflame or floating them in lakes. When the photos are sufficiently austere and dramatic, they seem to temporally expand the otherwise immediate and factual objects. Occasionally, though, the photos are less evocative than a viewer's imagination, or their presence implies that the object alone is not adequately expressive.

Japanese sculptors use stone in various ways, but those who define sculpture as material do not use it to make representational images. Although it may refer to other things, their sculpture is always abstract.

Shiro Hayami alludes to the traditional use of stones,

25.
Toshikatsu Endo (born 1950)
Coffin of Seele, event, 1985
Wood, water, fire, earth, air, sun, tar; 23⅝ × 118⅛ × 25⅝ in. (60 × 300 × 65 cm)

26.
Shiro Hayami (born 1927)
Country Mountains, 1986
African black granite; 11 parts

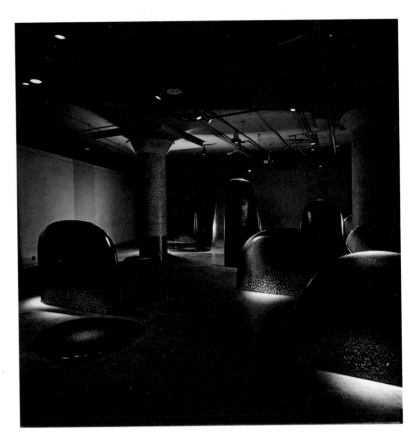

in gardens and tray landscapes *(bonseki),* to symbolize mountains. In *Country Mountains,* an eleven-part installation 26 of simply carved African black granite, vertical slabs suggest mountains while circular horizontal slabs call to mind lakes. The rounded shoulders and pocked bases of the verticals might be read as erosion, and (extending the metaphor of the title) the marks at the bases might be seen as representing the towns that swell up from the valleys of rural Japan and cling to the mountainsides. The marks might also refer to the seas that encircle the Japanese mountain-islands.

The vertical slabs look like broad tombstones. However, their front and back faces are not flat but are slightly pneumatic, which introduces yet another suggestion: that these are beings that breathe. In this reading of the forms, Hayami's arrangement seems less a landscape than a social grouping, a distribution of people in a community. The multiplicity of metaphoric possibilities in this work is exceptional in Japanese sculpture.

Hiroshi Egami creates weightless stone installations with a delicacy that induces an atmosphere of silence. A 1987 work consisted of a dark, human-scale monolith standing 27 in a bed of white sand. Hovering around the stone were perhaps a hundred smooth black pebbles suspended on fine white strings. This rock cloud or suspended garden comprised a single substance: rock in three states. Other

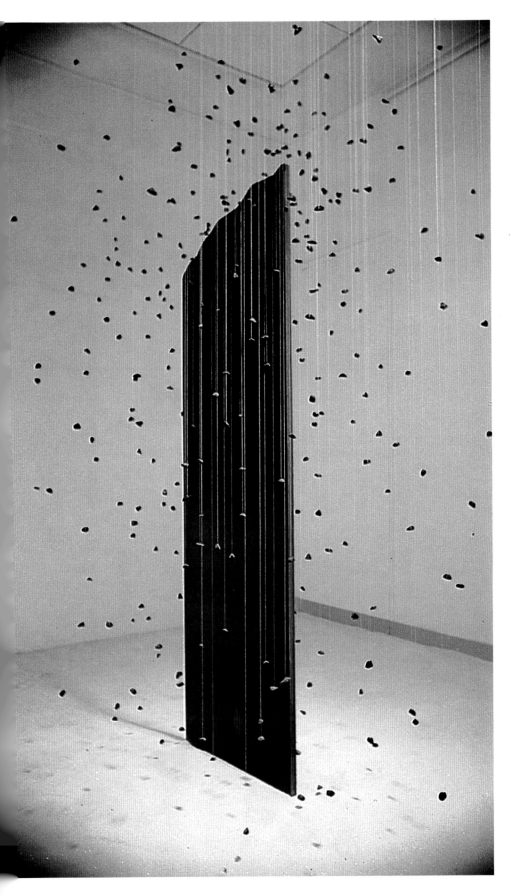

27.
Hiroshi Egami (born 1952)
000000000008, 1987
Black pebbles, stone slab,
sand, thread; 66⅞ × 19⅝ ×
¾ in. (170 × 50 × 2 cm)

28.
Makio Yamaguchi (born 1927)
Leaning Form H, 1984
Black granite; 54⅜ × 26¾ ×
16½ in. (138 × 68 × 42 cm)

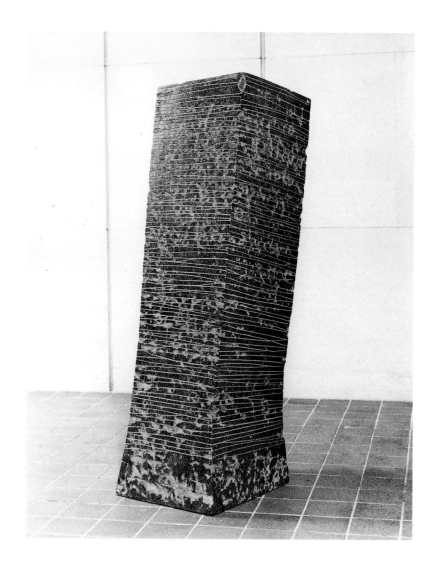

installations made by the same technique have created effects of rain or whirlwind (with the suspended stones seemingly sucked into a spiral) or hints of remembered structures defined only by a suspended sprinkling of stone dots outlining the form.

Makio Yamaguchi makes tilted columns that are chipped or gouged in narrow horizontal or sloping lines. The sculptor's contact with the recalcitrant stone results in objects that are intensely tactile, yet reserved and unemotional. These sculptures are matter-of-fact rather than evocative. Nothing is hidden. The work has a dual identity of natural stone and geometric solid.

Japanese sculptures that are focused on the use of materials do not always feature mass, weight, or solidity. An emphasis on hollow volumes and spatial containment is more common in contemporary sculpture in Japan than in the United States or Europe. When sculpture is not conceived of as a central mass, nontraditional materials—textiles, for example—can be used. Fiber—both as a single filament

and as a plane of many filaments—can be manipulated to yield volumetric sculptural forms.

Hisako Sekijima, Masao Ueno, and Tomoaki Ajiki are basketmakers whose work cannot be physically or conceptually distinguished from sculpture. All three make containers for ikebana, the spatially adventurous art of flower arranging that encourages vessels of similarly unconstrained form and requires only the most minimal concessions to function. Sekijima and Ueno, who continue to work at small scale even when making purely sculptural objects, explore the concept of a basket both as a structure and as a space.

Sekijima often conceives her forms from the inside out: she thinks of a space and makes a basket-sculpture around it. Thus she speaks of space as a "negative" material, as opposed to the tangible positive of vine, bamboo, etc. She is also interested in the spaces in the walls of her objects and chooses a constructive method to hold the space and prevent the solid materials from filling it up. Her interest in the void at the center of a basket is an extension of Zen thinking, she believes, or it may be a Japanese predilection predating Zen. This fascination extends to space that is completely enclosed—perceptible only intellectually, through the contrast of weight and dimensions—and to the minuscule spaces of chaotic baskets that she likens to birds' nests. She has defined one form with a figure eight of bark and has also made a thick-walled basket that she cut in half and offset, as if to let the confined interior space leak out.

Sekijima thinks of her work as a collaboration with nature, and she puts her own ideas aside to "let the material talk."[4] Her organic materials function structurally, visually, and conceptually. The vine or branch creates a line as fine and precise as wire, but its organic nature results in a

29.
Hisako Sekijima (born 1944)
Untitled, 1985
Wisteria; 14½ × 17¾ × 8 in.
(36.8 × 45 × 20.3 cm)

30.
Masao Ueno (born 1949)
Untitled, 1984
Bamboo, hemp, bark, grasses;
5⅞ × 11¾ × 5⅞ in. (15 ×
30 × 15 cm)

softer effect. It incorporates a history of changes from the tenderness of the growing tip, to the flexibility of the mature plant, to the rigidity of the dried form, to its temporary pliancy in the moistened state, to the slow deterioration of the basket. One seldom looks at a wire and thinks that it once was ore, then molten, now rigid, and eventually to rust, but basketry materials carry such connotations of time.

Ueno, too, is interested in the container concept, particularly in regard to how the object is structured. His baskets may allude not only to boxes, trays, and pots but also to other containers such as boats and even the human body. But in each of these allusions the primary identity of the object remains its material. Because the material is chosen first, its qualities, rather than the artist's unrestrained imagination, determine the final form—e.g., the length of a single element or the tightness of a curve. 30

Ajiki's sculptures are body-size or larger. He magnifies not only the measurements but also the tension that is intrinsic to basket construction. He eschews orderly structure in favor of random interlacing, and where the tension is greatest he may tie the resilient bamboo elements with wisteria vine, as 9

if to contain their energy. In contrast to the refinement of traditional small-scale Japanese baskets, Ajiki prefers the impression of incompleteness, what the Japanese call *chuto hanpa* (on the way). This looseness is like freehand drawing. The open basket wall functions as a marker of space rather than as a barrier. Ajiki makes baskets in relation to each exhibition space, contrasting their irregularity and openness to the brick or concrete of the gallery. He thinks of his baskets as visual antidotes to the "technostress" of living today.

31 In the early 1980s Katsuhiro Fujimura became known for his enormous corrugated-cardboard works in the shape of ceramic vessels, as large as six feet tall. The unorthodox material rejuvenated the standard form, first because it

31.
Katsuhiro Fujimura (born 1951)
Untitled installation at Gallery NW House, Tokyo, 1987
Corrugated cardboard; largest: 82⅝ × 47¼ × 23⅝ in. (210 × 120 × 60 cm)

permitted a scale not possible with clay and second because the combination of shape and substance was so unexpected. Because Fujimura's material is isolated as art, awareness of it is intensified: one thinks about the expected weakness of paper and about its transience. That cardboard is a material of convenience, not longevity, was demonstrated when several of Fujimura's works were displayed outdoors at the Hara Museum of Contemporary Art in 1985. Slowly, but gracefully, they dissolved in Tokyo's rainy weather.

Fujimura's recent work moves beyond the vessel format, featuring increasingly complicated pieced and multilayered forms. Looking through the pattern of the corrugations reminds the viewer of how textilelike cardboard can be, despite its rigidity. All his pieces are built of cut cardboard, lately of thin strips made into pillars or less definable forms.

Fujimura has shown his work at the Lausanne International Tapestry Biennial (a misnamed exhibition in which many works are three dimensional), where Japanese sculptural works employing fiber have been enormously successful. In 1985 and '87, more works were accepted from Japan than from any other nation. These have included textiles of all varieties, both linear and planar.

32.
Akio Hamatani (born 1947)
White Boat, 1984
Rayon threads; 16 ft. 4¾ in. × 45 ft. 11¼ in. × 6 ft. 6⅝ in. (5 × 14 × 2 m)

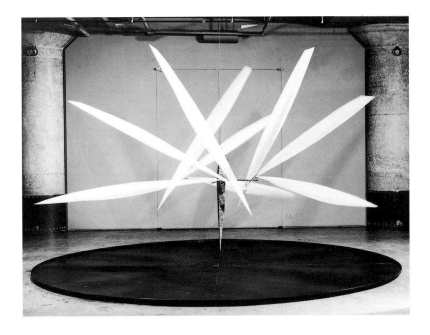

33.
Yoichi Takada (born 1956)
Aquatic Bird, Mirror, 1985
Japanese paper, bamboo,
water, steel, brass, lead;
length of each wing; 84⅝ in.
(215 cm), overall diameter:
13 ft. 1½ in. (4 m)
The Museum of Modern Art,
Saitama, Japan

Akio Hamatani, another Lausanne exhibitor, makes
sculptures of white rayon filaments in languorous suspension
between two points, defining a long, graceful catenary,
pinched together at both ends like the hull of a boat. Forms
are simple, with a potential for boredom that is averted
by the large scale: these hanging pieces are sometimes
enveloping enough to be considered environments. The
softness of the curve and the responsiveness of the fiber lines
to air currents create additional interest.

Hamatani has developed forms and associations that
suit his material rather than choosing a material only as a
means to express an image. There is considerable reso-
nance to the result, as there is to the title he gives the works:
over the last several years, most have been called *White
Boat*. The boat is a central cultural artifact in an island
nation, significant as mundane transportation as well as in
the more poetic sense of a link with other worlds. In Japan,
white is associated both with purity and with death. The
ghostly visual silence of the White Boats—an austere sensual-
ity that seems to deny the need for busy details—might be
seen as relating to death. Or, quite differently, the flowing
fibers might be described in terms of their associations with
water. Hamatani's work might also be taken as solely
formalist and sensory, beautiful for the sweeping movement
of its shape. Recently, he has begun to make other shapes,
such as an expansive S-curve that evokes a moon-hued
aurora borealis.

Many sculptures that capitalize on the nature of materi-
als concentrate on surface. Yoichi Takada develops an
acute consciousness of the surfaces of his sculptures of
stone, paper, and bamboo—traditional materials used in

a manner consistent with tradition but not limited by it. The suggestion of surface as skin is particularly strong in his volumetric sculptures that use *washi* (Japanese paper) over a skeleton of bamboo.

His sculpture *Aquatic Bird, Mirror* consists of three groups [33] of three paper-and-bamboo wings attached to a central scarred and irregular metal shaft in a way that allows vertical and horizontal movement. The graceful wings, each more than six feet long, respond to the air currents generated by viewers' movements, or even by their breath. As one

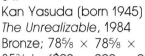

34.
Kan Yasuda (born 1945)
The Unrealizable, 1984
Bronze; 78⅝ × 78⅝ × 35⅜ in. (200 × 200 × 90 cm)
Seibu Takanawa Museum of Modern Art, Karuizawa, Japan

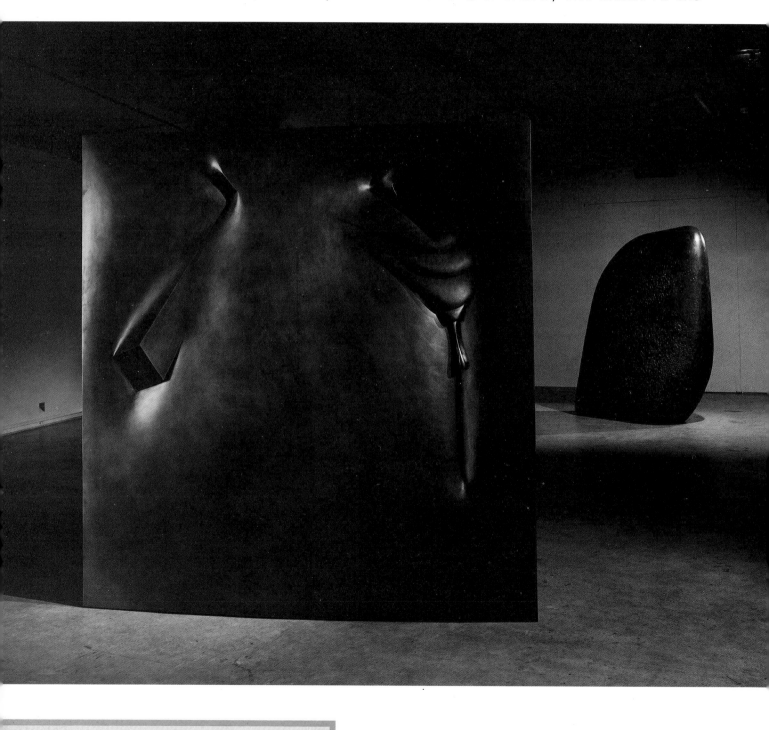

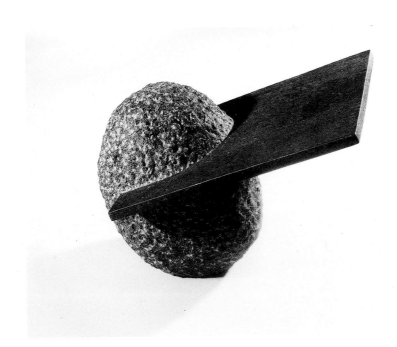

35.
Shintaro Nakaoka (born 1957)
Stones into Life: Iwamu, 1984
Stone; 7⅞ × 13¾ × 11¾ in.
(20 × 35 × 30 cm)

group bobs and seems to reach out, the others move in response, and the whole work seems to nod in graceful obeisance. The movement, coupled with the suggestion of skin established by the fragile paper, makes the sculpture seem an almost living presence. It is also extraordinarily beautiful. Recently Takada has created public works of more durable white silk and black-painted stainless steel, in which the organic gentleness is lost although the grace of movement is retained. An interesting development in these newer works is the "outlining" of fabric with multiple thin rods, making the sculptures look like three-dimensional pencil sketches.

Surface tension and surface sensitivity can be conveyed by three-dimensional form in any material. The bronze sculptures by Kan Yasuda, for example, are enriched by his attention to surface. Several of his bronzes are nondescript vertical masses that appear to have been distorted by forces or objects pushing out from the hollow core. The implication of such stretching is that the bronze wall is as flexible as skin. This suggestion of an organic quality is all the more interesting because neither the shape nor any other aspect of these sculptures indicates the human body or any other living thing. The amorphous bronzes are like large boulders as much as anything. But then, in Japan, stones are almost living things.

Shintaro Nakaoka calls attention to the skin of stones. One sculpture series alludes to bones in the style of Henry Moore, bringing hollowness into the work through the opposition of solid and void rather than through enclosure. In a series he calls Stones into Life, Nakaoka carves his material

34

35

so that it appears to consist of a textured soft stone with a smoother, harder thin slab shoved into it. The slab may be straight and horizontal, or diagonal, or it may undulate; it seems to slice into the soft, almost fleshy stone like a knife into a potato.

A completely different attitude toward materials—less mysterious than the spiritual expression, less sensual than the interest in surface—focuses on junk. Current junk sculpture may have been influenced by European precedents, but it comes more directly from Gutai and from slightly later groups such as High-Red-Center and the Neo-Dada Organizers, both based in Tokyo. Whereas Gutai artists used common materials, the later groups used trash. "This rubbish, indiscriminately cut away from the space of the living, had a freshness and unexpectedness which already seemed to have gone far beyond the works I had made with my own hands," Genpei Akasegawa of High-Red-Center wrote later of his 1960 activities. "This astonished me and as I clambered up these mountains of rubbish I began to find in them objects which had an unmistakable character of their own."[5] In the early 1960s Natsuyuki Nakanishi, another member of the group and now a prominent painter, filled transparent plastic eggs with trash and called them Compact Objects. Around the same time the irreverent idea of using junk aided potters who were attempting to break away from the vessel form. For example, in 1962 the potter Mutsuo Yanagihara began with a core of wood and iron bars and constructed a sculpture by adding clay, plastics (e.g., phonograph records), and metals (e.g., roof gutters), attached by means of the newly developed epoxy resins.

Perhaps it is a coincidence that all of the following artists now associated with the junk aesthetic have spent time in the United States. Ushio Shinohara, a former Neo-Dada Organizer who lives in New York City, is by far the best known. Neo-Dada sculptures incorporating junk were intended to be "incomparably bad sculptures"[6] in those anti-art days, and Shinohara has continued the style. His paintings are sometimes collaged with photos from girlie magazines, and his sculptures, mostly of motorcycles, are made of refuse. They are shaped of cardboard and plaster with the addition of aluminum cans, all kinds of plastic packaging, dried paint, mirrors, glass, and, in one famous motorcycle, jelly beans. Meant to reflect the flashy, trashy environments of Tokyo and New York, these garish resin-encrusted constructions are undeniably sleazy but also energetic and humorous.

Ryoichi Majima, who spent some years in southern California, has made the trash of Tokyo the material and the subject matter of a series of works. The discarded and lost items that he picks up from the streets are an unscientific

38

random sampling of contemporary Japanese material culture. Surface wear tells him how the object was treated and thus how it was regarded. He finds appeal in the form and surface of everyday objects such as paint tubes, pencil stubs, broken liquor bottles, old spark plugs, rusted cans. He has even made a relief of cigarette butts, coating them in resin for preservation and decorating them with fluorescent paint. One work enshrines an abandoned baby doll, clearly once well loved because she is much mended and most of her hair is worn away. Majima places her in a pink-satin-lined box—studded with "jewels" as a tribute to her former value—which serves as a coffin at the end of her "life."

There is precedent for such behavior in Japanese culture. A Japanese would probably find the suggestion sacrilegious, but Majima can be seen as a present-day version of the tea masters who found beauty in peasants' rice bowls and elevated them to the status of art. Majima doesn't have the tea masters' cultural authority, but he does have confidence that anything is suitable material for his art. He finds beauty in the accidental or incidental as well as in the contrived. Like Claes Oldenburg, he is enamored of the personalities of objects and fascinated with the social environment.

Yoji Matsumura is also fascinated with junk and with the events that mark the passage of time in Japan, such as the *matsuri* (festivals). An installation called *Festival or Politics* consisted of a red-painted bamboo framework from which hung toilet-tank floats, flat paper fans, fluorescent light rings, wire springs, a water faucet, and so on. The frame was suspended from a center post, for stability and in allusion to the tradition of the sacred center pillar in residential and shrine architecture. It bobbed, rotated, and rattled cheerfully, with a kind of simpleminded cordiality that fronted for the artist's serious concerns with community, religion, and the pains of living.

Seiji Kunishima, whose works will be considered more fully in the next chapter, has wrapped up art ephemera—exhibition announcements and periodicals—binding them with rope or wire, coating them with acrylic paint and resin, encasing them in lead. The Japanese precedents for these works are the wrapped objects by Genpei Akasegawa (of High-Red-Center), who swathed such things as a chair and an electric fan in paper and string in the early 1960s. Akasegawa was operating with the philosophy that everything, from the human body to the cosmos, is an enclosure. Kunishima's interest seems somewhat narrower. His packages are shields that protect and conceal. He is making a kind of cultural time capsule, or perhaps a diary, and in the process of embalming these discards he is making aesthetic artifacts out of trash.

Noriyuki Haraguchi does not work with junk, but he has long been involved with materials not usually considered attractive. As one of the Mono-ha sculptors, he brought together in the gallery a variety of materials—soil, concrete blocks, steel, tent canvas, clay, water, oil—as if in preparation for some further action. Haraguchi has consistently been interested in industrial materials, often using them for unexpected ends without changing their form. Examples are his "reflecting pools"—wide, low containers filled with waste oil. The beauty and perfection of their surfaces, sharply and darkly reflecting the surroundings, are quite at odds with the unpleasant smell and dirtiness of industrial waste. Toshiaki Minemura, the chronicler of Mono-ha, has suggested that Haraguchi was always moved by the sensuous qualities of materials rather than by the philosophic issues that motivated other Mono-ha participants.[7]

Recently Haraguchi has been working in copper, wood, and steel. A stacked work of square copper tubes and thick wooden beams is stored outdoors between gallery showings so that the copper will develop a patina and stain the wood. The unpretentious and undisguised materials are brought together in a simple structure that is consistent with the Mono-ha avoidance of rigidity and "creativity." The fact that the stack is symmetrical means that it is not particularly animated or interactive with the surrounding space. Dull composition was always a drawback to Mono-ha work and had to be overcome by the force of the material's character.

The material comes through powerfully in Haraguchi's 1988 works such as a frame and screen cut from heavy industrial steel. In this huge and freestanding but essentially two-dimensional and static form, the steel has a toughness (calling to mind the work of Mark di Suvero) that is mediated by a kind of refinement, a careful craftsmanship expressed in clean and polished surfaces. It is this surface character that makes the work interesting, not the form, which, because its flatness subverts any sense of volume, commands less space than its dimensions (roughly seven feet high and wide) would lead one to expect.

In sculpture as material, the artist finds not only means but meaning in his medium. The work may derive a metaphysical quality from the Shinto belief that spirits reside in natural objects, it may reflect a conscious desire to pay respect to nature, it may express a concern with the real rather than the ideal, or it may demonstrate an interest in the social meaning of materialism. In every case, the material is far more than an inert and passive substance. It is integral to the art.

8

CLOCKWISE, FROM TOP LEFT
36.
Ryoichi Majima (born 1947)
Let Us Talk No. 70, "Pretty Baby," 1986
Mixed mediums; 22 × 13¾ × 6⅝ in. (56 × 35 × 17 cm)
Kiyoshi Koizumi

37.
Seiji Kunishima (born 1937)
Asahi Shimbun, Nov. 1–Nov. 26, '81, 1981
Newspapers, lead, resin, acrylic paint, plastic rope;
3⅞ × 16⅞ × 11¼ in. (10 × 43 × 28.5 cm)

38.
Ushio Shinohara (born 1932)
Motorcycle Hawaii, 1986
Cardboard, acrylic, plastic, polyester resin; 40¼ × 65⅝ × 29½ in. (102 × 167 × 75 cm)
Gallery Yamaguchi

CHAPTER FOUR
SCULPTURE AS RELATIONSHIP

The sculpture and installations that I've grouped in the category of sculpture as relationship focus on connections or disconnections rather than on material or form. Indeterminateness is expressed by comparisons of wholes and parts and by heightened attention to contexts, changing states, incompleteness, tensions and balance within an artwork, and unexpected shifts of scale. Relational works appear to be primarily formalist, but underlying this appearance is the Buddhist perception of a world in flux—of things not fixed or independent but in ever-shifting linkages.

40–42 The perfect transition from the materials to the relationships group is provided by the Relatum sculptures of U-Fan Lee and the Relation works of Tatsuo Kawaguchi, because both artists have one foot in each camp. As Lee's Mono-ha philosophy requires, his sculptures are made of materials that he processes little or not at all but simply brings together. For example, he has repeatedly combined iron plates and stones; the pairing of such disparate materials makes concrete the basic Mono-ha description of existence—i.e., that the whole of existence consists of relative qualities— because the materials do not merge into a unity but retain their separate identities and play off each other in weight, form, color, etc. In a quintessentially Mono-ha work, he held several pieces of lumber to a gallery pillar by the modest tension of a few windings of rope—nothing structural, nothing permanent, just an essential relationship of parts. Each of Lee's sculptures defines its own specific physical situation of materials, form, and environment, and each is given the same title—Relatum. Lee has said, "A work of art offers a contradictory principle: the simultaneous presence of oneness and separateness"[1]; that presence is embodied in the relationships between the elements of the sculpture and between the sculpture and its environment.

Lee's sculpture is weighty, yet it is also open, flexible, permeable, and temporary. Stacked or leaning arrangements of iron plates and stones express physical factors such as tension, pressure, and weight, and relationships such as hiding–being exposed and giving-resisting. The sculptures

39.
Hachiro Iizuka (born 1928)
Variable Construction, installation at Komuro Studio, 1986
Painted wood

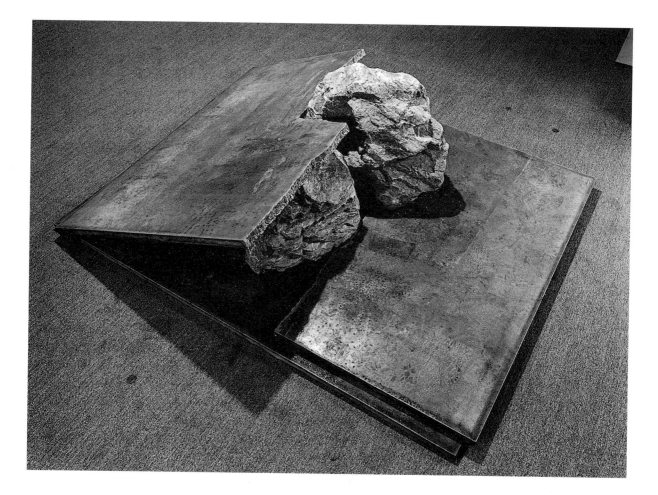

depict nothing and allude to nothing but themselves, but that does not mean they are without content. They suggest the histories of their materials: what stone has meant to Japanese culture, man's industrial development, the contemporary environments fashioned by nature and mankind.

Lee has written:

To have a sculpture come alive depends on the extent to which the sculpture is able to act on surrounding space and to liberate itself into that space. In other words, as an organic structure full of fissures, the sculpture is something which has to be matched against a still larger world. And we may say that it is conceivably for that reason that the work has an aversion to completion and a predilection to assume the air of a makeshift structure. Trying to fabricate a symbol with sculpture is the equivalent of sinning. A symbolic object like a statue smothers space with a specific meaning and throttles freedom. Instead of being blocked up, a sculpture should ideally be a structure which

OPPOSITE, TOP
40.
U-Fan Lee (born 1936)
Relatum, 1968
Stone, iron; 7⅞ in. × 9 ft. 10 in. × 13 ft. 1½ in. (.2 × 3 × 4 m)
Collection of the artist

OPPOSITE, BOTTOM
41.
U-Fan Lee (born 1936)
Relatum, 1968
Glass, stone, iron; 11¾ × 55⅛ × 70⅞ in. (30 × 140 × 180 cm)

ABOVE
42.
U-Fan Lee (born 1936)
Relatum—with Two Stones and Three Irons, 1984
Stone, iron; 23⅝ × 78⅝ × 47¼ in. (60 × 200 × 120 cm)

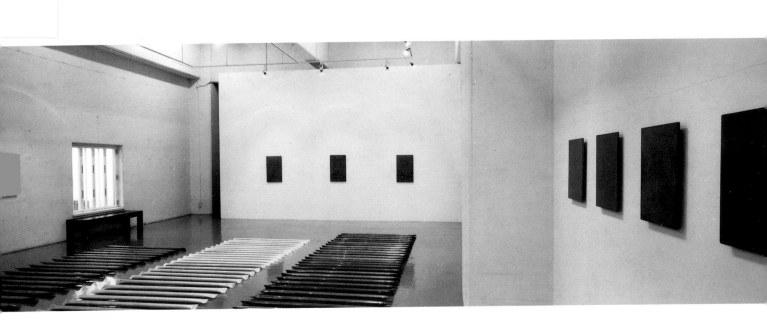

43.
Tatsuo Kawaguchi (born 1940)
*Relation—Water, Relation— Clay,
Relation—Air,* 1986. Copper and water,
aluminum and air, brass and clay; 30
units of each type, 3⅛ × 2 × 64½ in.
(8 × 5 × 164 cm)

44.
Tatsuo Kawaguchi (born 1940)
Relation—Seed, 1986. Lead, seeds;
27⅝ × 17⅝ in. (70 × 45 cm)

makes space-time more vividly transparent, thinner and [diffused].[2]

Relatum works are simple in elements, ordinary in materials, and unpretentious in arrangement. Because they are not about any specific, limited subject, because they address a universal concept (relationships), they can be seen as abstractly encompassing all of existence. Such a cosmic scope can never be articulated but it can be implied.

Kawaguchi is as versatile and prolific an artist as Lee, having made sculpture, two-dimensional works, conceptual projects documented by photographs, and even jewelry. Nearly everything he makes is titled *Relation;* his works are unified by consistency of concept rather than consistency of materials or style. He has described his interests as perception, time, natural processes, and the characteristics of materials (electricity is a material, in his view).[3] He acts in cooperation with nature, using to an aesthetic end processes that inevitably yield a perceptible result, such as the oxidation of copper producing a green stain. A 1970 work consists of twenty-six photographs recording a composition by nature: he placed four boards on a beach, tethering each to the land with a rope, and documented how the sea lifted and shifted them. The resulting photographs show the constantly changing relationship between land and sea, suggesting that any singular coastline on a map can never be true more than momentarily.

A recent multipart installation by Kawaguchi consisted of segments called *Relation—Water, Relation—Clay, Relation—Air,* in which sets of brass, copper, and aluminum cylinders contained the unseen title materials. The cylinders were shown with a group of wall reliefs entitled *Relation— Seed,* in which seeds of edible plants were encased in lead

43

44

plates. This is a piece to think about unemotionally: one ponders the containers and the contained, their probable weights, the repetition of forms, the arrangement of the elements in the gallery. It is also a piece to think about emotionally, for Kawaguchi is pessimistically hoarding nature in the nuclear age. This work points toward the future (hoping there will be a future). It is not alone among his works in seeking to establish a relationship with that unknown.

The hiding of materials inside or behind metal is consistent with earlier works by Kawaguchi. In 1975 he made a series called Light, in which illuminated fluorescent and incandescent bulbs were completely encased in iron. For a related work called *Dark Box* he worked without illumination, at night, allowing a box to fill with darkness, so to speak, and then bolting it shut. Even earlier he "showed" a totally blacked-out gallery. Kawaguchi says that through concealment he hopes to stimulate a sense of mystery in the viewer, who must seek information not readily apparent.[4] (He does not acknowledge the viewer who might expect visual art to be promptly comprehensible.) Believing that his own explanations must be limited to allow diverse interpretations, Kawaguchi expects the viewer to function much like an archaeologist, studying unfamiliar artifacts and speculating on their possible meanings.

One sort of Kawaguchi work exploiting natural pro-

45.
Tatsuo Kawaguchi (born 1940)
Relation—Line, Rectangle, 1984
Iron, handmade paper, wall;
6 ft. 6⅝ in. × 16 ft. 4⅞ in.
(2 × 5 m)

46, 47
Tatsuo Kawaguchi (born 1940)
*A Cylinder Made
of Twenty-Four*, 1972
Lead; 3⅞ × 3⅞ in.
(10 × 10 cm)

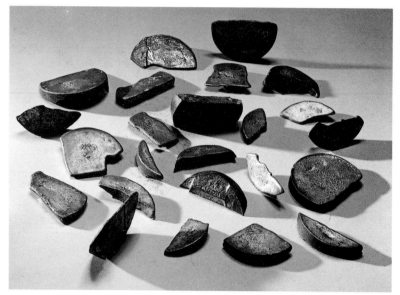

cesses has been called an oxidation frottage.[5] By pressing cloth or paper against copper or iron, he produces patterns of stain. In *Relation-Quality (Blue)* (1984) copper-stained cloth is stretched to make an abstract painting. In *Relation—Line, Rectangle* (1984) slender, short iron rods are wrapped in torn pieces of handmade paper and arranged on the wall to indicate a long rectangle; because the rods do not make a continuous line, the viewer must extrapolate to read the full figures. Kawaguchi thus encourages the viewer's mental involvement in his art. In both these works, he is interested in the characteristics of materials rather than the materials themselves.

The Relation—Line series capitalizes on incompleteness. Another approach to incompleteness is Kawaguchi's series

46, 47 called Made of Parts. It consists of geometric solids such as cylinders, spheres, and pyramids seemingly broken into many irregular fragments. Actually these are lead casts made in successive pours with the mold at various angles so that gravity decides the shapes of the parts. Other works in the Made of Parts series are simple geometric outlines (usually shown on the floor) composed of small rectangular solids with irregular ends that fit together like jigsaw-puzzle pieces. In all these works Kawaguchi considers the question of wholeness: what makes something complete? Identifiable? Is the whole more real than the parts? How much of something do we need in order to recognize it? Is any part independent?

In his early Mono-ha works Nobuo Sekine expressed relationships between materials in their natural states. He soon began to cast bronze, which separated him from the Mono-ha preference for directness and ephemerality, but which continued his focus on relationships. Transformation is conceptually important in his recent bronze works. The clay used in the preliminary stage absorbs both his touch and his ideas; subsequently, through the "sacred ceremony" of casting, the clay form becomes an image in bronze. In these works, bronze is almost always shown in multiple states, the roughly modeled segments contrasted with smoothly polished parts. His single-material works (he also makes stone sculptures) characteristically vary not only in surface but also in color and form: he makes rings, pyramids, shafts, a Möbius strip, an arch, even a landscape.

Sekine's most recent works for exhibition are punctured
48 reliefs of heavy Japanese paper covered with gold or silver leaf. Though visually reminiscent of Lucio Fontana's slashed canvases, they are not concerned with destruction. Rather, they continue the topological interests that have intrigued Sekine ever since *Phase-Mother Earth*. Here he digs out paper and piles it around the edges of the hole.

Sekine has said that he is not interested in expressing himself in his sculpture: he wants his work to be, for the viewer, an encounter with existence—both existence as demonstrated by the objective palpability of an object and existence as the subjectively sensed *ki* or universal life force.[6] In East Asian thought, this elemental force runs through the cosmos and its creatures, binding each to the other.

In 1972 Sekine established an "environmental art" busi-
49 ness in which he designs plazas, parks, etc., and then installs one of his sculptures in a prominent place. This move, which has resulted in many Sekine works in public sites, is in keeping with his belief that sculpture should not consist of discrete and isolated entities, with his interest in the Japanese garden, and with his belief that art involves sharing pleasure with people. A few compromises are necessary in such

NOBUO SEKINE

There are times when we see things [as] clearly as if they were enveloped in a magnetic force. A new, fresh encounter with plain ordinary things that are just lying about in reality. It's only for a brief moment, and it's only a personal experience, but at that time we think to sustain the perfection of the encounter and make it universal. We feel then the "desire to create," we want to make into flesh a thing which goes beyond ourselves. This we call the structuralization of encounter, a work of art.

But this process is definitely not "creating." It is rather sweeping away the conceptual dust that gathers on the surface of things, then turning them into what they really are and presenting clearly the world contained within them. Making visible that which cannot be seen. And it is not separating them out, defining them and then carrying out the details of their construction. Rather, it is strengthening their presence. Like flowers brought in from the field. Flower arranging is definitely not a tool for asserting one's ego. But rather giving to flowers themselves a new life.

"Activities 1968," in Makoto Ueda, ed., *Nobuo Sekine, 1968–1978* (Tokyo: Julia Pempel Atelier, 1978), unpaged.

RIGHT
48.
Nobuo Sekine (born 1942)
Left: *G150-18 "Triangular Window,"* 1989
Right: *G150-16 "Strip of O,"* 1989
Japanese paper, acrylic, gold foil; each 89½ × 63¾ in. (227.3 × 162.1 cm)

BELOW
49.
Nobuo Sekine (born 1942)
Plaza of Mother Earth, 1989
Basalt and environmental sound
Navel Park, Showa-machi, Japan

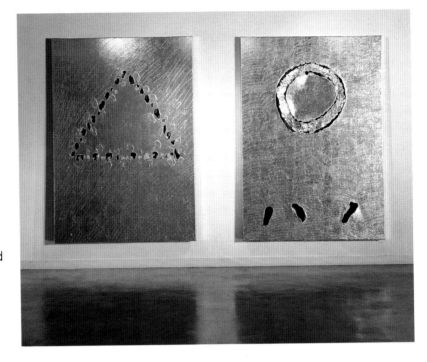

situations—especially considerations of safety and durability—but he intends the public works to convey the same feelings and images as his exhibition works. The public art, he says, is just more social.[7]

The relational quality in contemporary sculpture is most overt in works that are divided or incomplete. The simplest of several 1985 works by Keiji Ujiie that exploit the visual power of division is *Difference,* a three-foot post of black granite whose smooth surface changes to rough halfway up its height. In a black marble pillar called *90 Degrees Unified,* a striated surface is interrupted by a band of polished smoothness running three-quarters of the way up one side and then across the width of the pillar. The top quarter of the pillar is a separate piece of stone that sits unevenly above the polished band, permitting the passage of an elegant sliver of light. In *Rising and Falling 180 Degrees,* two narrow posts and a short lintel of black granite shift in surface and shape. Here a polished band runs across the top and nearly halfway down the right side; where it stops on the right, it starts on the left and continues down to the plinth. In all of these works the shift in surface treatment divides the pillar and, by means of contrast, heightens a viewer's perception of sensual qualities.

Seiji Kunishima, already mentioned for his junk packages, also creates stone sculptures in which raw and

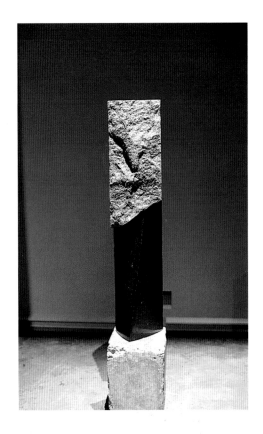

ABOVE
50.
Keiji Ujiie (born 1951)
Difference, 1985
Black granite; 37 × 11¾ × 11¾ in. (94 × 30 × 30 cm)

LEFT
51.
Seiji Kunishima (born 1937)
Stacking Stones, 1983
Stone; 140 × 42 × 42 in. (355.6 × 106.7 × 106.7 cm)
San Francisco International Airport

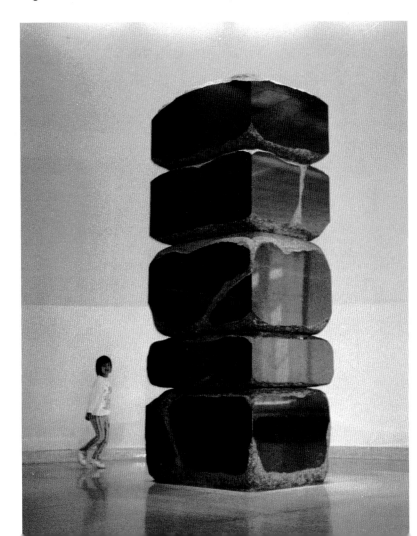

52.
Seiji Kunishima (born 1937)
Suspended Pool '86–9, 1986
Black granite; 12⅝ × 34⅝ ×
26⅜ in. (32 × 88 × 67 cm)

polished surfaces are contrasted and the relationships be-
tween parts emphasized. *Stacking Stones,* installed in the 51
central terminal of San Francisco International Airport, con-
sists of five roughly square slices of stone, of varying thick-
nesses but similar perimeters, making a totem pole. The
edges are irregular, although the surface is highly polished
where projections have been planed off. The fit of one slab
to the next is close enough to make the sculpture look safely
stable without seeming inert. The variation of thickness, more
than anything else, marks the individuality of the elements;
this individuality, a difference in "personality" rather than
kind, might be compared with people in a group: separate
but cooperating.

Kunishima has crafted telling relationships in works in
which stones divide a whole. One such is *Stone Work '82,* a
ten-foot-tall public sculpture in California consisting of two
tapering square pillars of white granite with a natural stone
between them near the top. The pillars are held apart by
the stone; the stone is held up by the pillars. Kunishima has
also divided works so that one part seems to float above
another. In *Suspended Pool '86–9,* for example, a flat piece 52
of black granite, so polished that it seems liquid, rests on a

pocked lower stone. Large pocks at the edges of the "pool" relate it visually to the pitted surface of the base.

Suggesting relationships through the division of parts is equally possible in metal sculpture. Daijun Tsunematsu takes 53 a long metal sheet, cuts slits from the bottom edge almost to the top, and then twists each segment at the slit. The result is a continuous band (or pair of bands) articulated by the cutting and twisting. A whole that is segmented by rotation without losing its unity, it brings to mind the cut-and-twisted paper pendants that hang from sacred ropes at shrines. The form of the sculpture creates a feeling of movement and lightness despite the weight of the material.

Atsuo Okamoto emphasizes relationships through division and incompleteness. Rounded river stones piled into a 54 work called *Stone Dimension: Accumulation* (1988) look as if they have been sliced with a magic sword, leaving an utterly flat smoothly polished plane at the back. The opposition between the uncut stones and the polished face is a contrast that Noguchi often used to reveal two natures of a stone, neither one more "real" or "natural" than the other (what would the "real" state of stone be when it ranges from a molten condition to a totally eroded dust?). In *Stone Dimension: Accumulation* the surface processed by nature seems more random than that processed by man, perhaps. But the rounded surfaces of the stones prevaricate when they suggest randomness. The fit of the stones is too perfect and thus reveals that they have been carved by the artist, not by nature. This sculpture is actually a subdivided whole rather than a group of individual elements.

Okamoto's works show a strong concern with materials, particularly his recent sculptures in which the subject is the various identities of stone as transformed for human use—stone as pavement, stone as architectural cladding, stone as sculpture. He furnishes an excellent example of incom-55 pleteness as a relational device in *Rock Bed (Memory)*, which refers to the mass from which usable stone is extracted. This work consists of the skin of two sections of rock face, held up, like a tent, by pointed metal rods. The heart of the rock bed has been cut out. These remaining fragments allude to the larger physical whole, just as they suggest a conceptual whole—namely, the stages of the stone's existence in the mountain, in the quarry, in the workshop, in the gallery. In a variation on this theme, *Stone Reduction*, Okamoto shows a hollow block of stone more than six feet tall, and the mass of stone that has been extracted from it. He first chipped away at a large block as if roughing out a sculpture, but rather than discarding the rubble and going on to make a statue, he has reassembled the chipped-off chunks—as if gluing a shattered vase back together—and shows the two parts together in the gallery, like a chick and

ABOVE
53.
Daijun Tsunematsu (born 1944)
Love in Sky, 1985
Steel; 5 ft. 10⅞ in. × 14 ft. 9¼ in.
× 3 ft. 3⅜ in. (1.8 × 4.5 × 1 m)

RIGHT
54.
Atsuo Okamoto (born 1951)
Stone Dimension: Accumulation,
Solfiero Castle, Sweden, 1988
Swedish granite; 8 ft. 6⅜ in.
× 13 ft. 1½ in. × 2 ft.
(2.6 × 4 × .6 m)

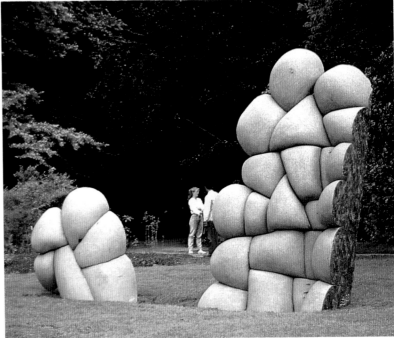

the egg from which it hatched. Rather than treating this stone as a neutral raw material ready to be transformed into an artwork, Okamoto retains the stone's identity and points out that it already has a life history.

Another type of division theme is what might be called reconstitution. In this approach, the artist begins with a single whole, splits it in some way, puts it back together again, and shows the remade whole. Ko Yamane has made several works like this. One, *Work XIII,* is simply a log that appears to have been cracked open by the process of weathering and aging. It is shown in the gallery seemingly complete, but with evidence of that division unconcealed. Another sculpture, *Wood Joint Work XI,* consists of a number of pieces of wood massed together in a roughly rectangular shape; if these separate elements were clay or some other soft substance they could be pressed into one whole, but the massing of these dozen or so pieces of wood implies a unitary state they can never resume. Yamane's work might

56

55.
Atsuo Okamoto (born 1951)
Rock Bed (Memory), 1987
Granite; 5 ft. × 20 ft. 2⅛ in. × 10 ft. 9⅞ in. (1.52 × 6.15 × 3.3 m)

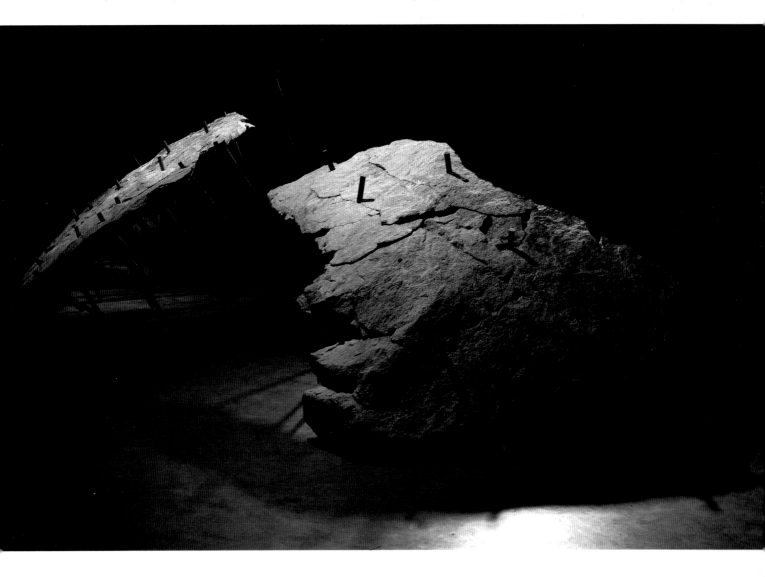

56.
Ko Yamane (born 1933)
Wood Joint Work XI, 1985
Oak; 19⅝ × 19⅝ × 11¾ in.
(50 × 50 × 30 cm)

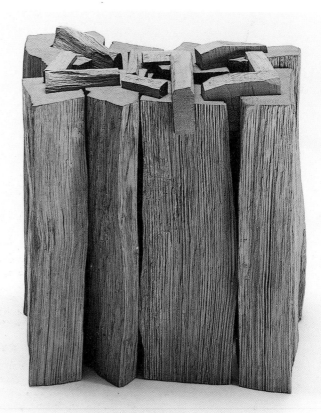

be described as being about joining in both literal and metaphoric senses. *Work VIII,* for example—a log cut into three sections and held together with exacting carpentry joints—is a tribute to the beauty and precision of Japanese joinery, while other works allude to social or sexual linking.

A conceptually similar example of reconstitution is the paper sculpture of Fumiho Kamijo. What appears to be a 57 simple wooden rectangle is made of layers of paper held together by bolts, with insets of wood. The paper almost seems to return to its original wooden state, and Kamijo treats it like wood, carving the surface. He has also shaped pillars and irregular forms from the same substance; in all these works, the paper's bulk, its seeming solidity, consists of individual sheets. This might be simply fact, but it might also be a metaphor for society—such an association would not be fanciful, given the relentless pressure of the group-oriented Japanese society.

The internal relationships of a sculpture may be emphasized by means of tension, balance, or contrast. Satoru Shoji often employs lengths of fabric as plane or line to demarcate space and also as a "substance" that can be "modeled" by means of tension. In one work, *Navigation (Level No. 1),* the plane is horizontal and wooden sticks poke into 59 it from above and below, pocking and distending the fabric. The distortion calls attention to the placid nature of

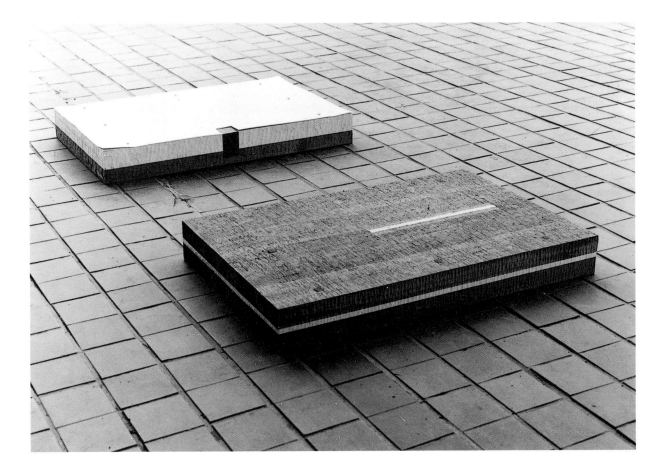

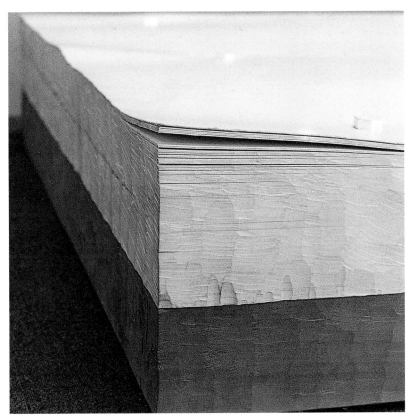

57, 58.
Fumiho Kamijo (born 1953)
Work 1985–8 (and detail), 1985
Japanese Judas tree, Kent
paper; 4⅝ × 70⅞ × 39⅜ in.
(12 × 180 × 100 cm)

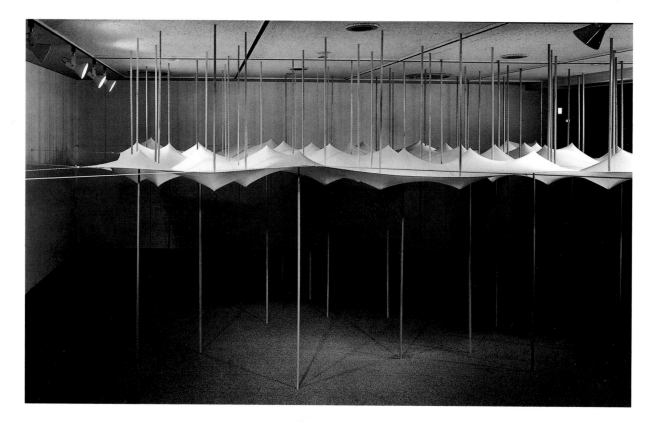

59.
Satoru Shoji (born 1939)
Navigation (Level No. 1), 1986
Cloth, rope, painted sticks;
8 ft. × 26 ft. 6⅞ in. × 14 ft.
9¼ in. (2.4 × 8.1 × 4.5 m)

fabric and its capacity to endure stress despite its thinness and seeming delicacy (qualities evident in the decorative and light cloths called *furoshiki,* which the Japanese use as carryalls). In other works Shoji stretches panels of fabric on a bifold frame, like a Japanese screen. These screens are dimpled on the outside surface of the broad V in which they stand and pimpled on the inside by taut threads that stretch from one panel to the other, distorting the fabric planes. Shoji's early works often relied on gravity to configure a draped length of fabric, but his works of recent years are more structural, with wood creating internal tension. His works communicate no specific meaning, but their emphasis on subtle relationships conveys a tentativeness and ephemerality that could be seen as a metaphor for living under contemporary conditions.

The sculptures of Keiji Uematsu are also made of fabric under tension, and they also delimit space. In his early work he forced wooden beams into the spaces between pillars or walls. Later he joined two contrastingly colored strips of 60 cloth and made a triangle by attaching their opposite ends to ceilings, pillars, or walls, maintaining the stretch by inserting a trimmed sapling between the wall and the point at which the cloths joined. In other works he hung a cone 61 of fabric from a ceiling and inserted into its center a tree limb that stretched taut the hanging cords and the fabric. In recent works Uematsu has replaced the fabric cones with

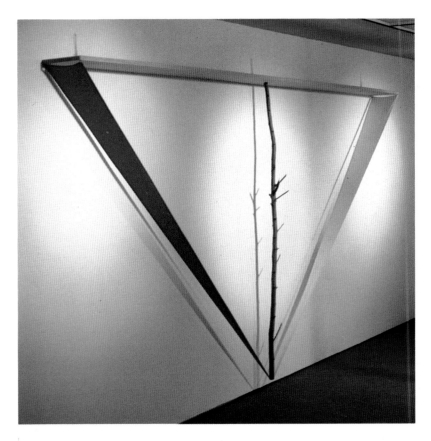

60.
Keiji Uematsu (born 1947)
Triangle—White/Red, 1987
Cloth, branch; 6 ft. 6⅝ in. ×
13 ft. 1⅜ in. × 9¾ in.
(2 × 4 × .25 m)

61.
Keiji Uematsu (born 1947)
Left: *Situation-Cone-White*,
center: *Situation-Cone-Red*,
right: *Situation-Cone-Yellow*, 1987
Cloth, string, branch, iron; di-
ameters: 9¾–106⅜ in. (25–270
cm), height: 118⅛ in. (300 cm)

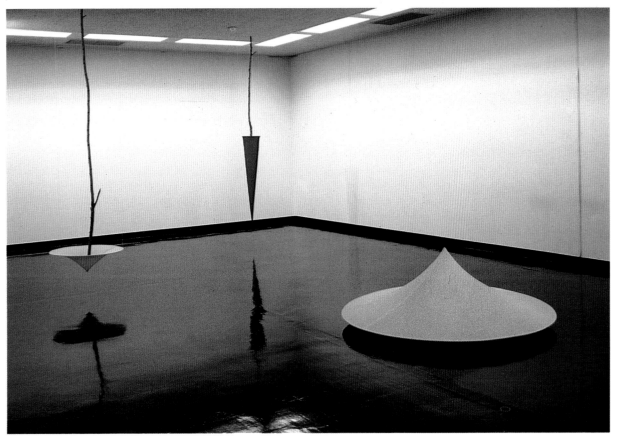

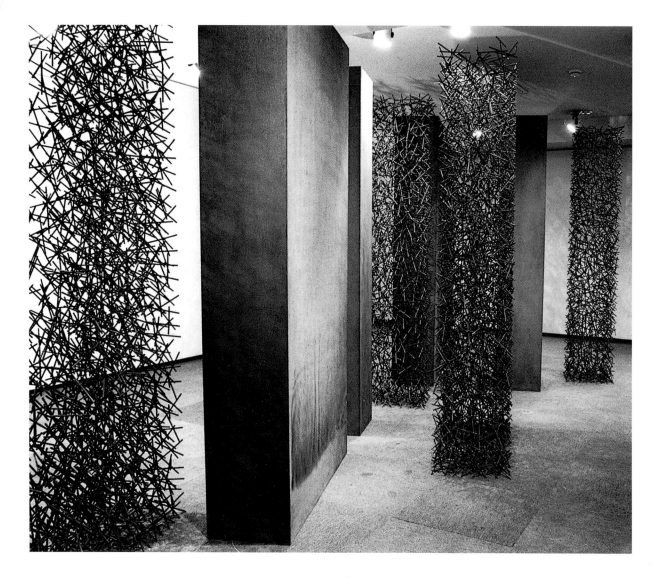

62.
Shuichi Furugoh (born 1952)
Link•Scenery III, 1986
Cor-ten steel; 7 ft. 10½ in. × 24
ft. 7⅜ in. × 15 ft. 1⅛ in. (2.4 ×
7.5 × 4.6 cm)

copper ones that maintain their own tension and are precariously balanced against the architectural elements of the display space, such as ceilings and walls.

In each case, the method is uncomplicated, the number of elements minimal, and the forms and colors clear. The elegance of Uematsu's work is in the contrasts: the irregularity of growth typical of the branch is opposite to the featureless smoothness of the fabric. The natural branch both literally and figuratively resists the man-made order (uniform fabric, manufactured string, and wall or ceiling) that confines it. In Uematsu's works the tensions derive from the fact that the failure of one element will cause the collapse of the whole. His works make a closed system, a tiny universe, in which one part resists or responds to the other, and large, indiscriminate natural forces such as gravity seem irrelevant.

Shuichi Furugoh has shown a sculpture consisting of six-foot columns of Cor-ten steel, some of them visually solid and some visually open. The "solid" ones are hollow square

pillars that seem massive because of their impassive impenetrability. The open ones are rectangular blocks made of hundreds of short steel rods welded together, like an industrial version of brambles. These open columns seem more organic and unpredictable, lighter in weight and less spatially demanding, more fragile and subject to change. Every one of those apparent qualities is false. They are just as much steel, just as heavy, just as rigid as the box columns. Together these contrasting parts make an environment—like tree trunks and brambles but also like urban architecture, alternately transparent and opaque. It is an environment both literal and suggestive (representing a fragmented, stylized conception of a tree, perhaps—one part trunk and one part foliage—or a microscopic close-up of the Cor-ten surface, with solid material giving way to flakes of rust). Both the allusions and the formal interests of this sculptural installation derive from the relationships of the parts.

The well-known sculptor Takeshi Tsuchitani frequently

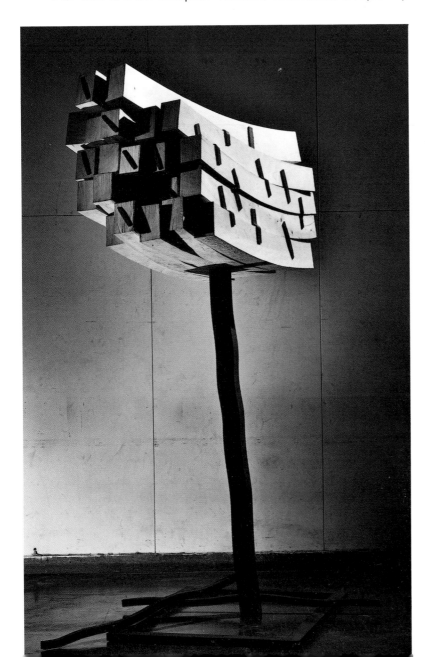

63.
Takeshi Tsuchitani (born 1926)
Like Flower, Like Tree, 1985
Wood, Cor-ten steel; 90⅞ × 60⅝ × 47⅝ in. (231 × 154 × 121 cm)

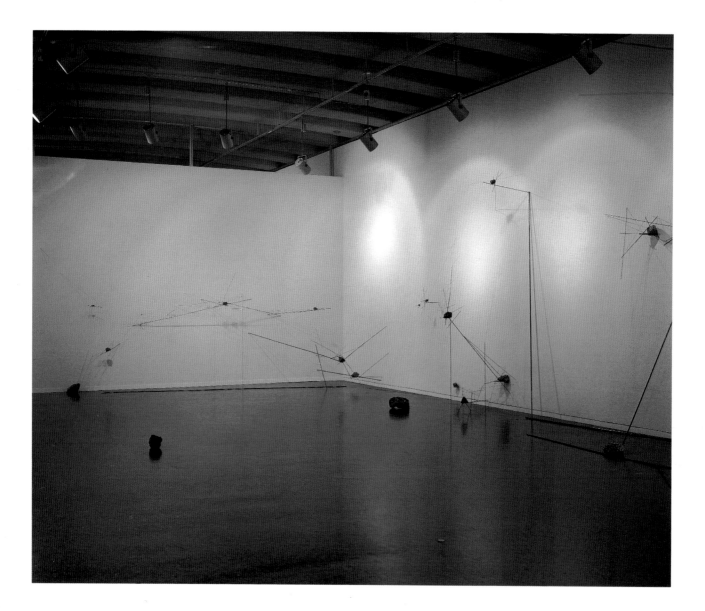

ABOVE AND OPPOSITE
64, 65.
Tamotsu Shiihara (born 1952)
Untitled installation at Tokyo
National Museum of Modern
Art (and detail), 1984
Stones, steel wire

combines wood and metal. The opposition of these materials is symbolic: the Japanese "culture of wood" is increasingly dominated by structures of steel. His sculptures have the formal attractions of balanced shapes, contrasting weights, and the like. One of Tsuchitani's works, *Like Flower, Like Tree,* 63 makes reference to the form of a tree. It consists of a bundle of slightly bowed wooden beams held aloft by a "trunk" of Cor-ten steel. This trunk has a small ripple, possibly to make the steel look more organic or to hint that it strains under its burden. Sinuous rods at the base stand for roots, and a frame there—rectangular, like the lofted beams—defines the perimeter of the tree's foliage. The wood is to the steel of the sculpture as leaves are to wood in nature—that is, lightweight and evanescent. The trunk lifts the wood, takes it away from earth, isolates it. Dozens of short steel strips that are attached to the wooden beams suggest limbs and

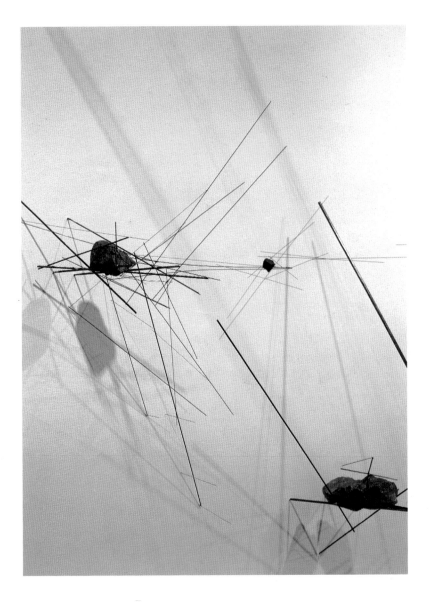

TAMOTSU SHIIHARA

When we think of sculpture, we have a tendency to think that it has mass and to imagine its material power, drawing our eyes into its substance. My work for this exhibition has on the contrary little power, but lets our eyes drift around, and is far from embodying material substantiality. It would be difficult to call my previous works sculpture, but they might be called "abstract installations." However, I have always used natural stones.

In the present work in this exhibition, I [create a place] by installing stones and iron materials. As we move the focus of our attention from one [part] to another, our cognitions of "place" melt one into the other. I am interested in producing a mobile cognition, flowing through a given space. When I am constructing a work, and when spectators let their eyes move through it, our consciousness is released into a space which includes natural objects (being made of stone and iron), and we are far from the self-enclosed world of constructive abstraction alone. Each part of the work is valued equally with larger parts. The environment of each small part melts into the larger one, and the larger into the smaller.

Environment and Sculpture: The International Contemporary Sculpture Symposium, 1984/Lake Biwa Contemporary Sculpture Exhibition (Otsu, Japan: Shiga Museum of Modern Art, 1984), pp. 26–27.

twigs glimpsed through foliage, but they also band and restrict the wood. Again, Tsuchitani seems to comment on the relationship between steel and wood today, as wood is being displaced, changing from structural necessity to decorative accessory.

Tamotsu Shiihara concentrates on balance and contrast in his installations of stones and steel wire. The light, fragile wire (sometimes so slender that one is not sure it's there, vision being complicated by shadows) supports the mass and weight of the stones, in seeming defiance of gravity. The viewer is acutely aware of the differences and the connections between parts, the delicate dance of elements defining a space that seems to extend beyond the physical boundaries of the room. The structure demonstrates no obvious organizational principle; lines cross and continue, with rocks unpredictably punctuating them. Each installation

When I was a student, I only saw the stoic works which emerged from Mono-ha school; I was repelled by them. I wanted to work more concretely and physically; then I could feel I was doing something. I wanted to have the feeling that I was actually in touch with what I was doing.

I collect scrap wood, and create something with it at a certain period, and then dismantle it and return the scrap wood to its original place. Then I go somewhere else, pick up more scrap wood, and again dismantle and return it after creating something. I may have something in common with Sisyphus and his endless labor of rolling a stone up a hill only to see it roll down again. Action based on this methodology will nullify the meaning of the action.

When I say "circulation," I am interested in the circulation of the town or the city itself. For instance, I want to reorganize a decayed or ruined house, which appears to be in a terminal condition. I call it "circulation" to create a work at the site and put it in a large cycle. I want the reorganized house to become a part of reorganizing the entire community and to have an influence on that reorganization.

Mika Koike, Motoi Masaki, and Makoto Murata, eds., *Kawamata*, trans. Junko Iwabuchi, Susan B. Klein, Lingua Guild (Tokyo: Gendaikikakushitsu Publishing, 1987), pp. 37–41.

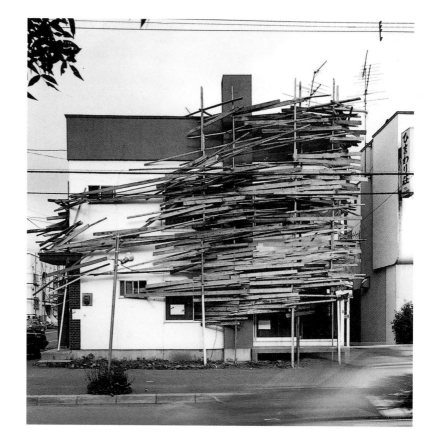

seems infinitely extensible and inevitably incomplete. Shiihara considers every part as important as the whole, and in any case he regards the whole of the sculpture as only a fragment of a larger whole.[8]

A particularly interesting group of relational works, demonstrating a preference that may be peculiar to Japan, consists of loosely constituted objects or installations that have no overriding logic of composition but rather are shaped by repetitive, irregular physical linkages. They take their structure and meaning from connecting separate things or from establishing a potentially limitless continuation of related elements.

The quintessential examples of this type are the installations by Tadashi Kawamata, which he conceives of as "cancers" on conventional buildings. Kawamata recycles scrap lumber from demolished buildings, assembling it by adding one piece to the next in a process more akin to vegetative growth than to a builder's regular measuring, cutting, and fitting. This approach has no rational stopping point, and Kawamata must restrain his urge to add more and more wood. In Japan, North and South America, and Europe he has created large temporary projects that either partition or envelop buildings. He observes differences between enclosure in masonry structures, for example, and in structures from other traditions that have more fluid distinc-

66, 67

tions between inside and outside. His installations, like those being created by many artists in Japan now, reflect a sensitivity to the current speed of change and ancient notions of ephemerality.

Kawamata makes both interior and exterior projects that balance on the knife edge between order and chaos. Some of his interior works that subdivide existing rooms are orderly and controlled. They more or less reproduce the interior structure of a wall and are sometimes applied over an existing wall in a kind of planar redundancy. Other interior installations consist of curving false walls that distort the volume of the room in which they are built.

Kawamata's interior installations of the later 1980s, his works that pass both through and around buildings, and particularly his exterior installations break away from order to a looser approach. In these works each piece of lumber functions as a line, and the lines often suggest the accidental orderings of nature, such as iron filings lined up by a magnet, grasses raked by the wind, sand and gravel graded by water currents. Kawamata's structures wrap the architecture to which they are attached, but not so much in the smooth fashion of the Japanese wrapping arts as in the way a windblown newspaper wraps itself around a utility pole.

OPPOSITE
66.
Tadashi Kawamata
(born 1953)
Tetra House N-3 W-26 Project,
Sapporo, Japan, 1983

67.
Tadashi Kawamata
(born 1953)
Destroyed Church Project,
Documenta 8, Kassel,
Germany, 1987

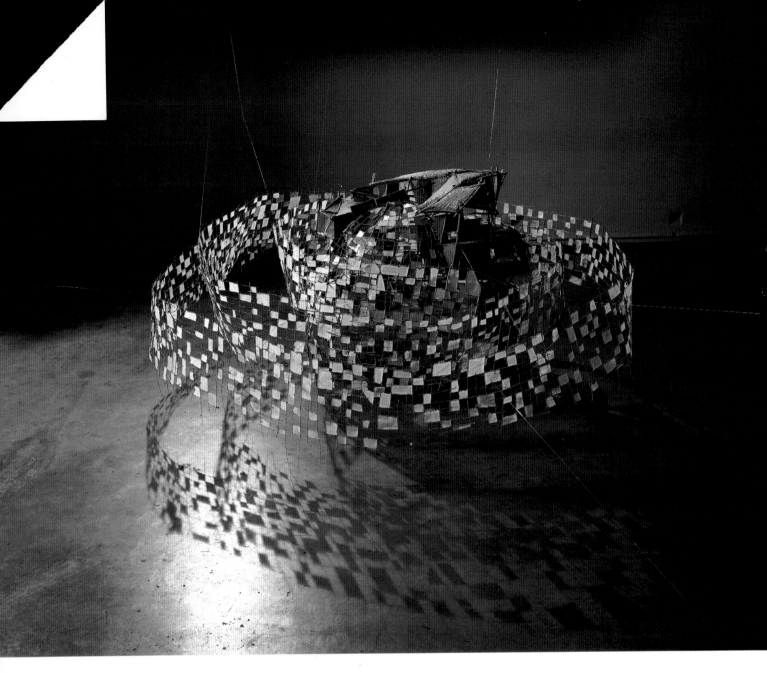

68.
Yoshio Kitayama (born 1948)
Watch in a Half-Sitting, 1987
Bamboo, wood, paper, glass,
lead; 36¼ × 94⅞ × 114¼ in.
(92 × 241 × 290 cm)

Each installation responds to its site but is not ruled by that site, overlapping it, expanding it, altering it. Always related to what hands can hold or arms can carry, Kawamata's works never lose the human sense of scale. This is undoubtedly because they are on-the-spot improvisations that are shaped by factors such as how much he can lift, how many helpers are available, what materials he can get, and where the piece is located.

Yoshio Kitayama uses the same method of accretion that Kawamata does, with different materials. He builds fragile thickets of bamboo twigs that may extend several feet outward from their wall attachments, twisting and turning, defying gravity, and poking out into space every which way. He fills the interstices between the limbs with colorful bits of paper or cloth or leather or even gouged planes of wood, contrasting fullness and emptiness, color

68

and its absence. The bamboo is often held together by copper wires, and one sometimes has the impression that the surprising length of the elements results from a frenzy of fastening. The effect is not one of psychological tenseness but of exuberant, lighthearted freedom.

Kitayama is among the handful of contemporary Japanese sculptors interested in color, possibly because he made his living as a kimono painter for many years. He has no predetermined theory of color. He inserts the dyed papers or cloth into the bamboo frameworks not by design but intuitively, much as he lets his structures "grow." He notes that his color is reality, not illusion; it is not a surface application but an independent material that he can manipulate as he wishes. Inspired by children's drawings, Kitayama has a fine sense of nonsense, which is communicated by his free forms and also by his titles. He gets titles from chance remarks or radio programs and applies them to whatever he is working on at the moment, a process that often yields surreal or amusing pairings. He regards his constructive method as a metaphor for the Japanese language—both are changeable and capable of infinite conjunctions—and his bamboo material seems to him to symbolize the brush stroke, having a fluid shape with a beginning, middle, and end.[9]

69 The sculptures of Keiko Yamada are formalist conjunctions of short wooden elements or, more recently, metal

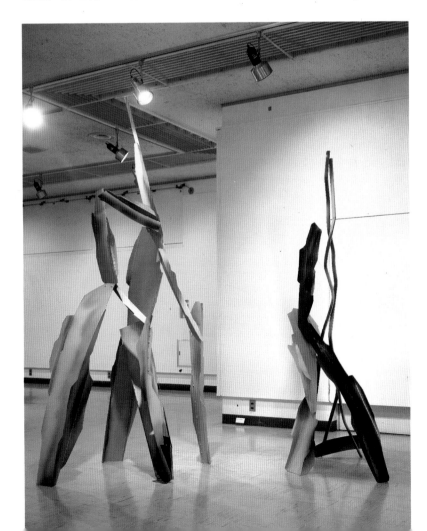

69.
Keiko Yamada (born 1950)
Color-Shot Space, 1988
Enamel lacquer on iron; left: 103⅞ × 51¼ × 36¼ in. (264 × 130 × 92 cm), right: 88¼ × 37⅜ × 37⅝ in. (224 × 95 × 95.5 cm)

elements that carry color through space. Her earlier works consisted of disorderly assemblies of planes, boards, and boxes nailed together and pushing sharply through space with no apparent ordering device. They looked like nothing more than the scraps of a carpentry project piled up and fastened together by an ambitious child. When she painted these rowdy assemblies, however, the color provided a tenuous visual order. Recent works consist of short, irregular pieces of steel welded or bolted together in skittery, mostly vertical lines. Because the barely overlapping connections suggest the growth joints of a stem, they are as organically additive as Kawamata's wooden installations and Kitayama's bamboo sculptures.

Yamada's metal sculptures generally have fewer parts and present a more extended, aspiring line than the blocky wood assemblies. The line climbs vertically, in pulses, constantly interrupted by sharp cuts, bent-up edges, or odds and ends welded to the main elements. The physical movement is ragged. And it is made more ragged by Yamada's application of color: changes in color are independent of changes in form. The spray-painted enamels generally blend or fade from one color to another, providing soft transitions quite different from the sharp transitions of form. The enamels do not seem to be applied according to any system, except perhaps that there are no dark colors at the tops. Yamada favors blues but employs a vast range of colors, from pastels to deep oxbloods and purples; the hues introduce a lyrical mood to the rectilinear hardness of form. Lush or bright colors seem to be the heart of Yamada's work; the metal simply serves as the carrier for what she describes as "color shot into space." Yet the repeated linkages are so central that this work cannot be considered merely formalist. Connection seems to be both her method and part of her work's meaning, and the sculptures hint at Buddhist expansiveness: everything is related.

Another expression of interest in connections is found in the relief sculpture of Hachiro Iizuka, which is made of overlapping short lengths of board, usually painted a solid blue. These are as much on the borderline of painting and sculpture as are the works by the influential artist and teacher Yoshishige Saito, for whom he was once an assistant. Iizuka's series called Variable Construction explores patterns and relationships among isolated but repetitive segments, which are sometimes freestanding and sometimes mounted on gallery walls. Their physical discontinuity is balanced by the uniformity of color. The seemingly random overlaps within individual clusters are given interest by the suggestion of familiar shapes. One can never be sure whether such recognition is intended or is just a projection by the viewer. (Iizuka has also played with this uncertainty in his prints,

6; 39

92

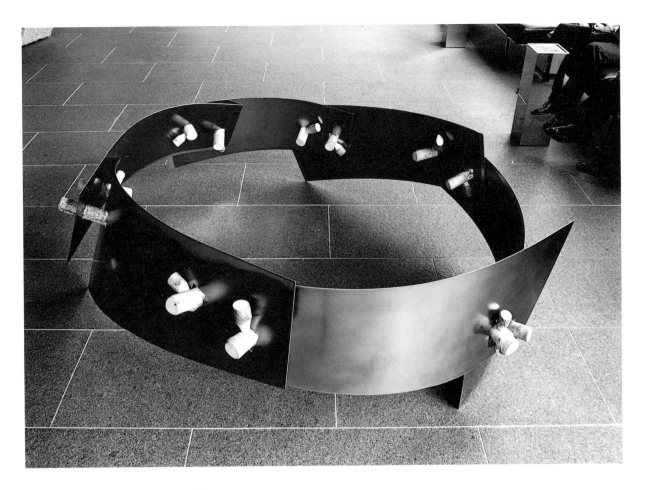

which comprise simplified geometric forms in brilliant flat colors.) A subtle sense of movement derives from the attraction of one discrete part to another. Movement is also inherent in the design: the works are constructed in the gallery from basic units of painted lumber, which may be combined or dispersed at whim. In fact, Iizuka sometimes invites viewers to shift the elements.

Shunpei Yamaoka's work also focuses on connections. He uses thin steel plates that are overlapped and connected with oversize wooden pegs and dowels. The sheets of steel or the heavy paper he occasionally uses are relatively modest in size and in weight. The round wooden plugs, individually carved, pass through unremarkable square holes. In Yamaoka's concept, wood is the weak point and must be enlarged to secure the connection. He often increases the apparent tension and strain on the wooden connecting points by bending the steel. Ultimately, the number and size of the linkages are so visually compelling that they, rather than the forms linked, are the focus.

Another type of relationship-based sculpture is dominated by considerations of scale and proportion. The Japanese sensitivity to scale is most often expressed in miniaturization, as in the work of Akira Kowatari. Kowatari

70.
Shunpei Yamaoka (born 1953)
Study for Construction, 1987
Steel, wood; 31½ × 66⅞ × 66⅞ in. (80 × 170 × 170 cm)

71.
Akira Kowatari (born 1945)
Scene, 1985
Wood, acrylic; 5⅝ × 4¼ ×
3⅞ in. (14.6 × 10.6 × 9.9 cm)

defines tiny volumes that refer to real space in a fantastic way. Within a box he creates an interior inspired by natural environments such as forests or caves as well as by the man-made spaces of city streets. Color evokes place and establishes mood, particularly when he creates a nagging sense of unease by opposing the visual devices of advancing and receding colors to the actual space within the box: the cool colors press toward the viewer, the warm colors diminish in the distance.

Space within every Kowatari box is compressed, and in some works he heightens the confinement by allowing the viewer visual access to the interior only through a tall, narrow slot. What's inside—a world that can be entered only through imaginative projection—is always simple but never predictable. There may be diminutive stairs or ramps that angle off or curve away or proceed straight across the

interior; space may be curtailed by a metal wall or variously colored wooden barriers. The constant and close boundaries heighten the viewer's sensitivity to the available space. The spatial pressure and the various views are characteristics that these boxes share with the streets of Japan.

Another example of miniaturized space is the early sculpture of Akira Kamiyama. His tiny structures akin to architectural models often look outdatedly industrial, like the mills and factories of the Industrial Revolution. Monochrome oil stains give them a soft, worn, dusty look. They appear to be models of usable buildings, yet the buildings' purposes are obscure. Kamiyama compounds the mystery with titles that name not industrial uses but personal ones, such as *I See the Moon from Here*. But surely nothing so complicated would be constructed for such a whimsical purpose, not even given the precedent of moon-viewing pavilions in traditional Japanese architecture. Kamiyama raises questions of purpose: how do we understand our technological world, who is served by it, how long will it last, and what happens to outdated things and people?

72.
Akira Kamiyama (born 1953)
I Think This Is the Place, 1984
Cedar, oil stain; 23⅝ × 39⅜ × 31½ in. (60 × 100 × 80 cm)

His works are like archaeological artifacts, asking to be analyzed for what they tell about the culture that produced them, not the artist.

Kamiyama repeats certain elements or motifs in his sculptures: pennants, barrels, moons, stairs, ladders, doors, railings, boats, wellheads, and emblems of flowing water. A few of these motifs might relate to group identification by occupation or by social or political affiliation, while others have to do with controlling space and directing movement; the moon may make spiritual allusions as well as refer to the future. But Kamiyama's meanings are never explicit. His recent works are larger, less like buildings, and they show an increasing compositional dynamism. Some seem to suggest psychological meanings, either in their titles, such as *Superstition* (a large platform with moons and emblems of fire), or in their arrangements (various objects are tethered to the wall, or two objects are counterweighted so they can never come together or ever be free of each other). Such configurations may suggest dependence or compromise.

Kenjiro Okazaki manipulates scale and proportion in a completely different way than Kowatari and Kamiyama. Okazaki's 1985 polypropylene sculptures can be as large as six feet tall, but they are so sensitively proportioned and so free of reference or allusion that there is no way to gauge their scale in photographs. These floor works, such as *Zinc,* are made of jury-rigged, ragged sheets of polypropylene leaning together or bent over to make an arched top, fastened with bits of wire or wood. Yet in photographs, these works have the translucence, refined edges, and delicacy of porcelain or paper, and they look diminutive, no more than tabletop size. Of course, photographs remove contextual indications of scale. And, of course, the flexibility and the white color of polypropylene give the sculptures visual lift. But those are not sufficient explanation of this particular effect. The sculptures' chameleon change of character comes from Okazaki's sense of proportion, as well as from his ability to see beyond the obvious characteristics of materials. His sculptures do not relate to nature, or to architecture, or to the human body, or to anything else beyond themselves, and this solely internal reference keeps them from being bound by "real" scale.

More recent works by Okazaki have been similar in effect although different in materials (he exhibits sculpture, drawing, collage-painting, and even video). His yard-tall angular abstract sculptures made of wood and plastic might be divided into two groups—bridging forms and converging forms. All are modest in scale, light in weight, open in construction, and vaguely suggestive of origami. They are anything but monumental. In each group the continuity of the form is disturbed by a sort of Cubist shift

73.
Kenjiro Okazaki (born 1955)
Zinc, 1985
Polypropylene, FRP, metal;
74¾ × 63 × 74¾ in. (190 × 160 × 190 cm)

of perspective; the shift might also be compared with architectural cutaways, in which one view of reality abruptly yields to another. Although the planes and joints that constitute the sculptures do not seem to make a whole, their proportions—they are related to the scale of light furniture such as deck chairs and end tables—make them seem comfortable and familiar.

Many sculptures by American Minimalist artists consist of multiple identical units in which the relationship between those parts is emphasized. Shape, color, and surface are simplified to the point of austerity, which brings increased attention to the relationships among the elements of each part (thickness, depth, edges, qualities of surface). Some Minimalists, like some Mono-ha artists, showed an interest in using everyday materials presented without illusion or evidence of the artist's presence. Aside from these shared characteristics, sculpture in Japan shows little resemblance to Minimalism. Japanese artists have produced a great deal

of what might be called minimalistic painting, including precisely defined forms and obsessive repetitions. Those repetitions, however, have non-Minimalist meanings. Some Japanese painters express Mahayana Buddhism's belief that the repetition of devotional acts accumulates merit. Others are motivated by Zen-like philosophies of a unity of action and image.

Few Japanese sculptors practice this same kind of dogged repetition. Kosho Ito, with his ceramic "fields," is one 75 of the few exceptions. Ito's works consist of white ceramic blocks or folded clay slabs or brittle clumps (achieved by firing clods of frozen earth) arranged over a wide floor space. The elements in his arrangements often diminish in size or dissolve from an orderly rectangular format into something looser. Some works are obviously an artist's fabrication, but more often they seem to be wholly natural products brought into the gallery. Ito's ways of ordering them (most often graded from large to small), by suggesting erosion, bring up the notion of change over time. Occasionally the works have a more explicit meaning: some "fields" of burnt earth, for example, allude to Hiroshima.

Minimalistic sculpture in Japan generally retains individuality—never becoming a featureless industrial form—and often retains a sensual or even slightly emotional character. By contrast, according to the American Minimalist Robert Morris, the goals of Minimalism were to get rid of the sensuous object and to avoid intimacy.[10]

Mutsuo Kawarabayashi makes individual objects that probably come as close to Minimalism as any sculpture in Japan. His stainless-steel "boxes" or "tables" consist of flat, 74

74.
Mutsuo Kawarabayashi
(born 1934)
Untitled 85-3, 1985
Stainless steel; 31½ × 27⅝ ×
27⅝ in. (80 × 70 × 70 cm)

75.
Kosho Ito (born 1932)
Eros of Alumina (White Solid Bodies Are...), 1984
Burnt alumina, feldspar; 11 ft.
5¾ in. × 28 ft. 10½ in.
(3.5 × 8.8 m)

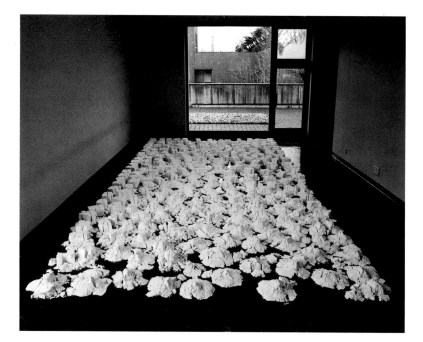

76.
Shintaro Otsuka (born 1953)
Untitled, 1987
Lacquer, bronze powder,
plastic plate, plywood; 36¼ ×
5⅝ × 5⅛ in. (92 × 14.5 × 13 cm)

smooth, nearly reflective surfaces that visually dematerialize. In recent works a single black stripe across the middle of the top of each sculpture divides the polished whole into parts and sets off a sequence of perceptions of rebounding relationships. Although he does not repeat forms, his sculptures may be called Minimalist because they are so reduced and self-contained.

The sculpture of Shintaro Otsuka might also be classified as Minimalist, but he identifies as his precedent not American art but Zen stone gardens, which require meditative concentration by the viewer. In a 1985 exhibition in Tokyo, Otsuka showed five slightly out-of-square boxes lacquered a mottled green, some sitting on the floor and others hanging on

77.
Natsuo Hashimoto (born 1953)
Untitled, 1987
Aluminum; 78⅝ × 70⅞ ×
15⅝ in. (200 × 180 × 40 cm)

the walls. The number and size of his objects are determined according to the available gallery space, and they are meant to stimulate the viewer's appreciation of relative locations: they are place markers within the space of the gallery, which is, in turn, a point in a larger architectural space, and so on. The self-effacing identification of the sculpture as merely a small part of a cosmic whole is a Zen attitude. A 1987 series uses a sharp ogival format for small, 76 laconic wood-and-lacquer wall pieces capable of commanding a wide expanse of wall space. Other recent work consists of similar forms made in bronze, which are dematerialized by an aura of light reflected by the polished surface. The blunt end of each gives the impression of being broken off, suggesting that the object is incomplete.

Natsuo Hashimoto offers another version of Minimalism. In his reliefs and freestanding sheets of aluminum, space is 77 flattened, the configurations are static, the material is inert. Any incidental appeal of surface and shape is mercilessly

eliminated, and even the concreteness of the object in space is reduced by a semireflective surface that confuses the object with its surroundings. The personalizing evidence of the artist's labor is retained only in the rough edges and obvious welds. His literalism is consistent with New York Minimalism, but the signs of his touch affirm his individual choices and activities.

Sculpture as relationship focuses on contrasts and repetitions within an object or installation, and occasionally between these and their surroundings as well. Like sculpture as material, this work generally turns away from direct engagement with the world in favor of, at most, analogical comment. The meanings of these artworks are subtle. They demand attention and analysis but not factual knowledge or articulation. The work is sensible—in both meanings of the term—rather than erudite. It invites contemplation.

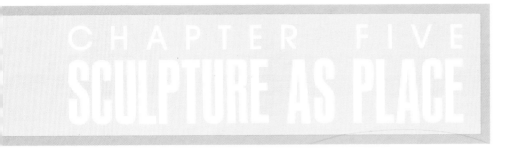

Contemporary Japanese sculpture finds value in themes far more ambiguous than political and social dialogue, appropriation, commodity critique, and other recent themes in the West. One such is the sense of place. But in neither painting nor sculpture is this sense of place expressed by *depicting* the landscape. A Japanese artist's work is more likely to address what the critic Tadayasu Sakai has called the "heart's landscape"—a deep feeling for the natural or man-made environment, conveyed indirectly. The category of sculpture as place includes works of varying degrees of abstraction, ranging from a relatively straightforward communication of emotional identification with a particular environment to a relatively neutral analysis of architectural divisions of space.

Having returned as an adult to live in the mountain landscape of central Japan that he had fled as a young man, Shigeo Toya has made that forested environment the subject of his art. His series title Woods alludes to a remembered place more than to the material he uses. Some

OPPOSITE
78.
Shigeru Nishina (born 1955)
The Shadow of Trees Becoming Deep Full Water, 1988
Wood, ground powder shell, pigment; 7 ft. 10½ in. × 13 ft. 1½ in. × 13 ft. 1½ in. (2.4 × 4 × 4 m)

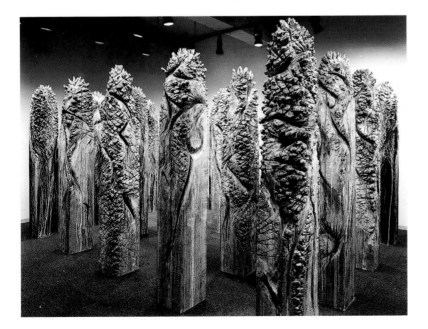

79.
Shigeo Toya (born 1947)
Woods, 1987
Wood, acrylic; each 83⅞ × 11¾ × 11¾ in. (213 × 30 × 30 cm)
Neue Galerie–Sammlung Ludwig, Aachen, Germany

SHIGEO TOYA

My artistic career started with my admiration for Western sculpture. I was born in a country dominated by deep surrounding forest. There, the old feudalistic village community relationships remain a strong part of spiritual life.

Young people like me really hated it. During my childhood, Western art—particularly Western sculpture, which I only saw as illustrations in books—was my only link with the outside world; it freed me from the daily round.

Now I try to get away from the spell of the modern sculpture that I once admired. I say to myself, "This is not the right place. The place that fits my soul is somewhere else, not here...." So I look for the right place with keys derived from my past memories and the senses I have developed.

Since I am an artist, such an ideal place should be one created by myself.... Neither installation as a dissolution of modernism nor installation as a return to ancestors are important subjects for me. I only want to provide an exciting encounter with new material configurations, where even materiality itself is dispensable. I want to deal with materials far beyond such restrictions.

Emiko Namikawa et al. *Continuum '85: Aspects of Japanese Art Today*, trans. Kaoru Kato, Hiro Tokita, Reiko Yamamoto, and Mike Jacobs (Melbourne: Australian Centre for Contemporary Art, 1985), p. 82.

of his earlier work, in which plaster forms were gouged and chopped until the iron rods at their cores were revealed, now looks like a rehearsal for his mature work with wood.

Toya's sculpture can be described as expressionistic, which makes it unusual in Japan. He captures many aspects of the forest—as a place of refuge, a place of meditation, and as a place of darkness and mystery. His expression is particularly powerful in a 1987 work of twenty-eight related but individual square wooden pillars lacerated with a chain saw and partially painted. (This work, shown in the Japan Pavilion at the 1988 Venice Biennale, is now in the collection of the Neue Galerie–Sammlung Ludwig, Aachen, Germany.) The pillars are approximately the height of a man with his arms raised above his head, and they stand in formation, in neat rows. At once human/tree and crowd/forest, they are tall enough to be majestic, and even slightly intimidating, but the familiarity of their human proportions is comforting.

Toya was inspired to begin his Woods series when he was suddenly disconcerted by a forest's writhing and moaning during a storm; it seemed to him to be a living thing.[1] His Woods sculptures and installations never specifically portray a forest, but they borrow such features as height, multiplicity, and especially texture from that vegetative source. They are not limited to the pillar form, but include circular platforms, spheres, square plaques, upright slabs, and irregular shapes, and they are unrestricted and open-ended in their suggestiveness. In addition to the associations with people and trees, the works bring to mind architectural regularity as they stand like the pillars of a public hall, and geological erosion because of their tortured surfaces. He also associates the works with death, relating the vertical posts to the smokestacks of crematories (cremation is the standard in Japan).[2]

Shigeru Nishina has said, echoing ancient Shinto and Buddhist ideas, "My work is deeply related to where I live. I live in a red pine forest and I'm affected very much by the energy these trees have. It makes me realize I'm a part of nature—that the landscape and man and man's things are bound up together, and I'm not the center."[3] Nishina's sculpture, like Toya's, conveys threatening and mysterious aspects of trees rather than their beauty or utility. Nishina is less interested in expressionistic surface than Toya, and more interested in the form of trees. Like the British sculptor David Nash, Nishina makes his sculpture in the shapes that nature offers him; sometimes he splits or chars or pigments the limbs, but he retains the natural form.

For a 1988 work, *The Shadow of Trees Becoming Deep Full Water,* Nishina partly split several tree trunks, held the splits open with metal rings, and then burned the unsplit ends as if the cauterization would hold them together by

79

78

visually terminating the slashes. Having painted the inside surfaces black and the outside surfaces white (sometimes with a touch of gold), he stood the trunks in a shallow dark metal container filled with water. This work, in which the water looks black and the trees are morbidly pale, refers to the unhealthy condition of the environment. In other works a title such as *Meltdown* makes his fears explicit.

Nishina has spoken about the importance of a home place, an intimately known locale associated with all aspects of one's life—birth, death, socialization, faith, art, thought—and distinct from all other places, yet related to them. He is describing the idealized *furusato,* or hometown, a place where family connections may go back hundreds of years—but a place that is becoming distant from urban contemporary Japanese. Nishina's low-key expression of concern with roots is typical of Japanese artists' treatment of social issues: they are obliquely invoked when they are dealt with at all. Characteristic of Nishina's work is a subtle emotional tone and a Shinto feeling for the natural mystery that is beyond articulation. Another reading of Nishina's work is metaphorically figural: his tree trunks, branches, and other elements are often arranged in multiples of four, because that is the size of his family and thus is a meaningful number for him.

More common than such expression of feeling for place is an attempt to engage the viewer's intellectual and physical sense of being located at a certain spot at a certain time in relation to a certain environment. Isamu Wakabayashi created a disturbingly familiar yet futuristic

80 place in an installation called *Sulfuret Garden—A Distant Imagery.* It was a postindustrial landscape of copper, sulfur, and steel, a barren space where the chemical action of sulfur patinated the copper panels lining the walls and faintly perfumed the air (in Japan, the sulfur smell is associated with volcanic hot springs rather than with the devil). Wakabayashi's reiteration of the wall planes with the two-dimensional copper plates reinforced the compressive, almost tomblike atmosphere of the windowless Tokyo gallery in which this work was shown in 1989. Prompted by the title of the installation, one might look for some connection with dry landscape gardens, but the uniformly flat surfaces of all the parts of the installation suppressed any hint of nature. At most, the patina patterns on the copper walls could conjure up a memory of light filtered by latticework or trees; nothing but light softens this blasted garden. The titles of earlier works by Wakabayashi also refer to natural elements or features such as forests and air, but his invariable use of cold, distressed, flat metals creates a bleak atmosphere. He has also designed outdoor landscape gardens that incorporate metal elements.

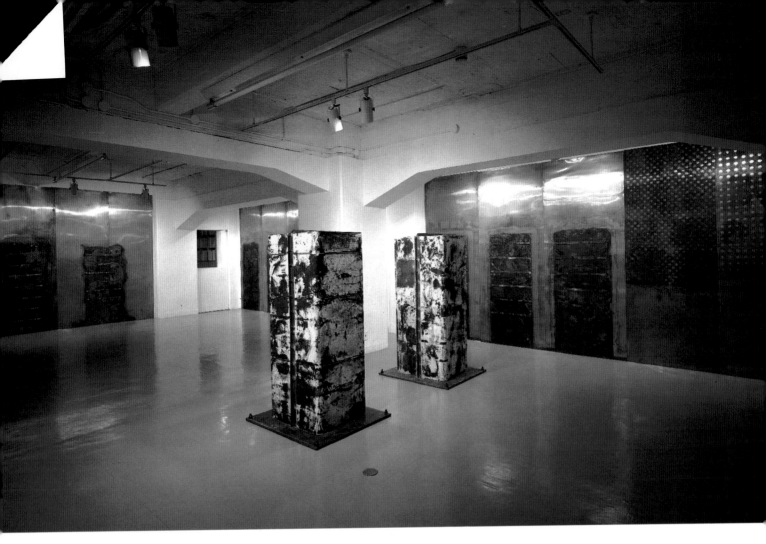

80.
Isamu Wakabayashi
(born 1936)
Sulfuret Garden—A Distant Im-
agery, installation at Akira
Ikeda Gallery, Tokyo, 1989
Copper, sulfur, steel

Bukichi Inoue makes architectural and metaphorical works that emphasize a cool modernity. His earlier works were interactive environments such as a room full of wooden ramps gessoed white (like a stage-set version of Greek ruins) or a plywood enclosure into which a viewer could climb to experience controlled conditions of reflections and manipulated light. Since 1978 Inoue has been working on a series entitled My Sky Hole—the term meaning both a place of refuge and an observation post—in which he develops relationships between objects and space in environments that can be perceived as referring to wombs, to houses, to cities. His continued use of the high-tech perfection of plastics and polished steel seems slightly out of step with most advanced Japanese sculpture today, but he works with Cor-ten steel, stone, and other materials as well.

Inoue's strongest works have involved digging into the earth. The first expression of this idea was a 1967 memorial to unknown soldiers at a Tokyo shrine for the spirits of the war dead, a serene arrangement of stone and water in which a pond seems to disappear into a cave. In this context his penetration of the earth was a symbolic burial, but entry into the earth can have other meanings as well. Inoue has described his holes as a primitive method of making a

81

place for himself in the universe with his bare hands.[4] He digs into the earth for purposes of concealment or protection.

Inoue has conceived a number of structures to be inserted into the landscape, above and below ground, which refer to birth, sexuality, and death. Even when they only rest on the ground, his sculptures seem to seek a rootedness. They also imply penetration—either physical, when the work can be entered, or visual, when it is pierced by a viewing hole. In the Sky Hole series, exteriors of entire sculptures, or interiors of the cylindrical viewing hole, have reflective surfaces. Exterior reflections dematerialize the sculpture, making it blend with its environment. The interior reflections, bouncing down the viewing tube, pull in the surrounding environment and make a small, distorted microcosm within the bounds of the sculpture.

Creating an altogether different effect is the sculpture of Saburo Muraoka, who like Inoue has made subterranean
82 works. His permanent outdoor installation called *Iron Grave* is heavy, dark, coarse, and rusty. Inserted in a man-made hill, *Iron Grave* is approached by three high brick steps leading to a low iron door. Beyond the door—within the
83 hill—is a small room barely high enough to allow a person

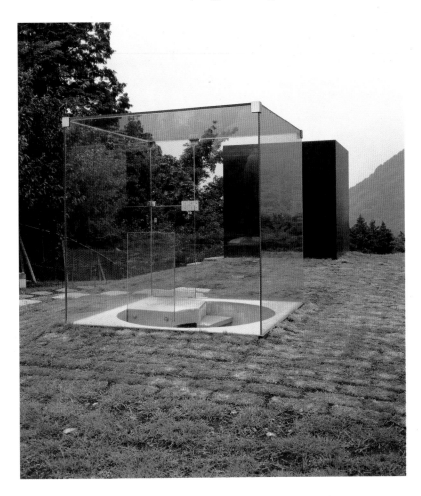

81.
Bukichi Inoue (born 1930)
My Sky Hole '79: Peephole on the Sky, Hakone Open-Air Museum, Hakone, Japan, 1979
Iron, glass, concrete, rubber, stainless steel; maximum overall height (above and below ground): 15 ft. 3 in. (4.65 m), overall width: 24 ft. 11¼ in. (7.6 m), maximum depth: 106⅜ in. (2.7 m)

82, 83
Saburo Muraoka (born 1928)
Iron Grave (exterior and
interior views), 1987
Iron, copper pipe, oxygen, glass-
ware, rubber tube, sand from
the Takramakan Desert of
China; 6 ft. 6⅝ in. × 19 ft. 8¼ in.
× 11 ft. 5¾ in. (2 × 6 × 3.5 m)
Higashida Blast Furnace
Memorial Park, Kitakyushu
City, Japan

to stand erect and without any source of light except the open door. Within this rectangular iron enclosure are five sculptures made primarily of iron, dating from 1979 to 1987, which "convey iron's practical functions (structural elements, work tools) and its physical attributes (hardness, weight, tendency to oxidize or rust)."[5] The "grave" suggests less a feeling of death and decay than of preservation. Muraoka is interested in physical change, and his works often include rust or sulfur or salt, all of which are present in this vault as dust on the tools or deposits on the floor or walls.

Other recent works by Muraoka seem to betray an anxiety about contemporary living. The two works in a 1989 exhibition entitled *Oxygen* suggested wounds and physical deterioration. *Vocal Cords* was a mysterious installation comprising unknown objects covered with lead sheets, ragged "arms" of iron clutching a sort of automatic drawing

around the artist's throat (drawn with one hand while he palpitated his neck with the other), and a gilded oxygen canister. *Burnt Out Vocal Cords* was a bandaged piece of tattered iron raised above a steel table. In the Japan Pavilion at the 1990 Venice Biennale, Muraoka showed oxygen bottles, an iron-slab wall, and a speaker emitting sounds from a microphone submerged in the polluted Venetian lagoon.

Muraoka's environments and sculptures tend to be closed in one way or another, but Naomi Kikutani's are quite oppositely open. Her slender, rusty steel frames start with quintessential architectural forms—the arch, the post and lintel—which she adopts in her sculpture. Then she packs her work with detail. One might find a Moorish-looking brace, a Scythian-looking finial, a Deco-looking cutout. These features, tucked in among the planks and beams and rods, come to one's attention only bit by bit. Her sculptures extend to the symbolically architectural, creating a sense of postmodern urban place, a nonnatural landscape. The connection of the rectilinear sculptures to the ground (there is no plinth) is so direct that it suggests a marker inserted into the landscape (fencepost, milepost, surveyor's measure).

Despite the three-dimensionality of Kikutani's sculpture,

84.
Naomi Kikutani (born 1960)
Feast: Columinations, 1985
Steel; 90½ × 70⅞ × 13¾ in.
(230 × 180 × 35 cm)

it bears remarkable affinities to collage, and the forms often read in photographs as two-dimensional line and plane. In some works she cuts away areas of metal, leaving an edge as ragged as torn paper. In others she cuts her metal planes as freely as Matisse cut his paper, and she places one shape against another so that the palpability of the sculpture is confounded by the kind of layering and richly ambiguous figure-ground relationships more commonly of consequence in two-dimensional work than in sculpture.

Environmental Sculpture Group Q situated abstract sculpture in the landscape to create a traditional sense of place, not to create mysterious, portentous, or descriptive sites. Like Nobuo Sekine's public sculptures, theirs were intended to be of service to the public by setting off spaces for special purposes, particularly to be havens from urban

85.
Sculpture Group Q (Rikuichiro Kobayashi, born 1938; Masakazu Masuda, born 1931; Makio Yamaguchi, born 1927) *Message from Andromeda,* Port Island Central Park, Kobe, Japan, 1977
Stone; 52 elements, 13 ft. 1½ in. × 187 ft. × 108 ft. 3¼ in. (4 × 57 × 33 m), overall

stress. The three sculptors in the group—Rikuichiro Kobayashi, Masakazu Masuda, and Makio Yamaguchi— worked collaboratively from 1968 to 1988 and expressed the hope that their landscapes might not even be recognized as works of art. To this end, they eschewed individual expression in favor of arrangements that are random (ninety-nine stones dumped from a truck), celestial (the configuration of the constellation Andromeda), or impersonally regular (the proportions of a *go* board).

85 These sculptures, meant for public interaction, consist of multiple parts through which spectators are expected to pass as they experience the sculpture physically as well as visually. In *Message from Andromeda,* the positions of stones follow the position of stars, but their sizes and surfaces make a landscape that invites sitting or climbing. *Meriken Theater,*

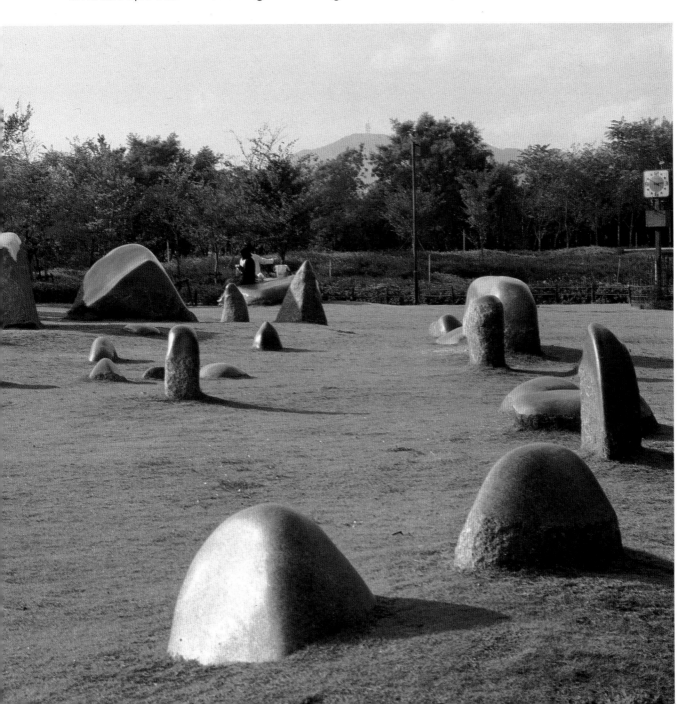

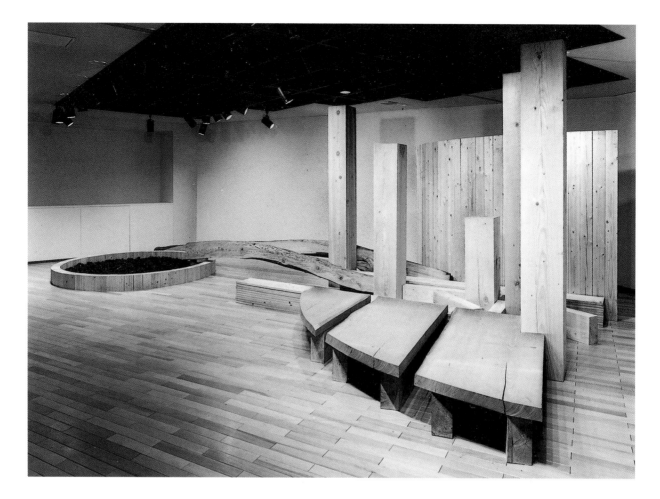

86.
Koichi Ebizuka (born 1951)
Related Effect S-86GT, installation at Galerie Tokoro, Tokyo, 1986
Wood, coal; 8 ft. 2⅜ in. × 27 ft. 7⅛ in. × 17 ft. 9⅜ in. (2.5 × 8.41 × 5.42 m)
Galerie Tokoro, Tokyo

which commemorates the first movie theater in Kobe, provides a platform behind a cutout frame so that visitors may play out fantasies by appearing on the "screen." The sculptural materials used by Group Q include bronze, natural stones, and in the case of the *Hokuto Mandala* at the Sapporo Sculpture Park, plantings. *Hokuto Mandala* consists of a square arrangement of natural stones and evergreen trees, centered on seven polished stones in the configuration of the Big Dipper. The trees, when mature, will make the sculpture cubic. It is possible to imagine most of Group Q's places as meditative gardens, although their usual urban locale precludes the necessary quiet. But they do serve other purposes, providing open space, playgrounds, meeting points.

Much sculpture as place has an architectural character. It visually and conceptually encompasses either constructed space or the elements and methods of construction. Some of these works refer to traditions of styles or of forms; others seem architectural because of their methods of assembly, most often stacking.

A prime representative of the spatially or stylistically architectural is Koichi Ebizuka, who trained as an architect.

Each wooden part in his Related Effect series of installations corresponds to some element of Japan's traditional post-and-lintel architecture. For example, in a 1986 installation a curving wall six or seven feet tall served as a backdrop to five massive square pillars and a curved floor that jutted forward, while two planed tree trunks reached horizontally from the structure to connect with a low circular enclosure eight or ten feet away. One way to understand this arrangement is to think of it as a Japanese house with a veranda and a path leading to a pond. Another way is to compare it with No or Kabuki stages and their access bridges. The latter evokes a deeper symbolism because the No stage represents the present, backstage is the realm of the gods, and the bridge can connect the two worlds.

All of the elements in Ebizuka's installation—the beams, the curving back wall, the floorboards—are harmoniously proportioned. The edges of the unplaned floor slabs are devoid of bark but retain the irregular surface of a living tree. The two lengths of wood that reach away from the structure are even more nearly whole than the floor slabs; they are still tree trunks, with just one slice trimmed away from front and back. They are naturally curved, like the "rainbow" beams in Buddhist temples or the irregularly arching beams of *minka* (traditional Japanese rural houses), which exploit the extra strength of twisted trees that have grown on steep slopes. These trunks connect to the circular "pond," which is filled with coal, a material that introduces associations with time, energy, fire, and also with charcoal— a heating material and an artists' material derived from wood that suggests the multitude of purposes wood has served in Japanese life.

Ebizuka's installation is both clear and elaborate in its treatment of architecture as a subject matter. But many young artists who do not specifically deal with architectural spaces or forms are nevertheless attracted to architecture's constructive orderliness as a point of departure for more formalist sculptures. Atsushi Ohashi, for example, makes sculptures using great hunks of wood as building blocks. They suggest tables or sometimes posts and pediments. The fact that the legs are not always set square or parallel and the "tabletops" are fragmentary, bridging elements gives Ohashi's works an almost defiantly graceless character and a broad-shouldered strength. They evoke construction, piling up, like stone wall-building. Set on or into the "tops" are simple geometric forms whose absoluteness contrasts oddly with the near brutalism of the rest of the sculpture, establishing an intellectual tension. This and other tensions point out a relational quality in Ohashi's sculptures, including the physical balances of the weighty parts and the visual balances of the composition. There is also a certain surprise

KIMIO TSUCHIYA

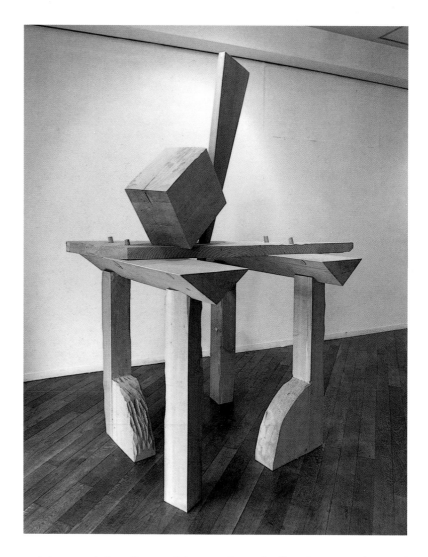

According to the words of a Celtic poet, "At one time, having a common language with all creatures on earth, man gathered with the animals and spoke with trees and rocks," however through his arrogance, man lied and caused conflict, which resulted in God taking away the common language. There is no doubt that since then there has been a boundary between man and nature through which their coexistence has become a mere fantasy, and humankind's subjugation of and rivalry with nature has probably begun. While the large-scale felling of trees around me (holocaust) has been justified by saying that it is to provide housing, the destruction of nature is being continued under the name of development. Nowadays development cannot be undertaken without technology: woods are instantly destroyed by bulldozers, and beautifully shaped trees that have been growing for decades are crushed, with only their remains scattered over the leveled ground where buildings are to be constructed at an unknown time in the future....

I began my present work after confronting this modern-day destruction. After gathering fragments resulting from this destruction I reorganized them into "total as an accumulation of pieces," and by greeting "death as life," I believe that life and death are relative.

Freddy DeVree and Toshiaki Minemura, *Europalia '89: Japan in Belgium* (Middelheim, Belgium: Openluchtmuseum voor Beeldhouwkunst, 1989).

at how minimally and how gingerly the heavy elements touch each other. In recent works Ohashi seems to be stretching his balances, with lots of diagonals and abbreviated, seemingly incomplete elements creating a new dynamism in his architectonic sculptures.

Stacking is an architectural method for building the simplest kinds of shelters. Kimio Tsuchiya has made a half-circle of stacked wood nearly six feet tall. It has no obvious architectural antecedent—although it may be a solid version of what is usually empty space within an archway (a positive of the negative)—but his method of construction by accretion is commonly seen in the placement of roof tiles, ceiling or floor planks, and stone or brick walls. Tsuchiya has applied his stacking technique quite elegantly and evocatively to many kinds of woods, their variety contrasting with the repetitiveness of his process. His works have an undiguised directness that is reminiscent of the early Mono-ha sculptures. Recent works, such as the 1987 stacking of wood blocks called *Landscape*, abandon regularity for 88

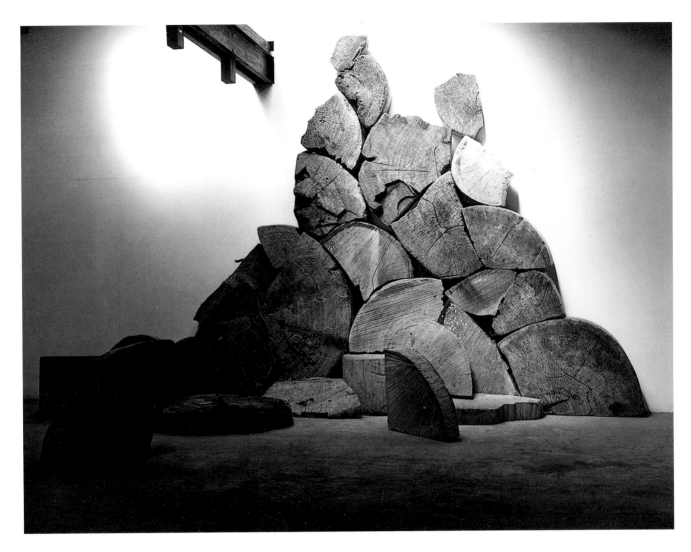

more open configurations. This work has the drama of a stage set and also calls to mind architectural ruins. That association was more than incidental in a semicircle of wood he constructed from a demolished house for the American exhibition *A Primal Spirit: Ten Contemporary Japanese Sculptors.*

Takamasa Kuniyasu uses tiny bricks of low-fired clay to build wonders and disasters of architectural scale. His early installations, in 1985, consisted of discrete low-rise structures, like models for city planning. His structures grew in ambition, complexity, and size to the point that his gallery installations were pushing the limits of indoor space. Brick towers (like square or rectangular skyscrapers) went too far—ever higher, wider, more ragged, less referential or allusive, elevated to an almost hysterical pitch, poised between humor and horror.

The introduction of cedar logs to his indoor pieces in about 1987 signaled a change in the scale of components that allowed further increase in size. A 1988 outdoor installa-

89.
Takamasa Kuniyasu
(born 1957)
Return to Self, installation at
Hillside Gallery, Tokyo, 1989
Ceramic, cedar logs

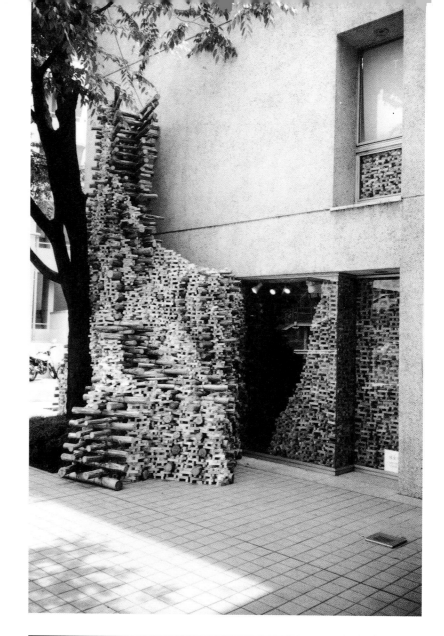

90.
Ryoji Suzuki (born 1944)
Unearthed Architecture,
installation at Moris Gallery,
Tokyo, 1985
Cardboard, steel

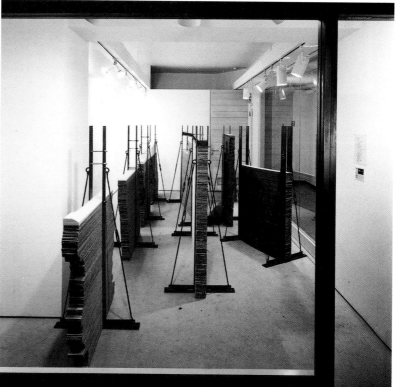

tion required eighteen days of stacking the bricks and logs to achieve its 24½-by-39-by-36-foot size. Also in 1988, an indoor work grew to two stories in an invitational exhibition at the Yokohama Citizens' Hall gallery. The logs were tied with transparent cord, but no viewer could be oblivious to the potential danger presented by piles of such size in an earthquake-prone land.

Ryoji Suzuki is a practicing architect and sculptor who intermingles his fields. He gives his habitable buildings the series title Experiences in Materials and derives his architectural style from the contrast of substances. His architecture has been described as adopting the sculptural methods of sectioning, excavating, and compressing.[6] That is, the complex mixture of shapes in his architecture is a consequence of the fact that his materials and forms do not merely unite efficiently but overlap or interpenetrate expressively to create a sculptural tension.

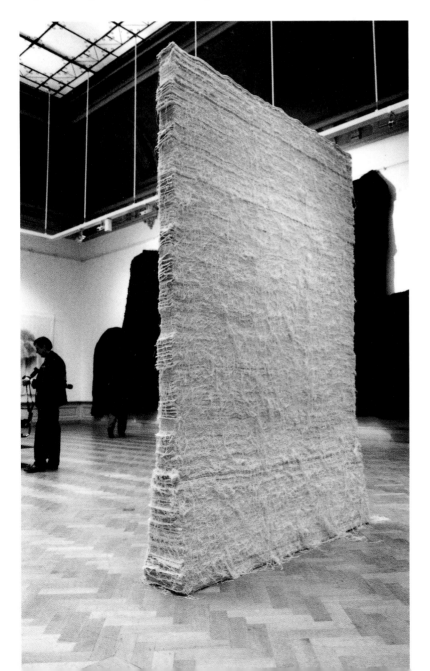

91.
Masao Yoshimura (born 1946)
Wall of Cloth No. 2, 1986
Cotton cloth, iron; 118 × 78¾ × 11¾ in. (300 × 200 × 30 cm)

In his artworks, conversely, Suzuki takes architecture as his subject matter and uses architectural modes. He employs stacking in a series called Dis-Locational Architecture. Some 90 of these works look like architectural models of structures that could be real; others are impractical or abstracted variations on a theme of walls or I beams. All consist of stacked strips of cardboard fixed between uprights and tension wires. Suzuki has also made mixed-medium reliefs corresponding to buildings he has encountered. In a series entitled Barrack Architecture, he extracts from his photographed sources a pattern of structural elements or exterior surfaces from which he makes an image that is more conceptual than representational.

One of Suzuki's more unusual works was a 1987 collaboration with the sculptor Kyoji Takubo and the photographer Shigeo Anzai: a traditional house that was to be demolished was carefully reduced to its skeleton and then fitted with a floor of glass plates, across which slippered visitors could walk during the two-week exhibition period. This seemingly precarious floor allowed visitors to look down to the soil and at the same time see the reflection of the sky, and the sense of place was both heightened and confused by the multiplied reflections of the structural elements.

It is only a small step from Suzuki's walls of stacked cardboard to the walls of stacked fabric constructed by Masao Yoshimura. Yoshimura has piled rectangular pieces 91 of fabric into a form almost nine feet tall, suggesting a room by means of a unit of wall. The work recalls other uses of textiles as architectural divisions in Japan, such as the privacy screens behind which aristocratic ladies were concealed in polite medieval society. In Japanese traditional aristocratic architecture, interior walls are made of paper, and even today many shops still use partial curtains across doorways, so architectural textiles are familiar in Japan. Yoshimura's stacks of raveled, natural-color cotton cloth make a wall that is paradoxically thick and bulky yet precarious. It is softly receptive and entangling yet weighty. Constructing a wall of cloth strips is as orderly an activity as piling up stones or bricks.

Hisayuki Mogami—whose long career has included participation in the Japanese painting and sculpture exhibition at New York's Museum of Modern Art in 1966—has recently created works that bring architecture to mind because of their assembly method or because of their form. Some of his wooden works adopt methods less visually complicated than the crossing, wrapping, and interpenetrating of his earlier constructions. For example, in one work he has simply stacked thick tripods, which are individually made but repetitive in form. In another work the relationship of stacked elements is turned on its head. This sculpture

92.
Hisayuki Mogami (born 1936)
Give It Up Point by Point II, 1985
Pine; 55⅛ × 70⅛ × 47¼ in.
(140 × 178 × 120 cm)

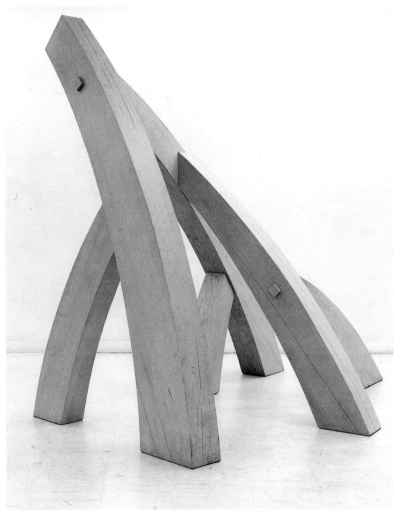

93.
Hisayuki Mogami (born 1936)
*Send It to Heaven, the Once
Again Dream of a Dream*, 1988
Pine; 84⅜ × 79⅞ × 68⅛ in.
(214 × 203 × 173 cm)

A crossroads symbolizes the crossing of dualities—for example, time and space. It has the function of raising us up or lowering us vertically. I definitely feel that I am standing at the point of crossing between space and time, being lowered vertically down to the place of memory....

In the past, when crossroads were known as tsuji, each corner of the intersection had a different name and travelers used them as guideposts to get to their destination. Today travelers go by the names of roads which connect two points, and it seems as if something is changing culturally....

Guardian deities are placed at the crossroads. It is the center of mystery. A meteorite or other stone thought of as sacred is placed there, or an old tree held up on crutches is worshiped there. Or, conversely, it is also a place where witches and devils gather, or a place where vampires, major criminals, suicides, or witches are buried. This is done so they will be confused as to which road to take and not return to this world. The crossroads can be an exit which leads nowhere for the drunk who does not know where to go. The crossroads is a place of strong magic.

"Crossroads Statement," in *Noboru Takayama, 1968–1988: Installation Works*, trans. Stanley N. Anderson, Kazue Kobata (Tokyo: Gallery 21 + YO, 1988).

resembles a corner stairway, but upended so that the steps [92] are on the underside. The piece juts forward into space, supported by only a single wooden rod that looks inadequate for its task. Mogami's carpentry skills are such that he can play with the rules in a piece like this without risking failure. The steps are cut so that the whorl of tree rings is repeated like a wave motif—an example of Mogami's preference for making things that are simple overall but complicated in detail.

In a 1988 exhibition in Tokyo, Mogami showed sculptures of various sizes that resemble a flying buttress, each [93] consisting of curved and tapered four-sided wooden beams. The largest, just over six feet tall, is constructed so that the three smallest beams that make up the sculpture touch only one other element; two beams touch two; and one touches three. A related work is also buttresslike, but each beam takes one or more angular turns. These works acquire directional force because graduated sizes of beams point toward the tallest element. Typical of Mogami, the works are simple, strong, and graceful.

Noboru Takayama, a Mono-ha artist, has used railroad [94] ties as his signature material and his theme since 1968. They offer three-dimensional structure and metaphor, standing like monuments, suggesting movement through incremental placement of identical forms, and defining enclosure or suggesting the physical remnants of a lost social organization. Takayama has been described as having a two-dimensional viewpoint (he was trained as a painter) and as placing the ties like brush strokes,[7] but the ties certainly occupy real space. Since his outdoor grid installation for the 1973 Paris Biennale he has variously stacked the ties, leaned them against a wall or against each other, or laid them end to end to create walls or obstacles whose forms imply collapse or post-collapse disorder. Takayama's use of overt symbolism is unusual for a Mono-ha artist, yet it does not make his works particularly accessible. They remain austere and difficult, perhaps because the multiple meanings are simultaneous and ambiguous. Takayama has spoken of the moiré effect of history, and his allusions are similarly shifting. He especially favors the cross as symbol, using it most often to suggest meeting places and interactions. But he also likes to point out that the cross can be turned forty-five degrees to make an *x*, which can be a checkmark (indicating a selection) or can signify "no" (Japanese often use the gesture of crossed forearms to mean the negative). He plays with that multiplicity in his installations.

A sense of place in sculpture is also created by works that enclose or disrupt space. The passage structures of Koji Tsuji are serial, modular units that vary in degree of enclosure

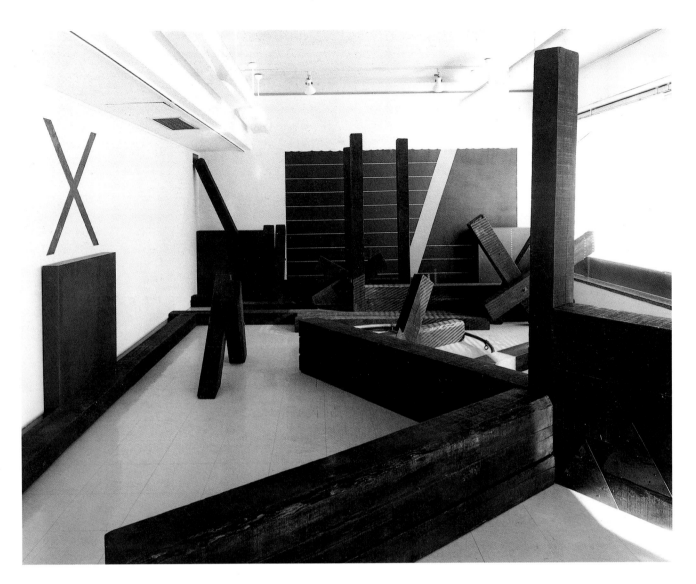

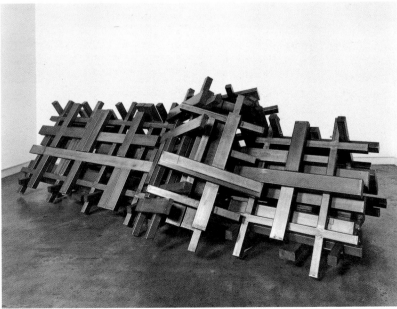

94.
Noboru Takayama (born 1944)
Headless Scenery, installation
at Tokiwa Gallery, Tokyo, 1984
Wood, iron, cotton canvas;
16 ft. 8¾ in. × 25 ft. 7⅛ in. ×
9 ft. 10 in. (5.1 × 7.8 × 3 m)

LEFT
95.
Koji Tsuji (1950–1987)
Along the Triangle II, 1987
Steel; 47¼ × 137¾ × 59 in.
(120 × 350 × 150 cm)

To assume that peripheries only exist to assure [the] reality of a central point is wrong. The thing placed in the center cannot have any reality without [the] reality of surrounding things. And even the central point is, in fact, only a periphery to something else.
January 13, 1988

There is no such thing as "form" until it is cognized from the infinite phenomena around us. Form is created by our consciousness which selects according to our needs or abilities. Everything is interdependent, without definition, until we become aware of one aspect; then "form" emerges for the first time.
March 2, 1986

No thing can be segregated from others; everything possesses its own position through mutual interdependence. Yet, if the state of non-interdependence [were] possible, I wonder how existence could then be manifested.
May 2, 1974

Separating a thing from its natural situation is like taking blood from flesh; it tears the thing away from its raison d'être.
January 7, 1973

Kishio Suga, 1988–1968, trans. Kaoru Kariyazono, Steven Forth, Yasuhiko Suga, Reiko Yamamoto (Tokyo: Kishio Suga, 1988), pp. 6, 24, 146, 156.

and often may be entered or passed through. His early works were made of plywood panels and looked like unfinished buildings or particularly dilapidated teahouses. He introduced lattice structure and then, seeking a more neutral material, changed from wood to steel. He treated the metal like wood, abutting, overlapping, and even interweaving short two-by-four-like lengths of steel into a staccato rhythm of abrupt visual movements. He took as his theme primary shapes. In *Along the Triangle II* he leaned 95 steel bars against each other and bolted them to form an elongated tentlike construction. The sides of this A-frame are reminiscent of wattle walls, and the crisscross of elements at the top calls to mind the decorative and anchoring devices of Japanese thatched roofs. The flatness of one side is interrupted midway along the length of the structure, where the metal elements buckle out to violate the geometric regularity and to introduce a new, irregular space.

Kishio Suga returns to the discussion here because his philosophy of "expanding outward" requires interaction of the artwork with the space of the world around it. Each of Suga's works marks a site and leads outward to connections that may be physical or conceptual or both. The works create no images, make no allusions, seldom or randomly employ color, and use mundane materials that rarely contribute sensual interest. Thus Suga's work tends to be an acquired taste, for it is most interesting because of his inexhaustibly fertile means of expressing the same idea.

A 1985 installation at a Tokyo gallery (re-created for the 96 permanent collection of the Tokyo Metropolitan Art Museum) might be described as yielding maximum interaction with space by minimum means. A huge, flexible aluminum loop stands on edge, both held down and held up by several pieces of soft, concretelike Oya stone while gravity flattens it into an ellipse more than six feet tall and thirty-six feet long. The shape and the materials are simple and ordinary. Temporary, visually permeable, and spatially expansive, the installation seems to encompass all of the space within the gallery.

A 1986 installation, also in Tokyo, consisted of low, subdivided, crudely fashioned aluminum boxes placed on the floor. Suga began with an aluminum plane and through an elementary and commonplace act he folded it into the third dimension and made it a container of space. He made that notion explicit by titling the work *Square Pond*. Other works from about the same time include a *Wood Pond*, constructed of loosely stacked blocks of lumber with glass over the top, and a freestanding vertical wood frame which he titled *Air Pond*. A more recent installation, which filled a 97 small Tokyo gallery wall to wall, was an irregular rectangle defined by open metal boxes fifteen inches tall, topped

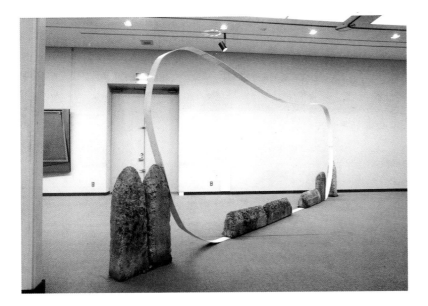

96.
Kishio Suga (born 1944)
Linked Objects, 1985
Aluminum board, oil paint,
Oya stone; 7 ft. 3⅝ in. × 20 ft.
8 in. × 7⅞ in. (2.25 × 6.3 × .2 m)

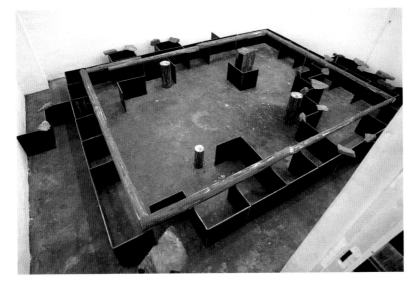

97.
Kishio Suga (born 1944)
Out of Multiple Surroundings,
installation at Kaneko G1,
Tokyo, 1988
Iron, stone, cedar; 15⅝ in. ×
14 ft. 1⅜ in. × 10 ft. 9⅞ in.
(.4 × 4.3 × 3.3 m)

98.
Kishio Suga (born 1944)
Protrusion YY-87, 1987
Painted wood; 38¼ × 73⅝ in.
(97.5 × 187 cm)

with a frame of cedar logs. At shifts in the perimeter—the corners and boxy digressions—stones rested precariously. They disrupted the composition, and their instability emphasized the fact that the whole work, like a building-block city, could be destroyed in an instant. Suga has no interest in resolved objects, and the many edges of this work suggested incompletion—or, more exactly, the impossibility of finality.

The metal boxes, like the aluminum loop, are rather uninteresting-looking things, and a viewer encountering work that looks so offhand may be a bit hostile, or at least skeptical. Suga has joked that viewers sometimes mistake his exhibitions for construction sites and ask when the art will be shown. Yet these works are consistent with his orientation toward expanded space; he looks not at a fixed and discrete aesthetic object but at commonplace materials and shapes that he borrows from the world and that he uses to try to direct the viewer's attention beyond the art object. Suga demonstrates his interest in boundaries, points of contact between things and space. He has said that he wants to express the vagueness of the intersection of things and things, and man and things.[8]

In a 1987 show Suga offered a series of works called Protrusion, which is probably his most accessible work [98] to date. These are rectangular reliefs reminiscent of Piet Mondrian's drawings or of architectural plans. They are restrained, cool, and surprisingly close to elegant. The reliefs are painted black or white only and are presented on the wall or, in a more intimate size, as the top of a pedestal. Because their rectangular format and wall placement are so similar to painting they seem less spatially expansive than is usual for Suga, but he breaches the "frame" by allowing small protrusions outward along the plane of the wall and forward into the viewer's space. The lateral extensions are treated differently, painted black on the white works, white on the black works, and unpainted on the pedestals. Each is a reminder that an artwork is not a whole, not a world in itself, but is continuous with the larger world.

Noe Aoki's mature work has always been made of steel. Although her own satisfaction with her work derives primarily from the process of making it, that process is not revealed to the viewer in the finished work. Aoki's works are nearly all "man-made environments" and thus architectural, although seldom directly so. Like Kushida, she has moved from linear to planar over the last several years. Her early works were welded wire. Once she made the contents of a room— table, chairs, vase of flowers—entirely of iron wire. More frequently, she has made domes and towers of wire and [99] shown them both indoors and out. These are enclosures that cannot be entered, structures that do not hide or protect their contents, environments that are in fact visibly empty.

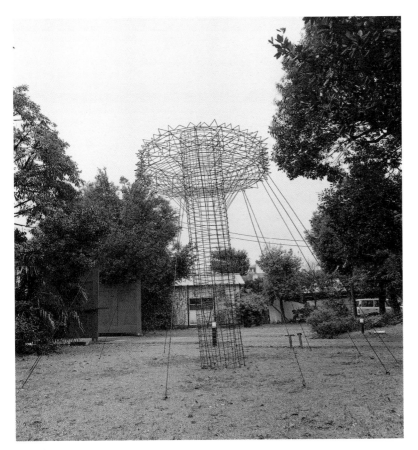

99.
Noe Aoki (born 1958)
Untitled, 1986
Steel; 13 ft. 1½ in. × 98⅜ in.
(4 × 2.5 m)

Since 1987 Aoki has been alternating between such "transparent" works and more solid forms, most often crescent-shaped planar cutouts that suggest boats or moons and that are shown in groups, dividing the gallery into layers of space like flats divide the depth of a stage.

100 Kenichi Kanazawa's sculptures are stable square or rectangular frames whose orderliness is disturbed when he pivots the elements and thus introduces perceptual shifts. His large floor sculptures consist of dark, hollow iron slabs and box beams that reach backward, forward, or diagonally in such a way that they suggest that the work was built and then pulled open, pushed ajar, to allow an accessible central space. The individual parts look stolid, but the work as a whole looks momentary. Form makes no pretense of inevitability, yet Kanazawa's fine sense of proportion, coupled with a respect for the material and for workmanship, results in a kind of grandeur. In keeping with their sober, deliberative character, each is titled *A Structure Made of [x] Parts to Satisfy a Certain Intention.*

 Probably Kanazawa's ideal combination of work and site was a sculpture temporarily sited at the Omiya Outdoor Sculpture Exhibition near Tokyo in 1987. In that park setting, the iron elements alluded to architecture—pillars, beams, walls—and brought to mind gazebos, follies, trellises, and

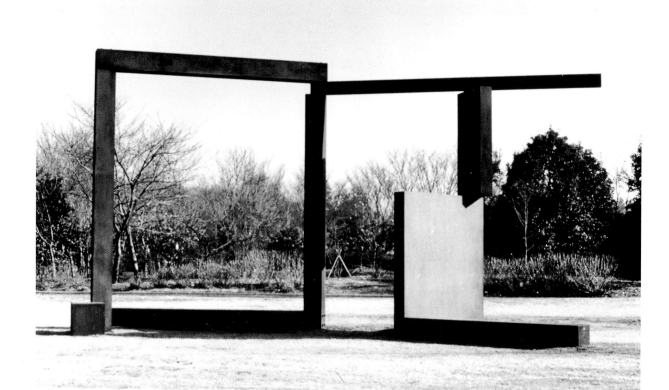

100.
Kenichi Kanazawa (born 1956)
A Structure Made Up of Nine Parts to Satisfy a Certain Intention, installed at Omiya Citizens' Park, 1987
Steel

101.
Sadao Takimoto (born 1948)
Chaotic Tetra, 1986
Roots; 70⅞ × 118⅛ × 98⅜ in.
(180 × 300 × 250 cm)

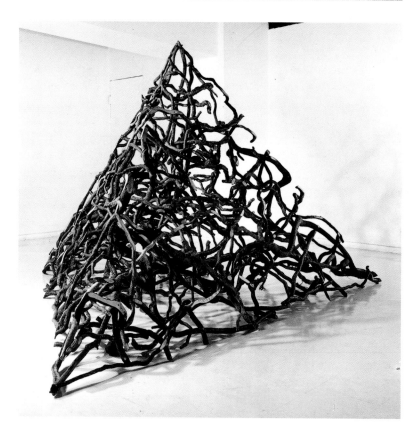

other garden structures. The work also functioned as both a frame for a distant view and as a gate marking passage. The rusty color related to nature, and the elements were simple and distinct enough to define a sense of place without being harshly intrusive. This work was a model of what sculpture in parks could be and offered a most welcome contrast to the unimaginative and too-small bronze nudes that are standard park fare in Japan.

The sculptures of Sadao Takimoto are tangles of branches or roots. Branches are so irregular that when dozens or hundreds of them are joined, the mesh is inextrica-

101 bly complex. *Chaotic Tetra* consisted of a six-foot pile of interlocked branches. Takimoto made them into a pyramid by slicing off the tips of the branches so that the plane of each side consisted of the dots and dashes of the terminated limbs. He also constructed a huge, hollow quarter-sphere in the same way. It first appeared to be a disorderly tangle, yet examination revealed the surprising order of branches that had been compacted and cut into segments forming the wall of the sphere.

Takimoto's ephemeral sculptures fall somewhere between the solid objects of traditional sculpture and the sweeping lines and planes more common in late twentieth-century sculpture. Having used unrefined natural materials to form basic geometric shapes that are more perfect than any natural landscape element, Takimoto has moved in recent works toward freer, riskier forms that suggest movement. Among his works from 1988 and 1989 are whirling spirals, lightning-bolt diagonals, and fluttering wings.

Osamu Kushida articulates space by outlining compli-

103 cated polygons with short lengths of board. The pieces may stand, or stretch out on the floor, or floor and wall portions may interlock. They mark off space. They are mobile boundaries in three dimensions. Kushida colors them with patches of bright paint that do not respect the physical divisions of the boards (an approach that he shares with Keiko Yamada and her colored-metal sculptures). The colors, which visually advance and recede, complicate the viewer's comprehension of how much volume the boards outline. In some cases the colors seem to cancel a dimensional or directional change, and in other cases they create one.

These works might be seen as related to those by Yoshishige Saito and Hachiro Iizuka in that they are paintings in space, articulating that space through undistinguished linear elements in which the specific material is not important. However, Kushida's works differ from those of both older artists because he creates an impression of continuous movement and because he uses color to interrupt or punctuate that movement rather than to unify form or neutralize material. Recently, Kushida has begun to build his works

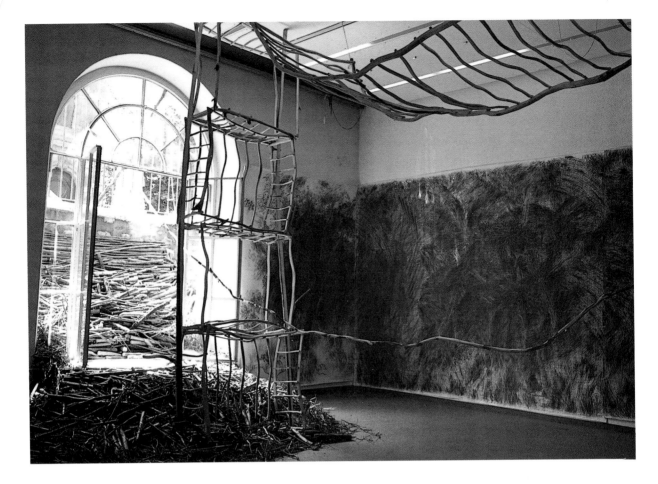

102.
Chieo Senzaki (born 1953)
Drawing/Branches, installation
at Rath Museum, Geneva, 1983
Drawing, branches

more solidly (although they are still mundane pine boards, casually nailed together) and to emphasize planes rather than lines. One can no longer look through the forms from a single viewpoint to puzzle out the configurations. Now they intransigently occupy a site and require the viewer to make a physical circuit rather than a purely visual one.

Some works by Chieo Senzaki have also been composed of dense tangles of branches. Senzaki, however, generally strips the bark from his branches, giving them a flayed, tense appearance. He also calls attention to splices in his wood lines by using protruding screws. His basketlike tangles are shown with large drawings. An early example 102 was made during his 1983 residency in France; the drawing was sited inside the gallery while the branches extended from inside to outside the building. A related installation shown in 1988 as part of a curated annual exhibition sponsored by a Tokyo ikebana school consisted of branches scraped bare and a drawing that seemed to depict the same tangle of branches nearly concealed by foliage.

Other Senzaki works consist of opposites—such as a huge slab of wood with tunnels gouged into it juxtaposed with slender pieces of wood that might be the positive of the tunnels' negative. He also uses reflections created by

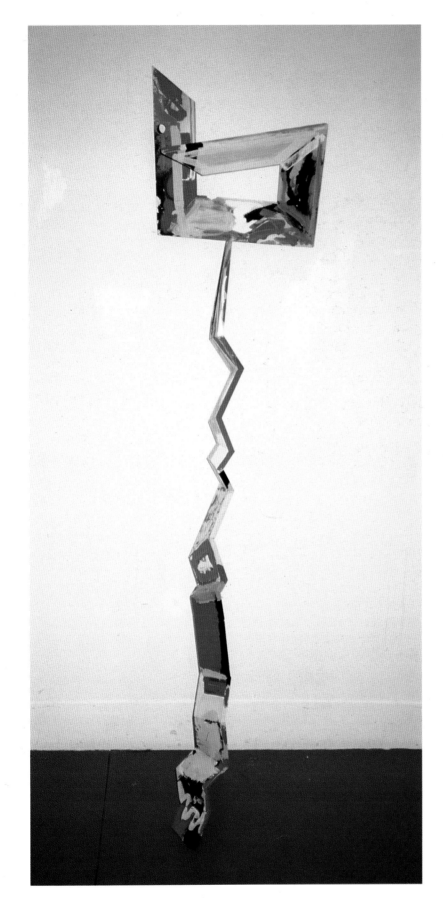

103.
Osamu Kushida (born 1952)
Face, 1987
Painted wood; 66⅞ × 17⅝ ×
19⅝ in. (170 × 45 × 50 cm)

104.
Satoru Kawagoe (born 1956)
Untitled installation at Gallery
Lunami, Tokyo, 1985
Wood, copper powder, linen,
green corrosion, wax; gallery
size: 8 ft. 6⅜ in. × 24 ft. 6½ in.
× 132 ft. 6¼ in. (2.6 × 7.48 ×
3.51 m)

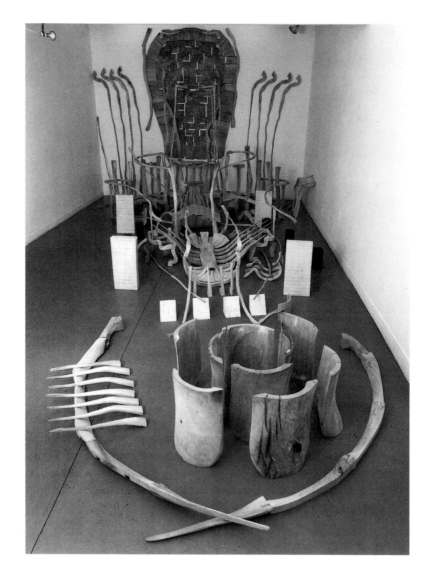

incorporating panes of glass to pull the viewer's image (or the artist's) into the work and to relate the work to its physical surroundings, or to suggest the surface of water. Senzaki's works may have an atmosphere that evokes a specific place. He has written:

A puddle appears on an asphalt road after rain. The puddle reflects the scene around it. My feet almost step in it.

Nature, which is exterior to me, seems to breathe quite normally, but, at that very moment, my own nature, which is interior, activates all my senses to grasp this scene as an extraordinary one.

This kind of feeling should always be present during the creation of my art. It's something I really want.[9]

Satoru Kawagoe has also spoken of his desire to achieve an intensity of place in his works. He makes dense, ritualistic configurations that heighten the viewer's percep-

tion of space and introduce a notion of processional time. A 1985 untitled installation in a Tokyo gallery was difficult to grasp as a whole because of its complexity. The gallery was choked with various all-wood elements (some were colored with copper powder and wax) carefully placed as if awaiting use in some unknown ritual. The density demanded time in observation as well as time to move around or through the space, and the viewer became conscious of the artist's time invested in the installation.

In a two-person exhibition in Kichijoji, a Tokyo suburb, in 1988, Kawagoe showed two installations, one suggestive of an altar, the other of an approach to some sacred place. Each element in the installations could be read both as a piece of a tree and as a sculptural object shaped by carving, faceting, and painting. In each work the place of honor was occupied by a segment of a log that, because of its twisted form or its appendages, could be seen as a figure. Kawagoe seems to be mapping out a relationship between art, nature, and humanity. Without abandoning attention to the meaning of his material and while retaining his interest in complex formal arrangements, he has added a portentous atmosphere.

The artists who create a sense of place with their sculptures and installations seem more concerned with sensation than with fact. They invoke emotions and associations, or they call up multiple conceptual or kinesthetic understandings of site, structure, and space.

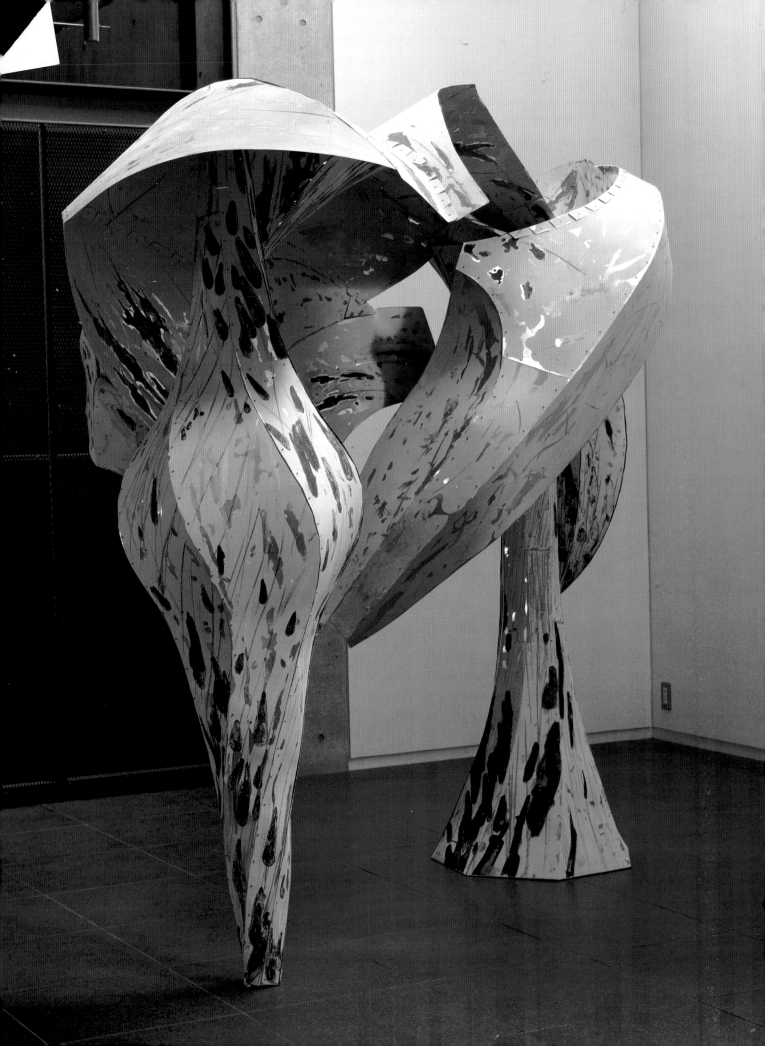

The impermanence of life has been the subject of countless artworks throughout the world. In Japan two-dimensional works such as ink landscapes and flower paintings have dealt with the passage of time more often than traditional sculpture has. But contemporary sculpture is pervaded by an acute sense of flux and change, which plays a part in the installations previously mentioned and in kinetic sculpture, as well as in sculptures that allude to living things. Great numbers of works in Japan involve organic images featuring the processes of growth or decay, a theme favored by young artists. A new work gives evidence that technology such as electronics can also convey themes of duration or sequence.

106 The kinetic sculpture of Aiko Miyawaki seems to express a far-reaching concept of change. In a series called Utsurohi (an archaic aesthetic term, which she translates as "moment of movement"), she uses steel wire, which is either permanently fixed into a concrete or stainless-steel pylon or temporarily laced into a movable cast-iron button that rests on the floor or ground. The shape of the sculpture is never static. Even when the loops of wire are permanently attached to a base, they are not fixed but gently swing or flex in response to the wind, and they may sparkle, gleam, or nearly disappear, depending upon the lighting conditions. The subdued materials are selected for their cool, smooth anonymity. In its sleek perfection, Miyawaki's sculpture is like that of José de Rivera, and in its dynamic grace it resembles George Rickey's kinetic works.

Miyawaki never treats her materials as unique; they are industrial and they are efficiently assembled without any evidence of the artist's hand. Neither does she emphasize the uniqueness of the sculptures; all Utsurohi works adopt the same format, and each one involves formal repetition on a scale that nearly precludes the viewer's encompassing the work as a whole (that is, grasping it as a coherent object or image). The viewer sees one part at a time, has one encounter after another. Movement, anonymous materials, and repetition combine to produce a curious insubstantiality.

105.
Naoyuki Kitta (born 1947)
Work 88-a, 1988
Oxidized aluminum, Conté crayon; 87 × 96¾ × 59 in. (221 × 246 × 150 cm)

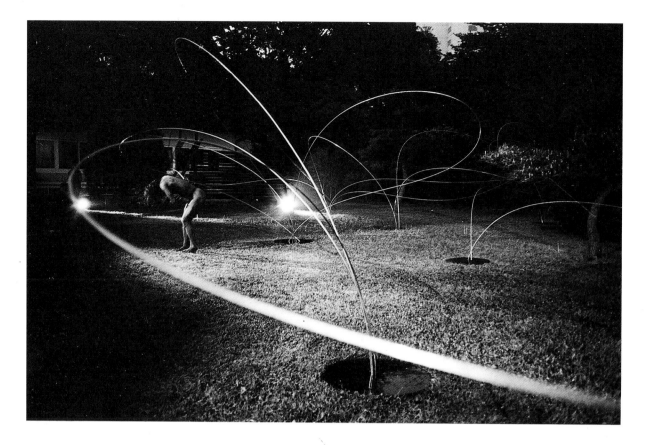

106.
Aiko Miyawaki (born 1929)
Utsurohi, installation at Institut
Franco-Japonais, Tokyo, with
Butoh performance by Min
Tanaka, 1984
Stainless-steel wire and plate

It is apparent that this work is not about material, for material is merely incidental in the flux of existence. In the flow of time, Miyawaki seems to say, sculpture must be seen not as an immutable object but as a temporary confluence of elements. By expressing the insubstantiality of existence, the sculpture demonstrates its own inconsequence in the grand scheme of things. This is precisely the opposite of the Abstract Expressionist idea of the artist as hero. Miyawaki cuts loose from the moorings of ego and specificity and minimizes the ballast of materiality.

More often, sculptors interested in the concept of change express impermanence by using such materials as wood or paper. In addition, forms—made in any material—that refer to animal or vegetable life convey the idea of organic cycles and, by extension, of change through time as well. Movement through space also implies time, and many sculptors have made works that suggest movement. Some of Takeshi Tsuchitani's works seem to represent the movement of wind or the angles and gestures of walking in their resilient curved or flexed shapes. Nobuo Sekine has given a humorous implication of life and movement to some public sculptures by raising blocks of stone on stainless-steel "legs" with flexed "knees." The contrast of bulky body and skinny legs gives these pieces an amusing lightness rare in public sculpture.

105 Naoyuki Kitta makes large aluminum sculptures that seem to speak of life forms such as flowers or shells (with an occasional glimpse of derivative architectural forms, such as shell-structure roofs). In size the sculptures mediate between human and architectural dimensions. He uses industrial methods, notching, scoring, and bending sheets of aluminum and then riveting them. The organic forms—in tension with the cool material and the machine-shop method of assembly—are swelling volumes suggestive of growth and movement, often consisting of flaring shapes with an opening at the top that reveals a dark, mysterious, and seductive interior hollow. This form is reminiscent of a lily (albeit a gargantuan one). The works are fully sculptural, although they offer little sense of mass. They spiral or twist so that no face of the sculpture is inert, and this suggestion of movement is reinforced by blotchy lines of paint or abrasion that echo the overall contours. Surprisingly, Kitta devises these forms by randomly folding paper, and the organic associations that are so powerful in the finished work are adventitious; he thinks of the sculptures simply as abstract forms.

107 Many sculptors use organic materials to deepen the resonance of an organic image. Akira Watanabe has made enormous wooden structures evoking natural phenomena such as surf and winds. He has placed these images-made-tangible on the beach or has put them into the landscape by interlacing his flexible lumber with living trees. Gallery pieces, only slightly smaller, also evoke the movement of such natural phenomena. The works are arrangements of box beams constructed of narrow strips of plywood glued into layers. The method allows the smooth construction of curves and results in a linear reduplication in which dozens

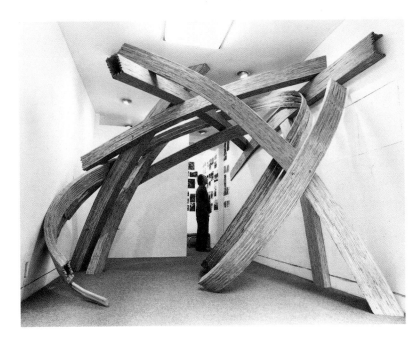

AKIRA WATANABE

I believe that life is movement. Movement can be violent or gentle. Life is not contained only in organisms, but also in the air that surrounds them and everywhere else. I feel from my experience in making work outdoors that every place has a kind of "breath" or atmosphere, and that when making a form in that place it is necessary to change it in response to the place even when the form of the work has already been basically determined. If the maker takes an attitude of resisting change, he kills the spirit of the place. He should not get upset if the ground is more uneven than he expected or trees have become rotten and fallen over and cannot be used, or if otherwise things do not go as he would have wished. He can achieve unexpected effects if he changes his way of working to make a positive response to the spirit of the place. He can experience his imagery becoming richer through the act of making forms in the midst of nature, in forests or meadows, on riverbanks or the seashore.

Akira Watanabe, letter to author, May 1988, trans. Stanley N. Anderson.

107.
Akira Watanabe (born 1947)
Structure 86.10, installation at Kaneko Art Gallery, Tokyo, 1986
Wood; 8 ft. 4⅜ in. × 15 ft. 10⅞ in. × 9 ft. 2¼ in. (2.55 × 4.85 × 2.8 m)

108.
Yasuhiro Takeda (born 1953)
Probably There Will Be a Blue Moon Tonight, 1986
Stained pine; 83½ × 104⅜ × 57⅛ in. (212 × 265 × 145 cm)

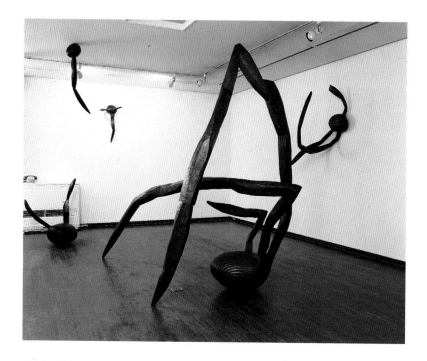

of horizontal lines race along the form, underscoring its sweeping movement. Watanabe plays off spatial limitations in the indoor pieces: some beams butt into others, some taper off where they meet walls, and a few stop with a ragged, seemingly torn-off end. The implication is that the beams do not end at all, but in various ways pass on into another space, in infinite extension, and that what the viewer sees is only a momentary configuration.

Yasuhiro Takeda has shown large abstract wooden works that call to mind both bean sprouts and spiders: the "body" is a flattened sphere textured with parallel rows of gouged lines, the "legs" are made of short sections of roughly sawn wood glued or pegged together to make long, twisting limbs. The work begins with organic inspiration but Takeda leaves representation behind as he becomes engrossed in gouging and staining the surface. The result looks like something in the midst of change: the generative force of a sprouting seed is magnified in works as much as seven feet tall that have a tense, energized presence.

Kosen Otsubo's work has taken varied forms, but most often he focuses on organic growth, using natural materials in unexpected ways. In Tokyo installations of the early 1980s he lined gallery walls with denuded willow saplings—an entire small tree, from branch tips to roots, or a top grafted to a top so that the tree had budding tips growing up and growing down. In neither case was the effect naturalistic, because limbs and roots were bare and exposed. Nature seemed wrenched from its rightful setting of earth and sunlight and subjected to a dissecting scrutiny.

109 In another Otsubo installation, called *Fragile Structure—Uncertain Relation,* his wooden material was not in its natural form but had been processed. This work, which occupied a small gallery at the Hara Museum of Contemporary Art in 1985, was made of disposable chopsticks joined by toothpick dowels. The rickety structure circled the room, and long, skinny chopstick arms reached from the circle to touch the walls and ceiling. The gallery was transformed into a bizarre space of frenzied gesture, the sticks jutting out tensely and the whole looking as if it were surging with an electrical charge.

Gaho Taniguchi is interested in real things, unrefined
110 substances. Her enormous 1987 installation at Tokyo's Spiral Garden exhibition space, titled *Plant Body,* was a wall relief of clay, straw matting, rope, rice, millet, soybeans, urethane, and metal mesh. Randomly distributed slabs of clay were encrusted with seeds and straw. Ropes hung out from the

109.
Kosen Otsubo (born 1939)
Fragile Structure—Uncertain Relation, room and doorway installation at the Hara Museum of Contemporary Art, Tokyo, 1985
Disposable chopsticks, toothpicks, lead, stone; 9 ft. 8 7/8 in. × 13 ft. 8 5/8 in. × 12 ft. 1 5/8 in. (2.97 × 4.18 × 3.7 m)

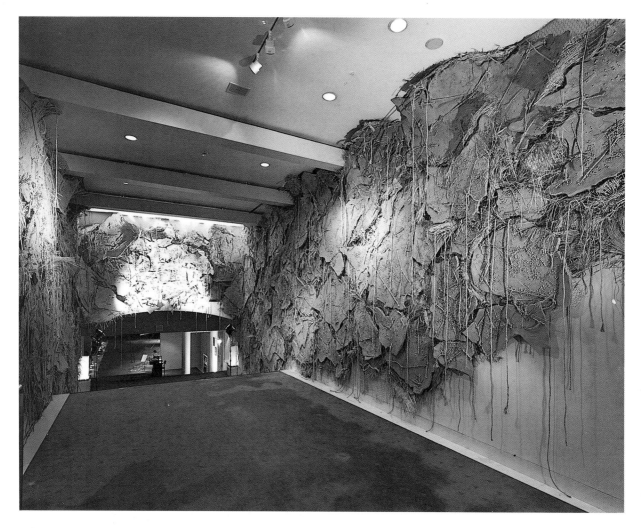

110.
Gaho Taniguchi (born 1944)
Plant Body, installation at Spiral Garden, Wacoal Art Center, Tokyo, 1987
Clay, straw matting, rope, rice, millet, soybeans, urethane, metal mesh; 14 ft. 6¾ in. × 26 ft. 9 in. (4.44 × 8.15 m)

surface aimlessly, like the roots that protrude from an eroded embankment. The installation was thick, crusty, disorderly, fertile. It seemed to symbolically compress the time from the wetness of planting to the dryness of harvest and to allude to the endlessness of such agricultural cycles. Despite the population shift to urban centers, many Japanese still follow the cycles of wet rice planting, which retains a symbolic importance in Japanese culture. Annually, the emperor dons rubber boots and bends in the muck of the paddy to transplant rice seedlings, emblematically petitioning for a successful harvest. Taniguchi draws on such associations, and her raw and chaotic installation transfigured the mundane elements.

Jae-Eun Choi, a Korean artist living in Tokyo, deals with cyclic and infinite time in many of her installations. In 1987 she filled a Ginza gallery with clay. Her installation did not have the impassiveness of Walter De Maria's *Earth Room* (on view since 1977 in a New York gallery, now the Dia Art Center). The point here was change. The clay was installed wet, and during the run of the exhibition it dried and shrank

111

and cracked. She stuck some wads of clay to the wall and as they dried they fell off. A light bulb was hung over a clay hill, parching it as the sun would. Mounds of clay, pushed against the walls like the surges of a flood, were scraped and scarred by the artist's hands and were seemingly pinned down with stalks of green bamboo that reached all the way to the gallery ceiling. She thus identified clay not merely as a responsive artist's material but as nourishment for life. In this work, Choi alluded to various uses of clay by presenting cut and stacked slabs that called to mind both the preparatory stages of pottery and clay-brick architecture. And she did not forget the human clay: a cloth-wrapped "shoot" arising from the clay suggested the human form, and a niche in the gallery was filled with an enormous clay phallus, cracked and about to crumble. The installation was a simple but powerful evocation of place, dim and odorous, a primary experience of primal material.

A Choi installation at Tokyo's Spiral Garden that same year centered on a three-story tree trunk surrounded by a three-lobed dome constructed log-cabin-style of peeled logs in graded sizes. The work was simultaneously garden, forest, building, and an invocation of life cycles. Paths leading into the lobes of the dome were banked with soil in which grass sprouted. The living grass, the once-living

111.
Jae-Eun Choi (born 1953)
Clay installation at Gallery Ueda, Tokyo, 1987
Clay, mixed mediums;
275½ sq. ft. (84 sq. m)

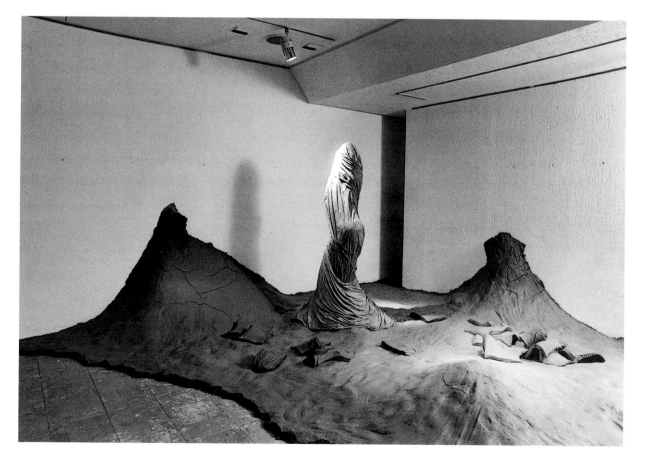

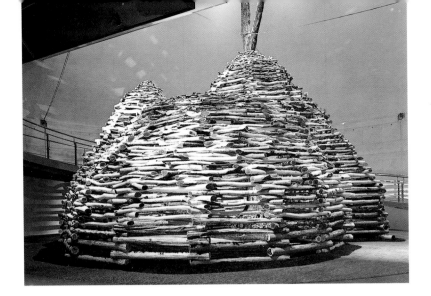

112.
Jae-Eun Choi (born 1953)
Tree, installation at Spiral Garden, Wacoal Art Center, Tokyo, 1987
Wood, soil, grass; 22 ft. 11⅝ in. × 16 ft. 4⅞ in. × 13 ft. 1½ in. (7 × 5 × 4 m)

wood, and the soil from which they emerged and to which they both would return summarized the vegetative life cycle. This work was site specific—its circularity echoed the rotunda in which it was exhibited—but its connotations were universal, presenting a continuum from man-made structure to man-made nature to unfettered nature, each with its own time scale.

Perhaps it is no coincidence that the three artists just cited—Otsubo, Taniguchi, and Choi—have backgrounds in ikebana. Flower arranging, like much contemporary art, employs ephemeral materials, and ikebana has a symbolic language as well as decorative precepts. Because the avant-garde schools of flower arranging encourage both new expression and large scale—Choi, for example, used thirteen tons of soil in the lobby of her ikebana school in her first major exhibition—ikebana blends seamlessly with more internationally common modes of contemporary art.

Hideho Tanaka favors sisal, steel wire, cloth, and fire. He selectively burns portions of nearly all his work, using fire to shape and color it. He also uses fire to suggest destructive force or benign transformation (as in the firing of ceramics). He often creates simple solids such as rectangles or pyramids or even flat sheets out of cloth, sisal, or woven wire (or various combinations of the three), opposing the specificity of the materials to the generality of the forms and burning holes in the cloth or singeing the edges of the solids to invade their geometric austerity.

Some of his most dramatic and memorable works have dealt with change over time. For a large installation at the seaside Hamamatsu Open-Air Exhibition in 1984, he spread rows of cloth on the sand and then burned them. In a 1986 work at the same location he allowed the wind to act as 113 his partner in shaping the artwork. He spread the cloth; the 114 wind spread the sand. During the week that the exhibition was on view, the forces of nature changed Tanaka's sculpture constantly; it could be seen in a certain way only for a moment.

OPPOSITE
113, 114.
Hideho Tanaka (born 1942)
Vanishing (Season to Season) (two views), 1986
Fabric, sand, wind; 65 ft. 7⅜ in. sq. (20 m sq.)

115.
Toshio Matsui (born 1955)
Gray Fire, 1987
Clay; 16½ × 137¾ × 29⅞ in.
(42 × 350 × 76 cm)

The sculptures of Toshio Matsui evoke slow change over time. Made of coarse and crumbling blocks of low-fired clay, his sculptures look like archaeological imprints in the earth made by ancient firepits, burial plots, or boats. *Gray Fire* appears to be the fossilized record of a long-decayed boat. Matsui has seemingly excavated this "earth print" and shows it in the gallery as an object. The inside is a relatively smooth impression of a wooden form; the outside is rough, as if this specimen had been wrenched from the earth.

Matsui's conception owes something to the celebrated series of relief prints by Shoichi Ida called Surface Is the Between, in which Ida treats surface as evidence of a relationship that once existed between a lithographic press and paper or between the earth molds that he digs and shapes in his garden and the paper pulp, twigs, stones, and cloth he arranges in these molds. Ida regards fossils—a record of contact between a surface and an object—as less a matter of space or substance than a marker of occurrence. Similarly, the surfaces of Matsui's work point to a time when a now-vanished object was present.

Matsui has painted some recent, more abstract works a brilliant blue. The uniform color emphasizes form, suppresses texture, and gives an appearance of lighter weight. In some of these newer pieces he has scaled the hand-built form in

115

proportion to his own body and built into the object allusions to the landscape of Italy, where he lived for several years.

Not every sculptural suggestion of change or movement is conveyed with organic materials. Takio Nakamura's medium is Cor-ten steel, and he creates the appearance that at some point the metal has suffered strain and has bent or sagged as a result. He makes installations consisting of box columns that tilt slightly from the vertical, each of which is penetrated diagonally by a solid bar that is twisted and crumpled at its base, presumably from the impact of its penetration of the column. Past movement is visually apparent, and if the rigid sculptures have moved before, it seems they could do so again.

Isao Tanaka makes motorized kinetic sculptures of aluminum, at roughly human scale. He has devised a computer program capable of yielding as many as sixty-four angular, Martha Graham–like poses. The variety keeps the work from being predictable, and the computer gives him control; nothing about the movement is random. Tanaka is programming the multidimensional nature of sculpture into these works. Any fully three-dimensional sculpture requires the viewer to circle it, to observe all its aspects, to remember them, and to combine them into a unified mental image of the whole work. For this reason photographs of sculpture are inevitably inadequate, because they can present only a single, insufficient aspect of an object or installation. Tanaka multiplies this already multiple character. And he enforces the commitment of time that viewing any sculpture requires, for even if one looks at his work from a single viewpoint, there can be sixty-four views of it.

Tatsuo Miyajima is rapidly becoming Japan's best-known young artist using advanced technology. His *Sea of Time,* an expanse of wires and digital counters glowing red from their LED faces, caught the attention of many viewers at the 1988 Venice Biennale's *Aperto* exhibition. The materials are high-tech—Miyajima insists that as a Tokyo native he knows nothing of nature and has been raised on a diet of television and electronics—but his underlying concept is not so very unlike that of his peers using more traditional materials. His works demonstrate change, time, connections.

Earlier works took a variety of forms. Miyajima has exhibited flowers formed out of lights, motors that try to crawl out of the gallery, and pocket TVs that show painterly images. His approach to electronics has been as informal and accessible as Nam June Paik's videos. But only recently has Miyajima explicitly articulated his Buddhistic meanings of constant change (expressed by the flashing numerals on his digital counters) and the interconnection of all things in existence (symbolized by the insulated wires that convey electrical impulses).

116–18.
Isao Tanaka (born 1944)
1·1 √2·64 II (three views), 1988
Aluminum, stainless steel, motor, microcomputer; maximum size: 10 ft. 6 in. × 13 ft. 1½ in. × 14 ft. 1⅜ in. (3.2 × 4 × 4.3 m)

92924 19 183 1847 18 19 18

119.
Tatsuo Miyajima (born 1957)
Counter Line, installation at
Gallery Takagi, Nagoya,
Japan, 1989
Light-emitting diodes, IC, electrical wire, aluminum panel;
4⅜ in. × 16 ft. 4⅞ in. × 1 in.
(.11 × 5 × .02 m)

Tatsuo Miyajima

In my recent work, I use a digital counting machine. This gadget was made on the basis of the following concepts.
 1. *Continuing endlessly*
 2. *Continually changing*
 3. *Forming relationships with all things*
 I built this device to express various images (human beings, time, the world, etc.). I use various settings to send various messages to the viewer.

Movement and Modern Art, trans. Tomoko Matsutani and Stanley N. Anderson (Urawa, Japan: Saitama Museum of Modern Art, 1988), p. 48.

Wakiro Sumi could appear in these pages in the sculpture as relationship chapter because the sensitive formalist nuances of his sculptures call attention to the relationships of parts, or in the sculpture as place chapter because his wax casts have recorded the specific corner of the specific building where they were poured and formed. He can also appear here, in the sculpture as time chapter, because his casts, whether wax, bronze, or plaster, record [120] the passage of time in the process of their making. Bronze casting typically does so: the shaping of the clay is evident in the metal form. But Sumi makes very large, flat expanses of bronze by the lost-wax method, painting layer upon thin layer of wax with a brush. The result is a "field" painting in bronze, with all the surface interest of a painting but without the color. He has also made columns of layered plaster in which the casting process is multiplied. Time is not as central a subject in his work as it is in Miyajima's, but Sumi introduces time by extending the process of creation beyond what would be necessary to achieve the varied surfaces and delicate edges of his sculpture. In Sumi's work, as in repetitive Minimalist painting and as in traditional religious art in Japan, time has a moral value.

Time is also implicit in the work of Kazuo Kenmochi, whose installations create a portentous environment and a strong impression of the communicative power of materials as well. A 1986 installation at Tokyo's Sagacho Exhibit Space [121] centered on a chest-high, serpentine line of piled wood about ninety feet long, rising at one end to about eight feet in height, made of enough lumber to fill five four-ton trucks. Each piece of wood was a scrap from some unspecified

LEFT
120.
Wakiro Sumi (born 1950)
Work M-5: The Opposite Bank,
1986
Bronze; 59⅜ × 110¼ × 59⅜ in.
(151 × 280 × 151 cm)

BELOW
121.
Kazuo Kenmochi (born 1951)
Untitled installation at
Sagacho Exhibit Space,
Tokyo, 1986
Wood, painting on panel; in-
stallation: 11 ft. 1⅞ in. × 18 ft.
4½ in. × 73 ft. 9¾ in. (3.4 ×
5.6 × 22.5 m); paintings: 14 ft.
10 in. × 32 ft. 7⅜ in. (4.52 ×
9.94 m)

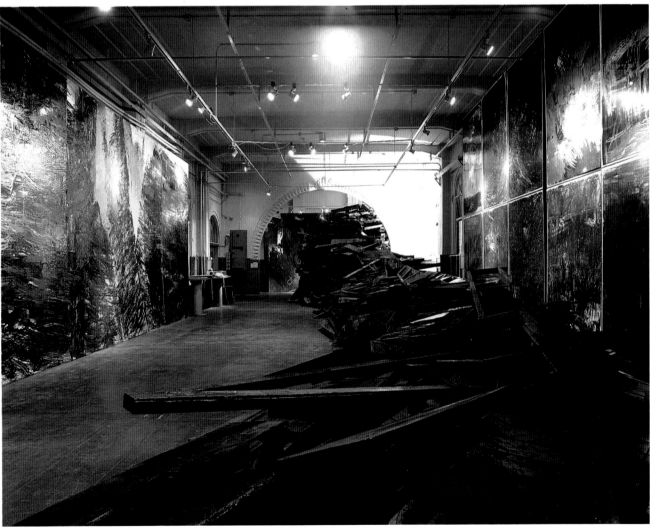

122.
Kazuo Kenmochi (born 1951)
Tail of Earth, Tochigi, installation at Tochigi Prefectural Museum of Fine Arts, Utsunomiya, Japan, 1987
Wood, coal tar, creosote, wire; 52 ft. 5⅞ in. × 13 ft. 1½ in. × 9 ft. 10⅛ in. (16 × 4 × 3 m)

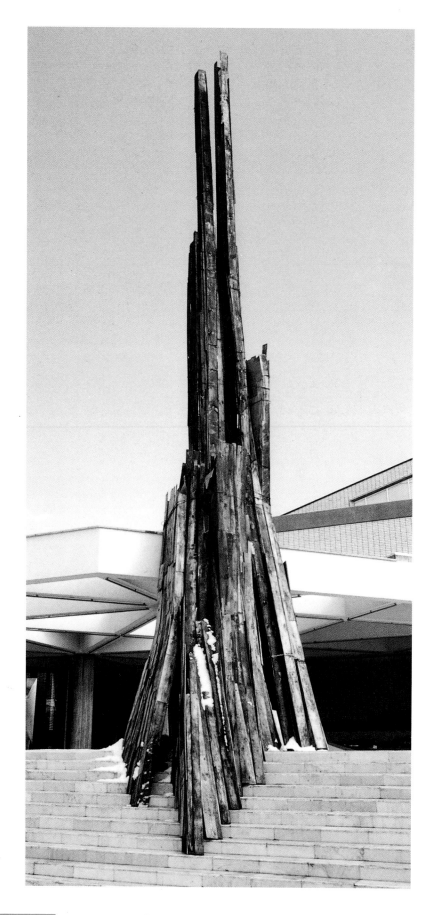

former life, carefully stacked by Kenmochi and splashed with black paint. One expects a scrap pile to look like a scrap pile, but the relative orderliness of this one, compressed into a sinuous line, suggested coercion. These hundreds of elements were contained within an ambiguous space defined by dozens of wall panels, most of them fifteen feet tall. On each panel were huge photographs of Kenmochi's previous installations and performances, barely discernible under ferocious slatherings of black paint. With this gesture, he seemed to cancel out his past.

A 1989 installation, similar in materials and configuration, offered different implications. Kenmochi's methodically laid-out pieces of wood suggested victims of some disaster crowded together in a makeshift morgue. At the same time, the mounded lines of wood faintly alluded to ancient Japanese tumuli. The wood was splashed with creosote. Photographic enlargements mounted on the panels that enclosed the space showed not just Kenmochi's earlier figural sculptures but also everyday tableware. These symbols of quotidian life were threatened by the gloom of dark paint descending over them like a German Expressionist nightfall. They could be read as memorial photographs of the deceased in this funereal installation. Kenmochi's references to the passage of time were further embodied in a similar installation for the exhibition *A Primal Spirit: Ten Contemporary Japanese Sculptors,* in which the semiobscured panels revealed photographs of the 1989 installation that in turn had shown earlier work. This most recent installation set up a kind of fun-house mirror reflecting through time.

Kenmochi has also made a few striking sculptures of more formalist character, also assembled from irregular pieces of dark-stained lumber. A 1987 work sited on a broad bank of stairs at the Tochigi Prefectural Museum in Utsunomiya seemed to take a run up the stairs before leaping to a height of thirty-six feet. A 1988 installation in the entry courtyard of a new Tokyo building by the architect Arata Isozaki achieved an equally sweeping command of the four-story space. Kenmochi piled up black-painted warehouse pallets, creating a sense of climb and aspiration despite the mundane nature of his material.

Even though Japan has no explicit *vanitas* tradition in painting, the Buddhist view of the cycles of existence before nirvana, the Shinto attention to seasonal cycles, and, possibly, the accelerated pace of urban life in Japan today have combined to support a variety of sculptural expressions of the passage of time. Conspicuously absent is the pessimistic emphasis on decay or the horror at lost or vanishing time sometimes seen in the West.

Japan's historical sculpture was figurative, and the Western-style sculpture introduced in the late nineteenth century and continuing in force until World War II was also figurative, yet the majority of contemporary sculpture in Japan is abstract. This situation might be a reaction—an overcompensation—for the former dominance of the figure. On the other hand, even in the West figural sculpture is in the minority today.

In any event, a few Japanese sculptors are doing significant representational work. Michio Fukuoka provides a link to tradition by making small bronze scenes (as well as related work in black plastic) not unlike nineteenth-century sculpture in appearance, although totally dissimilar in subject matter. Recent works include a scene of a man dropping a rock off a cliff to make ripples (this was in an exhibition of self-portraits); a bland box that looks like Minimal art until one notices that the top of the box is a vast sea with a tiny rocky island; and a scene of a man embracing a huge stone.

OPPOSITE
123.
Katsura Funakoshi (born 1951)
Summer Shower, 1985
Polychromed wood, marble; height: 30⅜ in. (77 cm)
Setagaya Art Museum, Tokyo, Japan

124.
Michio Fukuoka (born 1936)
Dig a Hole to Hide Myself-1, 1987
Bronze; 3⅞ × 7½ × 7⅞ in. (10 × 19 × 20 cm)

All Fukuoka's sculptures are slices of some larger reality, whether they are small pictorial bronzes or large polyester landscapes. And all refer, directly or elliptically, to the psychological states of contemporary individuals. Although some landscapes suggest a positive, peaceful solitude, Fukuoka is known for his expressions of loneliness and even a kind of matter-of-fact despair or resignation (perhaps embodying the famous Japanese phrase *shikataganai*, it can't be helped). In *Dig a Hole to Hide Myself,* a seemingly 124 ordinary person has paused to study an excavation that might be presumed to have some optimistic purpose, such as planting a tree, were it not for Fukuoka's painful title. Given the emotional focus of his work, it is surprising that he often makes abstract, scribbly drawings on the pedestals on which his tableaux are shown—an action that seems curiously formalist.

Katsura Funakoshi is the rising star of figural sculptors. He carves busts in wood and insets marble eyes (there is 123 precedent for this in ancient Buddhist portrait sculpture) that give them a disconcertingly lifelike, although impassive, gaze. The interesting tension of Funakoshi's sculptures derives from a lifelike illusion balanced with the artifice of his carving and coloring. The eyes, nose, and forehead of

125.
Takashi Fukai (born 1951)
Dissipating Thoughts, 1986
Camphor wood, gold leaf;
height: 49¼ in. (125 cm)

126.
Susumu Koshimizu (born 1944)
Deucalion's Table, 1983
Wood; 61 × 118⅛ × 54⅜ in.
(155 × 300 × 138 cm)

each figure are finely carved and finished, creating an effect of pale, thin, sensitive skin. But away from this representational core, the artist drops the pretense: the hair is unfinished, chisel marks remain in the clothes and skin, color is dashed on, and the figures are abruptly terminated, most often at the elbows or waist. The figures are stiff and their expressions blank, but the effect is that each sculpture is becoming real, starting with the eyes. Some of the figures have the specificity of real people, an impression that is strongest in Funakoshi's recent life-size full figures, but more often the sculptures are distanced from reality by odd costumes or strange hairstyles and are clearly imaginative or composite constructs.

Takashi Fukai's subject is the human condition, but humans are never seen in his works. He carves columns, wings, apples, books, horses, and furniture as metaphors for desire, knowledge, freedom, aspiration, time, and culture. His carving, in camphor wood, is done with great delicacy, but then he breaks or interrupts each elegant form in some way. The "living" things are often touched with gold leaf to express the preciousness of life. Gold leaf is used in both Western and Japanese traditions, and Fukai, true to the contemporary Japanese experience, draws on both in other ways as well. He may show an Egyptian falcon, a Chinese horse, a European settee, a Japanese pillar. The incompletion of his forms suggests both the ravages of time and a very contemporary sense of irresolution. The works are open and unpredictable.

Susumu Koshimizu, one of the Mono-ha artists, has had a long career with many changes in his work. His recent

125

127.
Toyoko Katsumata (born 1942)
Untitled, 1987
Iron; 5 ft. 2⅞ in. × 18 ft. × 3 ft.
3⅜ in. (1.6 × 5.5 × 1 m)

Deucalion's Table is a wooden table that evolves into a boat. The trestle table itself connects with the Mono-ha idea that sculpture begins with real things and daily life, but Koshimizu departed as early as 1971 from the Mono-ha idea that things should just be "brought together." He carves and constructs his work, and also adopts suggestive images that are beyond the Mono-ha pale. His table series is intended to make pedestals unnecessary by incorporating a base into the work; he chose the table because, seen as a work table, it seemed to incorporate the conceptual preliminaries into the end product. This work refers through its title to Greek mythology, and its form can allude to Japan's history as a seafaring nation. But here, and in other works such as *Working Table—Waterway* (1983), in which a circular trench is carved into the top of a square table and filled with water, he also demonstrates an interest in elusive, open metaphor. 126

Toyoko Katsumata presents pictorial images in surprising ways, half-drawing and half-sculpture. On a plane of iron, a fragment of a figure in action—running or swimming, for example—is incised in the metal. But at some point, incision is replaced by relief, and the figure bulges into the third dimension. And in every case, the figure extends beyond the boundaries of the plane. One might think of Michelangelo's figures that seek to be released from stone, for Katsumata's headless and anonymous figures seem to be fleeing from the iron. Her sculptures of this type include three-dimensional metal tree branches that mediate between the iron plane and the surrounding space. Other recent works have been welded of cut planes and rods of metal, depicting body parts of some gargantuan figure. 127

The most recent works by Hisao Suzuki are sculptural references to architecture. Since 1982 he has used stone, Cor-ten steel, wood, or combinations of those materials to

make fortresslike walls. Some look like the dry-stone walls of the moated embankments on which Japanese castles were built, but the recent ones using Cor-ten blocks are more akin to brick-and-iron European factories in appearance, complete with Romanesque arches. Suzuki emphasizes the contrasts between materials in his sculptures; he accentuates the sense of the sculpture's weight when he suspends the "building" within a steel cube frame; and he exploits the drama of tension when he binds stones together with wire or when a slab of Cor-ten breaks out of masses of stones. But his primary emphasis is the equivocal reality of his miniaturized image.

Hiroshi Kamo has made objects of wood depicting recognizable things (a boat, a piano) that spill from reality

128.
Hisao Suzuki (born 1946)
Single Surface Body, 1986
Cor-ten steel; 70⅞ × 47¼ × 31½ in. (180 × 120 × 80 cm)

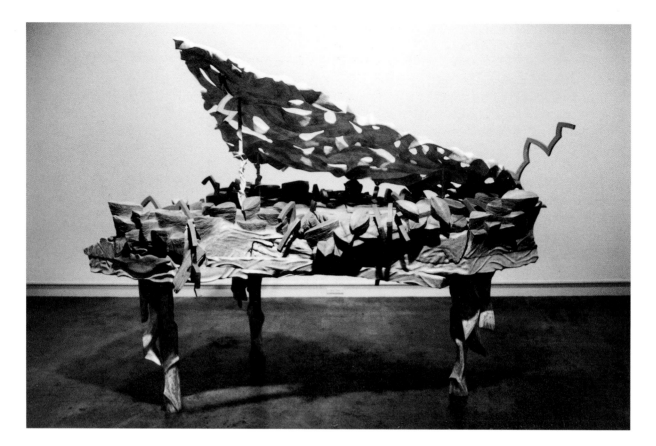

129.
Hiroshi Kamo (born 1955)
*Serenade (Theme and Varia-
tions)*, 1985
Wood, plaster, acrylic; 55⅛ ×
55⅛ × 78⅝ in. (140 × 140 ×
200 cm)

into lush, Henri Rousseau–like fantasy. In *Serenade,* the piano 129 is overgrown with leaves and other debris. It seems as though the sounds have turned into solid objects spilling out of the case. The lid, a baroque net of looping curves, seems to throb rhythmically. Or perhaps the piano is both a functional instrument and a living thing, with vine strings and leaf sounds. The sculpture is representational, yet transcends to a heightened world of imagination.

Kamo has been moving away from representation. Several large works made in 1988 refer to the figure or to landscape nonspecifically and can be read more than one way. Michiko Yano has been moving in the same direction. Her earlier works were half-painting, half-sculpture tableaux, often suggesting tropical settings. Her subsequent mixed-medium shaped drawings use suns, feathers, masks, and other imagery that could come from a great many cultures of the past. Yano's 1988 exhibition of reliefs and small 130, 131 pedestal or tabletop sculptures made of wood, plaster, and paint revealed that she was moving toward universals. All works in the exhibition seemed familiar yet unidentifiable— a leaf? a crankshaft? a pineapple? a basket? These small sculptures exude a sense of utter calm and rightness, unaggressive assurance, and comfort. But they are easy only if one asks no questions, baffling if one tries to impose an identity on them because any single characterization

seems inadequate. Yano has looked beyond the motifs of her own culture to devise modest pan-cultural objects open to interpretation. They may be fragments or wholes, from here or anywhere.

Fusako Tsuzuki has constructed life-size or larger-than-life-size animals, using branches of trees cut, bolted together, and sometimes painted, but not otherwise altered. Her works have a primitive vitality, and their large scale, appearance of weight, and bristly rigidity give them an intimidating presence. They recall the huge mud-and-stick horses by the American artist Deborah Butterfield, but Tsuzuki's animals differ in not suggesting psychological conditions. However, a recent group of works calls up fears of nuclear war. In 1988 Tsuzuki showed what were titled *Dogs of the Next World,* along with lead-encased plants and a human figure called *The Watchman.* Another exhibition featured a *Nuclear Rat* with a coffin-shaped body.

Two other artists who work with pictorial notions are Yusei Ogino and Makoto Okumura. Ogino creates an image of avian movement by constructing, in solid wood, a single wing and coloring it with tropical hues and glitter, as if he believes that the memory of the natural is preserved in the blatantly artificial. Okumura arranges real objects—desks, books, storage cases—in tableaux of violence and deterioration, attacking notions of convention and propriety and order, especially in regard to education in Japan. He takes objects from life as the Mono-ha artists did but uses them to tell a story.

Takako Araki makes ceramic sculptures that have the same ambiguous sculpture/craft status as recent ceramic work in the United States and Europe. Her works are three-dimensional yet not spatially interactive. Araki has been working for several years on a Bible series, depicting the book in various states of decay. Often the Bibles rest on a thick plinth: some works show loose pages, others are surreal semblances of loaves of bread or stones with pages. Despite their three-dimensionality, these works are essentially pictorial, presenting an image of an object rather than a composition in space. Because they are solid and small, they can be comprehended at a glance.

Takushi Aono's installations titled Line-Space appear at first glance to be rows of heavy threads stretched taut between wall and floor. But each straight line suddenly changes into an eccentric twisted path near its upper end. These, then, are not actually threads under tension but are images constructed of thread and wire depicting a jagged, lightninglike electric tension near the wall in contrast to the straight tension of stretching near the floor. Aono earlier dealt with natural examples of line moving in space. In a work called *Surface-Space* (1981), for example, he leaned

130.
Michiko Yano (born 1956)
No Title, 1987
Wood, plaster, paint; 46½ × 13 × 7⅛ in. (118 × 33 × 18 cm)

155

131.
Michiko Yano (born 1956)
No Title, 1987
Wood, plaster, paint; 18⅞ ×
16½ × 11⅜ in. (48 × 42 ×
29 cm)

132.
Yusei Ogino (born 1952)
The Spatial Wings, 1987
Wood, acrylic, polyester resin;
pink: 66⅞ × 70⅞ × 59 in.
(170 × 180 × 150 cm), yellow:
23⅝ × 31½ × 23⅝ in. (60 ×
80 × 60 cm), blue: 39⅜ ×
82⅝ × 47¼ in. (100 × 210 ×
120 cm), green: 13¾ × 31½ ×
19⅝ in. (35 × 80 × 50 cm)

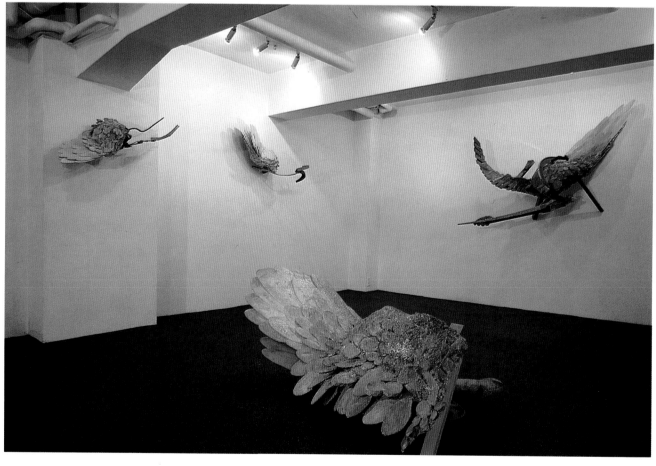

133.
Takako Araki (born 1921)
Degeneration Bible, 1984
Ceramic, silkscreen; 5½ ×
18¼ × 15⅞ in. (14 × 46.3 ×
40.5 cm)

134.
Makoto Okumura (born 1949)
Venus, 1986
Mixed mediums

135.
Takushi Aono (born 1951)
Line-Space '83, 1983
Yarn, steel wire; 8 ft. 2⅜ in. ×
26 ft. 3 in. × 16 ft. 4⅞ in.
(2.5 × 8 × 5 m)

against the wall of a gallery a slender sapling partly wrapped with thread and another that was unwrapped. The difference between the surfaces highlighted the irregular movement of the saplings' forms as lines in space.

Hideho Takasu makes sculptures that are curiously pictorial though not at all representational. He fashions narrow, elongated, usually vertical objects, often with curving edges or facets, and then presses tiny colored stones into the surfaces. These sculptures send a message of tenuousness and intangibility: they lean backward, their surface pattern of pebbles is random and impersonal. Their appearance suggests geologic strata, but they deny weight and solidity and discourage touch. They seem to be less sculptures (objects made of palpable materials) than slices of vision (images expressing the impalpable appearance of materials).

A considerable segment of contemporary painting in Japan eschews illusion and treats the canvas as an object. It is interesting to consider the contrast presented by sculptures that variously suppress or confuse their materiality by toying with illusions and focusing on appearances rather than on substances. Consistent with Japanese preferences, however, even these images are ambiguous and elliptical.

NOTES

INTRODUCTION (PAGES 7–17)

1. Kathy Halbreich, Shinji Kohmoto, Fumio Nanjo, and Thomas Sokolowski, *Against Nature: Japanese Art in the Eighties* (New York: Grey Art Gallery, New York University; Cambridge, Mass.: List Center for the Visual Arts, MIT; Tokyo: Japan Foundation, 1989); and Howard N. Fox, *A Primal Spirit: Ten Contemporary Japanese Sculptors* (Los Angeles: Los Angeles County Museum of Art, 1990).
2. William S. Lieberman, "Introduction," *The New Japanese Painting and Sculpture* (New York: Museum of Modern Art, 1966), p. 9. Lieberman wrote, "Sculpture has not been as swift as painting to realize Western goals"—a comment that twists back on itself when we realize that the sculpture became interesting only when it ceased pursuing Western goals.
3. See Kazuaki Tanahashi, *Enku: Sculptor of a Hundred Thousand Buddhas* (Boulder, Colo.: Shambhala Publications, 1982).
4. For a history of early Western-style painting in Japan, see Shuji Takashina and J. Thomas Rimer with Gerald D. Bolas, *Paris in Japan: The Japanese Encounter with European Painting* (Saint Louis: Washington University Gallery of Art, 1987).
5. For more information on the Japanese art world, see Janet Koplos, "Through the Looking Glass: A Guide to Japan's Contemporary Art World," *Art in America* 77 (July 1989): 98–107ff.

1. CONTEXT (PAGES 19–33)

1. Stuart D. B. Picken, *Buddhism: Japan's Cultural Identity* (Tokyo: Kodansha International, 1982), p. 41.
2. Ibid., p. 9.
3. Sir George Sansom, in Robert Treat Paine and Alexander Soper, *The Pelican History of Art: The Art and Architecture of Japan* (1955; Harmondsworth, England: Penguin, 1975), p. 24.
4. Stuart D. B. Picken, *Shinto: Japan's Spiritual Roots* (Tokyo: Kodansha International, 1980), p. 11.
5. Lafcadio Hearn, *Gleanings in Buddha-Fields: Studies of Hand and Soul in the Far East* (1897; Tokyo: Charles E. Tuttle, 1971), p. 62.
6. Stuart D. B. Picken, *The Role of Traditional Values in Contemporary Japanese Society*, Discussion Paper 4 (Stirling, Scotland: Centre for Japanese Studies, University of Stirling, 1984), p. 7.
7. Daisetz T. Suzuki, *Zen and Japanese Culture* (1959; Princeton, N.J.: Princeton University Press, Bollingen Series 64, 1970), pp. 359, 360.
8. Robert K. Heinemann, in Heinz Bechert and Richard Gombrich, eds., *The World of Buddhism: Buddhist Monks and Nuns in Society and Culture* (London: Thames and Hudson, 1984), p. 120.
9. Ibid., p. 227.
10. Paine and Soper, *Art and Architecture of Japan*, p. 424.
11. Ralph Adams Cram, *Impressions of Japanese Architecture and the Allied Arts* (1905; Tokyo: Charles E. Tuttle, 1981), pp. 75–76, 127.
12. Yoshinobu Ashihara, *Exterior Design in Architecture* (New York: Van Nostrand Reinhold, 1970), p. 31; the same point is made by Teiji Itoh, *The Roots of Japanese Architecture: A Photographic Quest by Yukio Futagawa* (Tokyo: Bijutsu Shuppan-sha, 1963), p. 143. Further, Mitsuo Inoue has described an early stage in the development of Japanese architecture when the pillar dominates the space around it and gives that space a new order; see Mitsuo Inoue, *Space in Japanese Architecture*, trans. Hiroshi Watanabe (Tokyo: John Weatherhill, 1985), pp. 7ff, 45, 48.
13. Inoue, *Space*, pp. 137ff.
14. Ibid., p. 136.
15. Kenzo Tange, in Robin Boyd, *Kenzo Tange* (New York: George Braziller, 1962), p. 13.
16. Isamu Noguchi, *Isamu Noguchi: A Sculptor's World* (New York: Harper and Row, 1968), p. 161.
17. Alan Watts, "Zen and the Arts: Haiku," in Nancy Wilson Ross, ed., *The World of Zen: An East-West Anthology* (London: Collins, 1962), p. 127.
18. Kakuzo Okakura, *The Ideals of the East* (1904; Tokyo: Charles E. Tuttle, 1970), p. 128.
19. Noguchi, *World*, pp. 16–17.
20. Ibid., p. 21.
21. Cram, *Impressions*, pp. 76–77.
22. Noguchi, *World*, p. 17.

2. PRECURSORS (PAGES 35–47)

1. Yoshihara was exhibiting geometric abstract paintings by the early 1940s. In his late paintings, for which he is best known, a single very irregular circle often splashes through a solid ground, as if completed in one stroke of a giant calligraphy brush, often in white on black. Other shapes—two horizontal strokes, a swarm of com-

mas—are also seen. In the 1950s he was applying shadowy calligraphic figures on grounds freely brushed in the Informel style.

2. Jiro Yoshihara, "A Declaration on Gutai Art," 1956; reprinted in *Grupo Gutai* (Madrid: Museo Español de Arte Contemporaneo, 1985), p. 12.
3. Shigeo Chiba, "Study of Yoshishige Saito: The Historical and Contemporary Value of Re-construction," in *Saito Yoshishige: Exhibition 1978* (Tokyo: National Museum of Modern Art, 1978), p. 26.
4. Saito, referring to his work of the 1980s, in *Saito Yoshishige: Exhibition 1984* (Tokyo: Tokyo Metropolitan Art Museum, 1984), text in Japanese.
5. Shigeo Chiba, "Yoshishige Saito," in Norio Ito, Fumio Nanjo, and Kunio Yaguchi, eds., *Art in Japan Today II* (Tokyo: Japan Foundation, 1984), p. 144.
6. Kishio Suga, conversation with author, Tokyo, July 8, 1987.
7. Nobuo Sekine, *Half-Autobiography* (Tokyo: Parco, 1985), text in Japanese, n.p.

8. Toshiaki Minemura has discussed the origins of Mono-ha work in *Mono-ha* (Tokyo: Kamakura Gallery, 1986); *Art in Japan since 1969: Mono-ha and Post-Mono-ha* (Tokyo: Seibu Museum of Art and Tama Art University, 1987); and "A Blast of Nationalism in the Seventies," in *Art in Japan Today II*.
9. U-Fan Lee, in Minemura, "Nationalism," p. 17.
10. Stuart D. B. Picken, *Shinto: Japan's Spiritual Roots* (Tokyo: Kodansha International, 1980), p. 60.
11. U-Fan Lee, *Lee U-Fan*, trans. Jean Campignon, assisted by Adam Fulford (Tokyo: Bijutsu Shuppan-sha, 1986), p. 158.
12. Sekine, *Half-Autobiography*, n.p.
13. Ibid.
14. Nobuo Sekine, in Makoto Ueda, ed., *Nobuo Sekine, 1968–1978* (Tokyo: Julia Pempel Atelier, 1978), unpaged.
15. Minemura, "Nationalism," p. 18.
16. Shigeo Chiba, "Modern Art from a Japanese Viewpoint," *Artforum* 23 (October 1984): 56–61.
17. Suga, conversation with author.

3. SCULPTURE AS MATERIAL (PAGES 49–65)

1. *East-West Forum: Japanese-Dutch Sculptors Symposium 1984* (Gorinchem, the Netherlands: Mandarin, 1984), p. 31.
2. Chuichi Fujii, in exhibition catalog for Carpenter + Hochman, New York, 1985; reprinted in *Fujii Chuichi 1980–85* (Tokyo: Gallery Ueda Warehouse, 1985), unpaged.
3. Ibid.
4. Sekijima, in Janet Koplos, "A Long Way Back to Tradition," *Asahi Evening News*, May 29, 1986.

5. Genpei Akasegawa, "The 1960s: The Art Which Destroyed Itself: An Intimate Account," in David Elliott and Kazu Kaido, eds., *Reconstructions: Avant-Garde Art in Japan, 1945–1965* (Oxford: Museum of Modern Art, 1985), p. 87.
6. Yoshiaki Tono, "Ushio Shinohara: Past and Present," in Rand Castile and Yoshiaki Tono, *Ushio Shinohara* (New York: Japan Society, 1982), pp. 9–10.
7. Minemura, *Mono-ha*, unpaged.

4. SCULPTURE AS RELATIONSHIP (PAGES 67–101)

1. U-Fan Lee, *Lee U-fan*, trans. Jean Campignon, assisted by Adam Fulford (Tokyo: Bijutsu Shuppan-sha, 1986), p. 156.
2. Ibid., p. 134.
3. Tatsuo Kawaguchi, conversation with author, Tokyo, July 9, 1987.
4. Ibid.
5. Yusuke Nakahara, *Tatsuo Kawaguchi: Blue* (Tokyo: Gatodo Gallery, 1984), text in Japanese, unpaged.
6. Makoto Ueda, ed., *Nobuo Sekine, 1968–1978* (Tokyo: Julia Pempel Atelier, 1978), unpaged.
7. Nobuo Sekine, conversation with author, Tokyo, July 7, 1987.

8. Tamotsu Shiihara, artist's statement, in *Environment and Sculpture* (Otsu City, Japan: Shiga Museum of Modern Art, 1984), pp. 26–27.
9. Yoshio Kitayama, conversation with author, Kyoto, Japan, July 22, 1987.
10. Robert Morris treated the subject of what sculpture should be, from a Minimalist viewpoint, in a series of essays in *Artforum*. The most relevant are probably "Notes on Sculpture, Part II," October 1966, pp. 20–23; "Notes on Sculpture, Part III: Notes and Nonsequiturs," Summer 1967, pp. 24–29; and "Notes on Sculpture, Part 4: Beyond Objects," April 1969, pp. 50–54.

5. SCULPTURE AS PLACE (PAGES 103–31)

1. Shigeo Toya, in Toshiaki Minemura, "Leaving Woods to Create 'Woods,'" in *Toya Shigeo, 1984–1987* (Tokyo: Satani Gallery, 1987), pp. 9–10.
2. Shigeo Toya, conversation with author, Los Angeles, June 17, 1990.
3. Nishina, telephone conversation with author, December 5, 1990.
4. Bukichi Inoue, *Bukichi Inoue: My Sky Hole '87: Way-Universe* (Tsu City, Japan: Mie Prefectural Art Museum, 1987), p. 7.
5. Kazue Kobata, "Kitakyushu: International Iron Sculpture Symposium," *Artforum* 26 (March 1988): 156.
6. Makoto Ueda, *Japanese Houses in Ferroconcrete* (Tokyo: Graphic-sha, 1988), p. 184.

7. Yuri Akita, "Noboru Takayama: Crossing of Railroad Ties and 'Mono-ha,'" in Noboru Takayama, *Noboru Takayama 1968–1988* (Tokyo: Gallery 21 + YO, 1988), p. 10. Yuri Akita, "Crossing Forms," in *Headless Scenery—Sunrise Sunset* (Tokyo: Akiyama Gallery, 1986), unpaged.
8. Toshiaki Minemura, "A Blast of Nationalism in the Seventies," in *Art in Japan Today II* (Tokyo: Japan Foundation, 1984), p. 19; see also Toshiaki Minemura, "Kishio Suga—Foundation of His Art," in Kishio Suga, *Kishio Suga, 1988–1968* (Tokyo: Self-published, 1988), pp. 196–201.
9. Chieo Senzaki, in Emiko Namikawa et al. *Continuum '85: Aspects of Japanese Art Today* (Melbourne: Australian Centre for Contemporary Art, 1985), p. 70.

SELECTED BIBLIOGRAPHY

This bibliography includes only English-language sources.

GENERAL

Against Nature: Japanese Art in the Eighties. Forewords and roundtable discussion by Kathy Halbreich, Thomas Sokolowski, Shinji Kohmoto, and Fumio Nanjo; essays by Shuhei Hosokawa and Eikou Ikui. New York: Grey Art Gallery, New York University; Cambridge, Mass.: List Center for the Visual Arts, MIT; Tokyo: Japan Foundation, 1989. Includes Katsura Funakoshi, Tatsuo Miyajima, Yusei Ogino.

Bell, Jane. "Eight Artists: Common Search." *Artnews* 80 (September 1981). Includes Aiko Miyawaki, Yoshishige Saito, Kishio Suga.

Chiba, Shigeo, et al. *Sculpture japonais contemporain.* Paris: Galerie Jullien-Cornic, 1985. Includes Michio Fukuoka, Noriyuki Haraguchi, Tadashi Kawamata, Aiko Miyawaki, Nobuo Sekine.

De Vree, Freddy, and Toshiaki Minemura. *Europalia '89: Japan in Belgium.* Middelheim, Belgium: Openluchtmuseum voor Beeldhouwkunst, 1989. Includes Noe Aoki, Toshikatsu Endo, Group Q, Susumu Koshimizu, U-Fan Lee, Nobuo Sekine, Kishio Suga, Shigeo Toya.

Environment and Sculpture. Otsu City, Japan: Shiga Museum of Modern Art, 1984. Includes Shiro Hayami, Kazuo Kenmochi, Tamotsu Shiihara, Koji Tsuji.

Fox, Howard N. *A Primal Spirit: Ten Contemporary Japanese Sculptors.* Los Angeles: Los Angeles County Museum of Art, 1990. Includes Koichi Ebizuka, Toshikatsu Endo, Chuichi Fujii, Tadashi Kawamata, Kazuo Kenmochi, Takamasa Kuniyasu, Shigeo Toya, Isamu Wakabayashi.

Frank, Peter. "Sculpture at the Venice Biennale." *Sculpture* 8 (January–February 1989). Includes Katsura Funakoshi, Shigeo Toya, Keiji Uematsu.

Heartney, Eleanor. "Mixed Messages." *Art in America* 78 (April 1990). Includes Katsura Funakoshi, Tatsuo Miyajima, Yusei Ogino.

Ichikawa, Masanori, Kunio Motoe, et al. *Metaphor and/or Symbol—A Perspective on Contemporary Art.* Tokyo: National Museum of Modern Art, 1984. Includes Toshikatsu Endo, Susumu Koshimizu, Tamotsu Shiihara.

Ito, Norio, Fumio Nanjo, and Kunio Yaguchi, eds. *Art in Japan Today II.* Tokyo: Japan Foundation, 1984. Includes Michio Fukuoka, Noriyuki Haraguchi, Kosho Ito, Tatsuo Kawaguchi, Tadashi Kawamata, Susumu Koshimizu, U-Fan Lee, Hisayuki Mogami, Yoshishige Saito, Nobuo Sekine, Satoru Shoji, Ushio Shinohara, Kishio Suga, Shigeo Toya, Takeshi Tsuchitani, Isamu Wakabayashi.

Koplos, Janet. "Stubborn Specificity." *Asahi Evening News,* June 20, 1986. Includes Takushi Aono, Akio Hamatani, Tatsuo Kawaguchi, Satoru Shoji, Keiji Uematsu, Masao Yoshimura.

————. "All Things to All People." *Asahi Evening News,* November 21, 1986. Includes Group Q, Kazuo Kenmochi, Takeshi Tsuchitani.

————. "Sculpture: The Premier Contemporary Art." *Winds* (Tokyo) 9 (March 1988). Includes Katsura Funakoshi, Tadashi Kawamata, Naomi Kikutani, Yoshio Kitayama, Atsuo Okamoto, Yoshishige Saito, Nobuo Sekine, Kishio Suga, Keiji Uematsu, Keiko Yamada.

————. "Mono-ha." *Sculpture* 7 (March–April 1988). Includes Noriyuki Haraguchi, Susumu Koshimizu, U-Fan Lee, Nobuo Sekine, Kishio Suga, Noboru Takayama.

————. "Mono-ha and the Power of Materials." *New Art Examiner,* June 1988. Includes Takashi Fukai, Katsura Funakoshi, Tadashi Kawamata, Naomi Kikutani, Yoshio Kitayama, Naoyuki Kitta, Atsuo Okamoto, Kishio Suga, Keiko Yamada.

————. "Enku's Heirs." *Asahi Evening News,* August 19, 1988. Includes Katsura Funakoshi, Shigeo Toya, Keiji Uematsu.

————. "Japan's Contemporary Arts." *Sumitomo Corporation News* (Tokyo) 72 (January 1989). Includes Tadashi Kawamata, Takamasa Kuniyasu, Tatsuo Miyajima, Keiko Yamada.

————. "Letter from Tokyo." *Arts Magazine* 63 (February 1989). Includes Koichi Ebizuka, Osamu Kushida, Nobuo Sekine, Kishio Suga, Michiko Yano.

————. "The Many Forms of Fiber." *Sculpture* 8 (May–June 1989). Includes Katsuhiro Fujimura, Akio Hamatani, Hideho Tanaka, Keiji Uematsu.

————. "Letter from Tokyo." *Arts Magazine* 64 (September 1989). Includes Chuichi Fujii, Akira Kamiyama, Takamasa Kuniyasu, Saburo Muraoka, Isamu Wakabayashi.

————. "West Meets East: Contemporary Japanese Art." *Reflex* (Seattle) 4 (March–April 1990). Includes Chuichi Fujii, Katsura Funakoshi, Takamasa Kuniyasu, Tatsuo Miyajima, Yusei Ogino.

————. "The Two-Fold Path: Contemporary Art in Japan." *Art in America* 78 (April 1990). Includes Tatsuo Kawaguchi, Tadashi Kawamata, U-Fan Lee, Yoshishige Saito, Nobuo Sekine, Ushio Shinohara, Kishio Suga.

Miki, Tamon. *The 1960s—A Decade of Change in Japanese Art.* Tokyo: National Museum of Modern Art, 1981. Includes Tatsuo Kawaguchi, Hisayuki Mogami, Aiko Miyawaki, Saburo Muraoka, Yoshishige Saito, Nobuo Sekine, Ushio Shinohara, Kazuo Shiraga, Isamu Wakabayashi.

Minemura, Toshiaki. "From 'Sculpturoid' to Sculpture." In *East-West Forum: Japanese-Dutch Sculptors Symposium.* Gorincheim, the Netherlands: Mandarin, 1984. Essay includes Michio Fukuoka, Tadashi Kawamata, Yoshio Kitayama, Susumu Koshimizu, U-Fan Lee, Yoshishige Saito, Nobuo Sekine, Satoru Shoji, Kishio Suga.

————. *Mono-ha.* Tokyo: Kamakura Gallery, 1986. Includes Noriyuki Haraguchi, Susumu Koshimizu, U-Fan Lee, Nobuo Sekine, Kishio Suga, Noboru Takayama.

————, ed. *Art in Japan since 1969: Mono-ha and Post-Mono-ha.* Tokyo: Seibu Museum of Art and Tama Art University, 1987. Includes Takashi Fukai, Tadashi Kawamata, U-Fan Lee, Nobuo Sekine, Kishio Suga, Shigeo Toya.

Movement and Modern Art. Urawa, Japan: Saitama Museum of Modern Art, 1988. Includes Tatsuo Miyajima, Atsuo Okamoto, Yoichi Takada, Isao Tanaka.

Nakamura, Hideki. *24th Artists Today Exhibition.* Yokohama,

Japan: Yokohama Citizens Gallery, 1988. Includes Takamasa Kuniyasu, Hisayuki Mogami, Takeshi Tsuchitani, Keiko Yamada.

Namikawa, Emiko, et al. *Continuum '85: Aspects of Japanese Art Today.* Melbourne: Australian Centre for Contemporary Art, 1985. Includes Toshikatsu Endo, Kazuo Kenmochi, Chieo Senzaki, Ushio Shinohara, Shigeo Toya.

Otoba, Satoshi, et al. *Forty Years of Japanese Contemporary Art.* Tokyo: Tokyo Metropolitan Art Museum, 1985. Includes Tatsuo Kawaguchi, U-Fan Lee, Kishio Suga.

Takashina, Shuji, Yoshiaki Tono, and Yusuke Nakahara, eds. *Art in Japan Today I.* Tokyo: Japan Foundation, 1974. Includes Michio Fukuoka, Bukichi Inoue, Tatsuo Kawaguchi, Susumu Koshimizu, Aiko Miyawaki, Hisayuki Mogami, Yoshishige Saito, Nobuo Sekine, Ushio Shinohara.

Takeshi, Hanazawa. "For the Opening of Hara Annual V." In *Hara Annual V.* Tokyo: Hara Museum of Contemporary Art, 1985. Includes Katsuhiro Fujimura, Takashi Fukai, Kosen Otsubo, Hideho Tanaka, Fusako Tsuzuki.

Tono, Yoshiaki. *Artists' Books: Japan.* New York: Franklin Furnace; Tokyo: Fuji Television Gallery, 1985. Includes Koichi Ebizuka, U-Fan Lee, Isamu Wakabayashi.

Uchiyama, Takeo, and Keinosuke Murata. *Fabric and Threads in the Contemporary Art Scene.* Tokyo: Spiral Garden, Wacoal Art Center, 1986. Includes Takushi Aono, Akio Hamatani, Tatsuo Kawaguchi, Satoru Shoji, Hideho Tanaka.

Yasunaga, Koichi. *2d Asian Art Biennale, Bangladesh, 1983: Japan.* Tokyo: Japan Foundation, 1983. Includes Yoshio Kitayama, Shigeo Toya, Michiko Yano.

TOMOAKI AJIKI

Koplos, Janet. "Speaking Acquaintance." *Asahi Evening News,* September 20, 1985.

Myerscough, Marie. "Artistry in Bamboo." *Andon* (Tokyo) 7 (Autumn 1982).

NOE AOKI

Koplos, Janet. "Analyzing the Annual." *Asahi Evening News,* April 25, 1986.

———. "Arts." *Asahi Evening News,* June 24, 1988.

———. "Groups and Individuals." *Asahi Evening News,* September 2, 1988.

Minemura, Toshiaki. "Homage to Joseph Beuys." In *Hara Annual VI.* Tokyo: Hara Museum of Contemporary Art, 1986.

Tani, Arata. "The Existence Crisis of Sculpture Apocalypsed." In *Noe Aoki.* Tokyo: Gallery AlphaM, 1988.

TAKUSHI AONO

Lamarova, Milena. "Textile Sculpture: The 12th International Biennial of Tapestry." *American Craft* 45 (October–November 1985).

Sculpture Textile, 12th International Biennial of Tapestry. Lausanne, Switzerland: Musée Cantonal des Beaux-Arts, 1985.

TAKAKO ARAKI

International Ceramic Symposium USA '85. Cookeville: Tennessee Technological University, 1985.

Japanese Ceramics Today—Masterworks from the Kikuchi Collection. Washington, D.C.: Smithsonian Institution, 1983.

Klinge, Ekkart. *Araki Takako.* Osaka, Japan: Gallery Kasahara, 1986.

Kuchta, Ronald. "Araki Versus the Romantic Spirit." In *Takako Araki: Recent Work.* Syracuse, N.Y.: Everson Museum of Art, 1989.

Levy, Mark. "Takako Araki." *American Ceramics* 2, no. 4, 1984.

Schnyder, Rudolf. "Bibles Made of Clay." In *Takako Araki: Recent Work.* Syracuse, N.Y.: Everson Museum of Art, 1989.

Smith, Tobi, et al. *Pacific Connections.* Los Angeles: Institute of Contemporary Art, 1985.

JAE-EUN CHOI

Brown, Azby. "The Ikebana of Jae-Eun Choi." *Winds* (Tokyo) 9 (July 1987).

Fujita, Shig. "Teaching after Only Three Years." *Asahi Evening News,* January 20, 1984.

Kageyama, Yuri. "The Arts—Three Women Artists Show Works." *Japan Times Weekly,* April 18, 1987.

Koplos, Janet. "Salable and Unsalable." *Asahi Evening News,* January 23, 1987.

———. "Vulgar Substances." *Asahi Evening News,* April 24, 1987.

———. "Japan: To the Depth." *Sculpture* 6 (September–October 1987).

Minamishima, Hiroshi. "Towards a Final Destination." In *To the Depth.* Tokyo: Spiral Garden, Wacoal Art Center, 1987.

Nakamura, Yoko. "Jae-Eun Choi's Industrial-Sized Creativity." *Japan Times Weekly,* September 9, 1989.

Roberts, James. "Jae-Eun Choi." *Artscribe International* 70 (Summer 1988).

Silva, Arturo. "Spiraling—Responsibly and Otherwise." *Daily Yomiuri,* April 2, 1987.

"Stepping Out—Jae-Eun Choi at Gallery Ueda." *The Magazine,* January 1988.

Yaguchi, Kunio. "Tokyo: Choi Jae-Eun." *Artforum* 25 (Summer 1987).

KOICHI EBIZUKA

Koplos, Janet. "Four Shows, Three Dimensions." *Asahi Evening News,* June 27, 1986.

———. "States of Existence." *Asahi Evening News,* June 19, 1987.

———. "States." *Asahi Evening News,* October 7, 1988.

Nakamura, Hideki. "Site Sight." In *Koichi Ebizuka.* Tokyo: Gallery Yo, 1984.

———. *6th Triennale, India, 1986: Japan.* Tokyo: Japan Foundation, 1986.

———. "Koichi Ebizuka." In *Koichi Ebizuka.* Tokyo: Galerie Tokoro, 1988.

Silva, Arturo. "Art at Play, Art Too Serious." *Daily Yomiuri,* July 2, 1987.

———. "Koichi Ebizuka: Sculpted Drawing." *Daily Yomiuri,* November 17, 1988.

Tono, Yoshiaki. *19 Bienal de São Paulo: Japão.* Tokyo: Japan Foundation, 1987.

———. "A Short Essay." In *Koichi Ebizuka.* Tokyo: Galerie Tokoro, 1988.

———. *4th Asian Art Biennale, Bangladesh, 1989: Japan.* Tokyo: Japan Foundation, 1989.

HIROSHI EGAMI

Haryu, Ichiro. "For Hara Annual VII." In *Hara Annual VII.* Tokyo: Hara Museum of Contemporary Art, 1987.

Koplos, Janet. "Floating World." *Asahi Evening News,* April 10, 1987.

———. "Arts." *Asahi Evening News,* May 8, 1987.

Vallombrosa, Jean-Paul. "Hara VII." *Tokyo Journal* 7 (April 1987).

TOSHIKATSU ENDO

Icons in Contemporary Art. Urawa, Japan: Saitama Museum of Modern Art, 1987.

Koplos, Janet. "Circles and Sites." *Asahi Evening News,* December 18, 1987.

Miki, Tamon. "Japanese Artists' Works." In *New Trends in Contemporary Sculpture*. New York: Salvatore Ala Gallery, 1987.

Nakamura, Hideki. *6th Triennale, India, 1986: Japan*. Tokyo: Japan Foundation, 1986.

Nanjo, Fumio. *On Fire*. Helsinki: Nordic Arts Center, 1989.

O'Brien, Rodney. "Celebrant of Fire, Water, and Earth." *Japan Times Weekly*, April 8, 1989.

Vetrocq, Marcia E. "Vexed in Venice." *Art in America* 78 (October 1990).

CHUICHI FUJII

Fujii Chuichi, 1980–85. Tokyo: Gallery Ueda Warehouse, 1985.

Joseph, Lawrence. "Tokyo: Tradition vs. High Tech." *Artnews* 84 (November 1985).

———. "Fujii Chuichi: Carpenter + Hochman." *Artnews* 84 (December 1985).

Koplos, Janet. "Arts." *Asahi Evening News*, May 3, 1985.

———. "Arts." *Asahi Evening News*, May 15, 1987.

———. "Nature and Art." *Asahi Evening News*, January 13, 1989.

Silva, Arturo. "Hot Artists." *Nadir* (Japan), Summer 1987.

KATSUHIRO FUJIMURA

Billeter, Erika. *Sculpture Textile, 12th International Biennial of Tapestry*. Lausanne, Switzerland: Musée Cantonal des Beaux-Arts, 1985.

Denvir, Bernard. "Bursting the Bonds." *Art and Artists* (London), July 1985.

Huml, Irena. *6th International Triennale of Tapestry*. Lodz, Poland: Central Museum of Textiles, 1988.

Koplos, Janet. "Primal Images." *Asahi Evening News*, April 5, 1985.

———. "Arts." *Asahi Evening News*, October 31, 1986.

Lamarova, Milena. "Textile Sculpture." *American Craft* 45 (October–November 1985).

Trucco, Terry. "Hara Art in Tokyo Is a Treat." *International Herald Tribune*, May 4–5, 1985.

TAKASHI FUKAI

Aoki, Hiroshi. "Two Time-Space Trippers." *Art in Tokyo '86—IMA* 1 (June–July 1986).

Koplos, Janet. "Arts." *Asahi Evening News*, December 5, 1986.

———. "Five in Three Dimensions." *Asahi Evening News*, October 23, 1987.

Minemura, Toshiaki. "Whither Daphne?" In *Takashi Fukai*. Tokyo: Nishimura Gallery, 1987.

O'Brien, Rodney. "Cutting through the Veneer." *PHP Intersect* (Tokyo), April 1988.

Sakai, Tadayasu. "The Quiet Persuasion of Contemporary Japanese Sculpture." In *Contemporary Japanese Sculpture and Prints*. Hong Kong: Hongkong Land Property Co., 1988.

Tatehata, Akira. "Iconoclasm as Pleasure." In *Takashi Fukai*. Tokyo: Nishimura Gallery, 1989.

MICHIO FUKUOKA

Gibson, Michael. "The Paris FIAC Show." *International Herald Tribune*, October 21–22, 1978.

Harris, Timothy. "Three Sculptors." *Asahi Evening News*, July 7, 1978.

Miki, Tamon. *Michio Fukuoka—Japão—São Paulo Bienal*. Tokyo: Japan Foundation, 1981.

Warburton, Rosemary. "Arts." *Asahi Evening News*, June 11, 1982.

KATSURA FUNAKOSHI

Aoki, Hiroshi. "Two Time-Space Trippers." *Art in Tokyo '86—IMA* 1 (June–July 1986).

Gomez, Edward M. "No More Tributes to Mount Fuji." *Time*, July 31, 1989.

Heartney, Eleanor. "Katsura Funakoshi at Herstand." *Art in America* 78 (April 1990).

Kimmelman, Michael. "Japanese Artists Forgo Lotus Blossoms for Urban Blight." *New York Times*, August 6, 1989.

Koplos, Janet. "Arts." *Asahi Evening News*, October 3, 1986.

———. "Careful Balances." *Asahi Evening News*, December 2, 1988.

———. "Japan: Katsura Funakoshi." *Sculpture* 8 (July–August 1989).

Mollenkof, Peter. "Works of Three Young Artists." *Japan Times*, September 18, 1986.

Murata, Makoto. "Katsura Funakoshi." *Artcoast* (Los Angeles) 1 (March–April 1989).

Okada, Takahiko. "Sculpture by Katsura Funakoshi." In *Funakoshi/Kondo/Senzaki*. Tokyo: Nishimura Gallery, 1986.

Sakai, Tadayasu. "Katsura Funakoshi: Someone Like You." In *New Trends in Contemporary Sculpture*. New York: Salvatore Ala, 1986.

———. "The Hand of Imagination." In *Funakoshi Katsura*. Tokyo: Nishimura Gallery, 1988.

———. "The Quiet Persuasion of Contemporary Japanese Sculpture." In *Contemporary Japanese Sculpture and Prints*. Hong Kong: Hongkong Land Property Co., 1988.

20 Bienal de São Paulo 1989: Japão. Tokyo: Japan Foundation, 1989.

SHUICHI FURUGOH

Haryu, Ichiro. "For the Hara Annual VII." In *Hara Annual VII*. Tokyo: Hara Museum of Contemporary Art, 1987.

Kato, Sadao, and Tsuyoshi Kanazawa. *Completion and Incompletion*. Tokyo: Gallery Nakama, 1987.

Koplos, Janet. "All A-Prickle." *Asahi Evening News*, August 23, 1985.

———. "Floating World." *Asahi Evening News*, April 10, 1987.

O'Brien, Rodney. "Perspectives on Steel." *PHP Intersect* (Tokyo), March 1985.

Tomiyama, Hideo. *Shuichi Furugo: New Sculpture*. New York: E. M. Donahue Gallery, 1989.

Warburton, Rosemary. "Shuichi Furugo: One-Man Show." *Asahi Evening News*, August 20, 1982.

GROUP Q

Sakai, Tadayasu, and Kiichi Iino. *Sculpture Group Q*. Tokyo: Spatial Design Consultants, 1986.

AKIO HAMATANI

Koplos, Janet. "Distanced from Life." *Asahi Evening News*, November 11, 1988.

Tatehata, Akira. *Hamatani—Fiber and Space*. Tokyo: Hillside Gallery, 1989.

NORIYUKI HARAGUCHI

Kobata, Kazue. "On Location: Kazue Kobata on Noriyuki Haraguchi." *Artforum* 25 (Summer 1987).

Koplos, Janet. "From Memory, from Industry." *Asahi Evening News*, March 18, 1988.

———. "Japan: Noriyuki Haraguchi." *New Art Examiner* 16 (September 1988).

Love, Joseph. "Tokyo Letter." *Art International* 17 (Summer 1973).

McGill, Douglas C. "Japanese Influence." *New York Times*, March 4, 1988.

O'Brien, Rodney. "Oil, Water and Steel: Noriyuki Haraguchi." *PHP Intersect* (Tokyo), February 1989.
Shapiro, David. "A View of Kassel." *Artforum* 16 (September 1977).

NATSUO HASHIMOTO
Koplos, Janet. "Allusions vs. Literalism." *Asahi Evening News*, March 6, 1987.
Lunami Selection '86. Tokyo: Gallery Lunami, 1986.

SHIRO HAYAMI
Harris, Timothy. "Three Individual Artists." *Asahi Evening News*, July 28, 1978.
———. "Shiro Hayami, Sculptor." *Asahi Evening News*, August 3, 1979.
Inui, Yoshiaki. "Geo-Shapes—The World of Shiro Hayami." In *Works of Hayami Shiro*. Tokyo: Kodansha, 1985.
Koplos, Janet. "Do Stones Breathe?" *Asahi Evening News*, July 18, 1986.
Love, Joseph. "Tokyo Letter." *Art International* 17 (Summer 1973).

HACHIRO IIZUKA
Koplos, Janet. "Arts." *Asahi Evening News*, July 8, 1988.
Okamoto, Kanjiro. *Hachiro Iizuka*. Tokyo: Dainana Gallery, 1968, 1970, 1971, 1972.
——— and Shigeo Chiba. *Hachiro Iizuka*. Tokyo: Kaneko Art Gallery, 1982.
Saint-Gilles, Amaury. "At Angles with Form." *Tokyo Journal*, April 1986.

BUKICHI INOUE
Harris, Timothy. "Awareness of Space." *Asahi Evening News*, September 15, 1978.
Inoue, Bukichi. *Bukichi Inoue: My Sky Hole '87: Way-Universe*. Tsu City, Japan: Mie Prefectural Art Museum, 1987.
———. *Bukichi Inoue: My Sky Hole*. Tokyo: Vingt et un, 1989.

KOSHO ITO
Fourth Triennale—India. Tokyo: Japan Foundation, 1978.
Koplos, Janet. "Salable and Unsalable." *Asahi Evening News*, January 23, 1987.
Love, Joseph. "This Week in Art." *Japan Times*, June 22, 1975.
1985 International Ceramics Exhibition. Taipei, Taiwan: Taipei Fine Arts Museum, 1985.
O'Brien, Rodney. "Hiroshima Stone Garden." *PHP Intersect* (Tokyo), November 1988.
Pohlen, Annelie. "A Few Highlights but No Festival." *Artforum* 23 (September 1984).
Tani, Arata. "Kosho Ito." In *La Biennale di Venezia 1984: Giappone*. Tokyo: Japan Foundation, 1984.
———. "Kosho Ito: Fascination of Clay." In *Kosho Ito*. Niigata, Japan: Hakushindo Co., 1989.
Worthen, Charles. "Kosho Ito." *New Art Examiner* 16 (October 1988).

AKIRA KAMIYAMA
Kanazawa, Takeshi. *Hara Annual VIII*. Tokyo: Hara Museum of Contemporary Art, 1988.
Koplos, Janet. "Annual and Perennial." *Asahi Evening News*, January 30, 1987.
———. "Five in Three Dimensions." *Asahi Evening News*, October 23, 1987.
———. "Japan: Akira Kamiyama." *Sculpture* 7 (July–August 1988).
———. "Transcendence and Familiarity." *Asahi Evening News*, May 26, 1989.

20 Bienal de São Paulo 1989: Japão. Tokyo: Japan Foundation, 1989.
Weisenfeld, Gennifer. "Puzzles of Truth and Time." *Mainichi Daily News*, April 17, 1989.
———. "Merging Carpentry and Psychology." *Japan Times*, May 21, 1989.

HIROSHI KAMO
Koplos, Janet. "With Feeling." *Asahi Evening News*, January 15, 1988.
———. "Tokyo: Hiroshi Kamo." *Flash Art* 140 (May 1988).
Lunami Selection '87. Tokyo: Gallery Lunami, 1987.

KENICHI KANAZAWA
Koplos, Janet. "Arts." *Asahi Evening News*, August 29, 1986.
———. "Spiffed Up." *Asahi Evening News*, April 7, 1989.
Tadagawa, Leo. *Experimental Musical Instruments: The Sound Garden*. Tokyo: Striped House Museum, 1987.

TOYOKO KATSUMATA
Koplos, Janet. "Arts." *Asahi Evening News*, July 22, 1988.

SATORU KAWAGOE
Kondo, Yukio. "Reviews: Japan." *Flash Art* 136 (October 1987).
Koplos, Janet. "Sensations of Space." *Asahi Evening News*, April 8, 1988.
Lunami Selection '86. Tokyo: Gallery Lunami, 1986.
Tani, Arata. "Surrealism-Fukawa vs. Baroque-Kawagoe." In *Hirokazu Fukawa/Satoru Kawagoe*. Tokyo: Gallery AlphaM, 1988.

TATSUO KAWAGUCHI
Catastrophe: Art from the East. Milan, Italy: Galleria San Fedele, 1972.
Crossing '86—Japan/Hawaii. Honolulu: University of Hawaii Art Gallery, 1986.
Kawaguchi, Tatsuo. "Memory of Sense." In *Art for Touching*. Tokyo: Seibu Museum of Art, 1988.
———. "Ground as 'Field of Relation.'" In *The Space: Material, Tension, Vacancy in Japanese Contemporary Art*. Urawa, Japan: Saitama Museum of Modern Art, 1989.
Koplos, Janet. "Nature and Universals." *Asahi Evening News*, November 29, 1985.
———. "Portraits, Puzzles, Passages." *Asahi Evening News*, August 1, 1986.
———. "Arts." *Asahi Evening News*, May 19, 1989.
———. "Tokyo: Tatsuo Kawaguchi." *Art in America* 77 (November 1989).
Masuda, Hiromi. "The Modern World and Tradition in Japanese Art." In *Fifth Triennale, India, 1982: Japan*. Tokyo: Japan Foundation, 1982.
Nakahara, Yusuke. "Tatsuo Kawaguchi and 'Relation.'" In *Tatsuo Kawaguchi*. Tokyo: Hillside Gallery, 1989.
Nakamura, Hideki. "Organic Works of Art Which Hide in Order to Reveal." In *Kawaguchi Tatsuo*. Nagoya, Japan: Sakura Gallery, 1989.
Today's Artists III—'90. Kamakura, Japan: Kamakura Museum of Modern Art, 1990.
Tono, Yoshiaki. "Tatsuo Kawaguchi's Multifarious Ks." In *Tatsuo Kawaguchi*. Tokyo: Minami Gallery, 1975.

TADASHI KAWAMATA
Ashton, Dore. "Document of What?" *Arts Magazine* (September 1987).
Brenson, Michael. "Kawamata: From Destruction to Construction." *New York Times*, May 20, 1988.

Cohen, C. J. *Perspective*. New York: Korean Cultural Service Gallery, 1985.

Dunning, Jennifer. "The Stage as an Element of Dance." *New York Times*, May 11, 1987.

Finkelpearl, Tom. *Kawamata Project*. Tokyo: On the Table, 1986.

Hara Annual: Vision for '80s. Tokyo: Hara Museum of Contemporary Art, 1980.

"Interview: Tadashi Kawamata." In *Hara Museum Review*, Autumn 1988.

Koike, Mika, Masaki Motoi, and Makoto Murata, eds. *Kawamata*. Tokyo: Gendaikikakushitsu Publishing, 1987.

Koplos, Janet. "Looking at 'Inside and Outside.'" *Asahi Evening News*, December 9, 1987.

———. "Tokyo: Tadashi Kawamata." *Art in America* 78 (May 1988).

Levin, Kim. "Kawamata." *Village Voice*, May 31, 1988.

Marmer, Nancy. "Documenta 8: The Social Dimension?" *Art in America* 75 (September 1987).

Munroe, Alexandra. "A Continent Away—Japanese Artists in New York City." *Winds* (Tokyo) 8 (August 1986).

Obigane, Akio. *Material and Space*. Fukuoka, Japan: Fukuoka City Museum of Art, 1983.

O'Brien, Rodney. "Shivering Timbers: Tadashi Kawamata." *PHP Intersect* (Tokyo), December 1988.

Philips, Patricia C. "Added Attractions." *Artforum* 27 (May 1989).

Roberts, James. "Tadashi Kawamata." *Artscribe International* 70 (Summer 1988).

Sato, Tomoya. "Art as 'Foot-work.'" In *Tetra House N-3 W-26 Project*. Tokyo: On the Table, 1983.

Smith, Roberta. "A Wide-Ranging Spread of Artists and Installations." *New York Times*, November 4, 1988.

Tani, Arata. *La Biennale di Venezia 1982: Giappone*. Tokyo: Japan Foundation, 1982.

Tono, Yoshiaki. *19 Bienal de São Paulo: Japão*. Tokyo: Japan Foundation, 1987.

MUTSUO KAWARABAYASHI

Nakahara, Yusuke. *Kawarabayashi Mutsuo*. Tokyo: Fuma Gallery, 1974, 1976.

Tono, Yoshiaki. *Kawarabayashi Mutsuo*. Tokyo: Yanase Ginza Center, 1970.

KAZUO KENMOCHI

Koplos, Janet. "Poisonous or Passive." *Asahi Evening News*, February 17, 1989.

Murata, Makoto. "Kazuo Kenmochi." *Flash Art* 134 (May 1987).

O'Brien, Rodney. "Back to Earth: Kazuo Kenmochi." *PHP Intersect* (Tokyo), January 1989.

Silva, Arturo. "Kazuo Kenmochi's Private Vision." *Daily Yomiuri*, February 16, 1989.

———. "Kazuo Kenmochi." *Artcoast* (Los Angeles) 1 (May–June 1989).

Schoenberger, Karl. "Japanese Art." *Los Angeles Times* (Pacific Rim edition), March 19, 1989.

NAOMI KIKUTANI

Koplos, Janet. "Analyzing the Annual." *Asahi Evening News*, April 25, 1986.

Minemura, Toshiaki. "Homage to Joseph Beuys: On the Occasion of Hara Annual VI." In *Hara Annual VI*. Tokyo: Hara Museum of Contemporary Art, 1986.

Tazaki, Hideaki. "What Is the Iron." In *Kikutani Naomi*. Tokyo: PS Gallery, 1989.

YOSHIO KITAYAMA

Gendel, Milton. "Report from Venice." *Art in America* 70 (September 1982).

Koplos, Janet. "Arts." *Asahi Evening News*, June 26, 1987.

———. "Japan: Yoshio Kitayama." *Sculpture* 6 (November–December 1987).

Nakahara, Yusuke. *Yoshio Kitayama*. Self-published for Venice Biennale, 1982.

Panicelli, Ida. "Venice Biennale 1982: Japan." *Artforum* 21 (November 1982).

Seisboll, Lise. "Yoshio Kitayama and the Japanese Tradition of Visual Art." *Yoshio Kitayama, 1979–1989*. Self-published, 1989.

NAOYUKI KITTA

Koplos, Janet. "Naturally." *Asahi Evening News*, January 16, 1987.

———. "Moving." *Asahi Evening News*, April 29, 1988.

Lunami Selection '86. Tokyo: Gallery Lunami, 1986.

O'Brien, Rodney. "Floating Metal: Naoyuki Kitta." *PHP Intersect* (Tokyo), December 1987.

Shinoda, Tatsumi. "Surface Structure: The Sculptures of Kitta Naoyuki." In *Kitta Naoyuki*. Tokyo: PS Gallery, 1988.

Silva, Arturo. "Keeping It on the Surface." *Daily Yomiuri*, April 21, 1988.

SUSUMU KOSHIMIZU

Love, Joseph. "The 10th Tokyo Biennale of Contemporary Arts." *Art International* 14 (Summer 1970).

———. "Tokyo Letter." *Art International* 15 (May 1971).

Miki, Tamon. *17 Bienal de São Paulo: Japão*. Tokyo: Japan Foundation, 1983.

AKIRA KOWATARI

Koplos, Janet. "Portraits, Puzzles, Passages." *Asahi Evening News*, August 1, 1986.

———. "Animals and Objects." *Asahi Evening News*, September 23, 1988.

SEIJI KUNISHIMA

Clothier, Peter. "Seiji Kunishima at Space Gallery." *LA Weekly*, October 4–10, 1985.

Cortright, Steven, and Miles Kubo. *Seiji Kunishima: Wrapped Works, 1978–1985*. Tokyo: Akira Ikeda Gallery, 1985.

Devine, Alison, and Michael Singer. *New Work Japan*. Brattleboro, Vt.: Brattleboro Museum and Art Center, 1987.

Donohue, Marlena. "Galleries." *Los Angeles Times*, November 4, 1988.

Gardner, Colin. "The Galleries—Hollywood." *Los Angeles Times*, September 27, 1985.

Garfinkel, Ada. "A Harmonious Relationship." *Independent-Journal* (Larkspur, Calif.), November 16, 1979.

Goad, Frank, and Ed Loomis. "Image in Sound and Sculpture." *Artweek*, December 17, 1977.

Haydon, Harold. "Seiji Kunishima: One-Man Show." *Chicago Sun Times*, April 21, 1978.

Hugo, Joan. *Seiji Kunishima: Works, 1976–1982*. Los Angeles: Space Gallery, 1983.

Laurence, Michael. *Seiji Kunishima*. Nagoya, Japan: Sakura Gallery, 1988.

———. "Seiji Kunishima." *Sculpture* 8 (March–April 1989).

McCloud, Mac. "Recognizing Eternity: Seiji Kunishima." *Visions* (Los Angeles), Fall 1987.

Mollenkof, Peter. "Opposition and Harmony." *Asahi Evening News*, January 19, 1979.

Pincus, Robert L. "The Galleries—Hollywood." *Los Angeles Times*, March 2, 1984.

TAKAMASA KUNIYASU

Jones, Derek. "The Insane and the Creative." *Asahi Evening News*, June 9, 1989.

Koplos, Janet. "Into the Wondrous." *Asahi Evening News*, February 12, 1988.
———. "Japan: Takamasa Kuniyasu." *New Art Examiner* 15 (May 1988).
Perron, Joel. "The Critical Point in Art." *Japan Times*, August 21, 1988.
Shiota, Junichi. *Kuniyasu Takamasa*. Tokyo: Hillside Gallery, 1989.
Silva, Arturo. "Takamasa Kuniyasu." *Artforum* 28 (October 1989).
Weisenfeld, Gennifer. "Takamasa Kuniyasu's Looming Logs." *Japan Times*, June 4, 1989.

OSAMU KUSHIDA

Lunami Selection '86. Tokyo: Gallery Lunami, 1986.
Mizai '86. Tokyo: Group Mizai, 1986.
Koplos, Janet. "Three-Dimensional Painting." *Asahi Evening News*, January 6, 1989.

U-FAN LEE

Bienal de São Paulo 1969: Japão. Tokyo: Japan Foundation, 1969.
Bienal de São Paulo 1973: Japão. Tokyo: Japan Foundation, 1973.
Chiba, Shigeo. "Modern Art from a Japanese Viewpoint." *Artforum* 23 (October 1984).
Harris, Timothy. "A Cunning Irregularity." *Asahi Evening News*, March 10, 1977.
———. "A Lovely Essence." *Asahi Evening News*, January 13, 1978.
———. "U-Fan Lee." *Art International* 22 (February 1978).
Japanese Contemporary Art Exhibition. London: Camden Art Center, 1982.
Koplos, Janet. "Biography of the Brushstroke." *Asahi Evening News*, January 17, 1986.
Lee, U-Fan. *Lee U-Fan*. Translated by Jean Campignon, assisted by Adam Fulford. Tokyo: Bijutsu Shuppan-sha, 1986.
Love, Joseph. "Exhibitions in Tokyo." *Art International* 14 (Summer 1970).
———. "Tokyo Letter." *Art International* 15 (May 1971).
Minemura, Toshiaki. *Sculpture of Lee U-Fan*. Tokyo: Kamakura Gallery, 1985.
———, Masahiro Aoki, and Kiyoshi Okada. *Lee U-Fan*. Gifu, Japan: Museum of Fine Arts, 1988.
Mollenkof, Peter. "Arts." *Asahi Evening News*, June 29, 1979.
———. "Arts." *Asahi Evening News*, June 27, 1980.
Roberts, James. "U-Fan Lee." *Artscribe International* 70 (Summer 1988).
Silva, Arturo. "Lee U-Fan." *Artforum* 25 (February 1987).
Tatehata, Akira. *Lee U-Fan*. Tokyo: Kamakura Gallery, 1990.
Three-Man Exhibition. London: Juda-Rowan Gallery, 1983.

RYOICHI MAJIMA

Honda, Margaret, and Brent Riggs. "Japanese Art Today—A Background." In *Japanese Art Today*. La Jolla, Calif.: University of California—San Diego, 1986.
Koplos, Janet. "Subject to Objects." *Asahi Evening News*, May 23, 1986.
McDonald, Robert. "Japanese Art: Sublime to Lightweight." *Los Angeles Times* (San Diego County edition), May 24, 1986.
McManus, Michael. "A Japanese Avant-Garde." *Artweek*, June 14, 1986.
Pincus, Robert L. "Exhibit Shows Today's Japanese Art." *San Diego Union*, May 22, 1986.
Sasaki, Mieko. "Unconventional Works of Art." *Daily Yomiuri*, March 3, 1983.
Vallombrosa, Jean-Paul. "The Found-Ations of Art." *Tokyo Journal*, June 1987.

Yamaguchi, Katsuhiro. "The Discovery of Pliable Susceptibility and Originality." In *Hara Annual III*. Tokyo: Hara Museum of Contemporary Art, 1983.

TOSHIO MATSUI

Koplos, Janet. "In Kyoto This Week." *Asahi Evening News*, February 6, 1987.
O'Brien, Rodney. "Ceramic Excitement: Akikazu Matsui." *PHP Intersect* (Tokyo), September 1987.

YOJI MATSUMURA

"Alumni Focus." *VCU School of the Arts Journal*, Spring 1983.
Koplos, Janet. "Not a Monument." *Asahi Evening News*, May 1, 1987.
Merritt, Robert. "VCU Couple's Art Show Invites Viewers to Play." *Richmond News Leader*, August 7, 1980.
Silva, Arturo. "Art in 'Young Town' Kichijoji." *Daily Yomiuri*, May 12, 1987.
"'Unseen Motion' Sculptor Exhibit Opens Today at VA Science Museum." *Richmond News Leader*, June 14, 1980.
"Viewers Invited to Watch Sculptor at Work." *Richmond Times-Dispatch*, June 24, 1980.

TATSUO MIYAJIMA

Cooke, Lynne. *Reorienting: Looking East*. Glasgow: Third Eye Centre, 1990.
Kanazawa, Takeshi. "For the Hara Annual VIII." In *Hara Annual VIII*. Tokyo: Hara Museum of Contemporary Art, 1988.
Kent, Sarah. "Dearth in Venice." *TimeOut* (London), July 13–20, 1988.
Koplos, Janet. "Constructions." *Asahi Evening News*, March 13, 1987.
———. "Boosting Contemporary Artists." *Asahi Evening News*, April 1, 1988.
———. "Groups and Individuals." *Asahi Evening News*, September 2, 1988.
———. "Arts." *Asahi Evening News*, April 21, 1989.
———. "Tatsuo Miyajima." *Art in America* 77 (October 1989).
Lunami Selection '88. Tokyo: Gallery Lunami, 1988.
O'Brien, Rodney. "Technology Demystified: Tatsuo Miyajima." *PHP Intersect* (Tokyo), July 1988.
Packer, William. "Venice Biennale: Hard Sell of Jasper Johns." *Financial Times*, June 30, 1988.

AIKO MIYAWAKI

Canaday, John. "Aiko Miyawaki." *New York Times*, September 27, 1969.
Koplos, Janet. "Formless." *Asahi Evening News*, February 20, 1987.
Linker, Kate, and George Staempfli. *Aiko Miyawaki: Recent Sculpture and Maquettes*. New York: Staempfli Gallery, 1986.
Miyawaki, Aiko, et al. *Utsurohi, A Moment of Movement*. Tokyo: Bijutsu Shuppan-sha, 1986.
Nakahara, Yusuke. *Aiko Miyawaki: Lights in Brass Reeds*. Tokyo: Tokyo Gallery, 1967.
———. *Aiko Miyawaki*. Lodz, Poland: Lodz Modern Art Museum, 1970.
———. *Aiko*. Milan, Italy: Galleria del Naviglio, 1976.
Okada, Takahiko. *Aiko Miyawaki*. New York: Staempfli Gallery, 1969.
———. "Works of Art as Intermediaries in the Discovery of the Unseen." In *Aiko Miyawaki, 1960–1980*. Nagoya, Japan: Gallery Takagi, 1980.
Popham, Peter. "Playing with Wire." *The Magazine* (Tokyo), November 1987.
Ray, Man, et al. *Aiko Miyawaki*. Tokyo: Tokyo Gallery, 1964.
Russoli, Franco. *Aiko*. Milan, Italy: Galleria Minima, 1961.
Silva, Arturo. "Rivers of Steel: Truth According to Weather." *Daily Yomiuri*, February 13, 1987.

HISAYUKI MOGAMI

"Art Today '79." *Daily Yomiuri*, March 14, 1979.
Japanese Art Today. Tokyo: Japanese National Committee for the International Association of Plastic Arts, 1965.
Koplos, Janet. "Arts." *Asahi Evening News*, May 27, 1988.
Lieberman, William S. *The New Japanese Painting and Sculpture*. New York: Museum of Modern Art, 1966.
Modern Art of Japan: Masterpieces in the Museum. Tokyo: Keshosha Publishing Co., 1985.

SABURO MURAOKA

Chiba, Shigeo. "Saburo Muraoka." *Japan Ushimado Fourth International Art Festival*. Ushimado, Japan: Japan Ushimado International Art Festival, 1988.
Europalia '89, Japan in Belgium: Saburo Muraoka. Ghent, Belgium: Museum Van Hedendaagse Kunst Gent, 1989.
Kobata, Kazue. "Kitakyushu: International Iron Sculpture Symposium." *Artforum* 26 (March 1988).
Koplos, Janet. "Speechless Steel." *Asahi Evening News*, May 12, 1989.
Minamishima, Hiroshi. "Japan: Saburo Muraoka, Shinanobashi, Osaka." *Flash Art* 147 (Summer 1989).
Vetrocq, Marcia E. "Vexed in Venice." *Art in America* 78 (October 1990).

SHIGERU NISHINA

Koplos, Janet. "Sensations of Space." *Asahi Evening News*, April 8, 1988.
————. "The Chosen." *Asahi Evening News*, August 26, 1988.
————. "Shigeru Nishina." *Sculpture* 8 (January–February 1989).
Tani, Arata. *Kodama: Neo Tone, Neo Style*. Tokyo: Spiral Garden, Wacoal Art Center, 1988.

YUSEI OGINO

Kimmelman, Michael. "Japanese Artists Forego Lotus Blossoms for Urban Blight." *New York Times*, August 6, 1989.
Koplos, Janet. "Naturally." *Asahi Evening News*, January 16, 1987.

ATSUSHI OHASHI

Koplos, Janet. "Finesse and Fantasy." *Asahi Evening News*, July 25, 1986.
————. "Careful Balances." *Asahi Evening News*, December 2, 1988.
Weisenfeld, Gennifer. "From Structure to Symbol." *Mainichi Daily News*, February 3, 1989.

ATSUO OKAMOTO

Detrick, Ann. "New Art Forms." *Sculpture* 5 (March–April 1986).
Koplos, Janet. "States of Existence." *Asahi Evening News*, June 19, 1987.
————. "Japan: Atsuo Okamoto." *Sculpture* 6 (July–August 1987).
————. "The Meaning of Stone." In *Atsuo Okamoto*. Tokyo: Gallery Yamaguchi, 1989.

KENJIRO OKAZAKI

"From Kenjiro Okazaki's Classes." *Contemporary Art Exercises 2*. Edited by B-Semi Schooling System. Tokyo: Gendaikikakushitsu, 1989.
Hayami, Takashi. *12e Biennale de Paris 1982: Japon*. Tokyo: Japan Foundation, 1982.
Koplos, Janet. "Transformation, Petrification, Energy." *Asahi Evening News*, April 19, 1985.
————. "Arts." *Asahi Evening News*, October 30, 1987.

————. "Kenjiro Okazaki at Hillside Gallery." *New Art Examiner* 15 (Summer 1988).
Lutfy, Carol. "'Stepmother of Genius' Haunts Japanese Artists." *Asian Wall Street Journal*, August 7–8, 1987.
Nanba, Hideo. *Kenjiro Okazaki*. Tokyo: Ando Gallery, 1985.
————. *Kenjiro Okazaki*. Tokyo: Nantenshi Gallery, 1987.
Okazaki, Kenjiro. "Twelve Points to Note When Judging." In *12e Biennale de Paris 1982: Japon*. Tokyo: Japan Foundation, 1982.
————. "Brass II." In *Art for Touching*. Tokyo: Seibu Museum of Art, 1988.

MAKOTO OKUMURA

Koplos, Janet. "Arts." *Asahi Evening News*, March 14, 1986.

KOSEN OTSUBO

Koplos, Janet. "Primal Images." *Asahi Evening News*, April 5, 1985.
Lunami Selection '86. Tokyo: Lunami Gallery, 1986.
"Mazda Gallery: Automobile Capriccio." *Mazda World* (Tokyo), June 1986.
O'Brien, Rodney. "A Big Splash in Suburbia; Kosen Otsubo." *PHP Intersect* (Tokyo), May 1986.
————. "In the Ikebana World, New Offshoots Are Blooming." *Japan Times*, March 12, 1989.

SHINTARO OTSUKA

Koplos, Janet. "Speaking Acquaintance." *Asahi Evening News*, September 20, 1985.
————. "Arts." *Asahi Evening News*, May 22, 1987.

YOSHISHIGE SAITO

Chiba, Shigeo. "Study of Saito Yoshishige: The Historical and Contemporary Value of Re-construction." In *Saito Yoshishige: Exhibition 1978*. Tokyo: National Museum of Modern Art, 1978.
Harris, Timothy. "Formality and Reticence." *Asahi Evening News*, June 23, 1978.
Lieberman, William S. *The New Japanese Painting and Sculpture*. New York: Museum of Modern Art, 1966.
Miki, Tamon. "Locus of Saito's Art." In *Saito Yoshishige: Exhibition 1978*. Tokyo: National Museum of Modern Art, 1978.
Nakahara, Yusuke. *Saito Yoshishige, 1936–1973*. Tokyo: Tokyo Gallery, 1973.

HISAKO SEKIJIMA

Fiberarts Design Book I. Asheville, N.C.: Lark, 1981.
Fiberarts Design Book II. Asheville, N.C.: Lark, 1983.
Fiberarts Design Book III. Asheville, N.C. Lark, 1988.
Fuchs, Douglas. "Contemporary Basketry." *Craft Australia*, Summer 1981.
Hammel, Lisa. "A Passel of Baskets." *Town and Country*, August 1988.
Koplos, Janet. "A Long Way Back to Tradition." *Asahi Evening News*, May 29, 1986.
————. "Hisako Sekijima, Basketmaker." *Fiberarts* 13 (September–October 1986).
Larsen, Jack L. *Interlacing*. Tokyo: Kodansha International, 1987.
Malarcher, Patricia. "What Makes a Basket a Basket?" *Fiberarts* 11 (January–February 1984).
Massy, Patricia. "Crafts and Craftsmen." *Japan Times*, February 15, 1984.

NOBUO SEKINE

Cotter, Holland. "Nobuo Sekine at Staempfli." *Art in America* 78 (April 1990).

Harris, Timothy. "Phases of Nothingness." *Asahi Evening News*, October 13, 1977.
———. "Nobuo Sekine: Phases of Nothingness." *Art International* 22 (Summer 1978).
Hayashi, Yoshifumi, ed. "Sculpture of Scenery: Works of Nobuo Sekine and Environment Art Studio." *Process: Architecture* 74, 1986.
———, ed. *Sekine: Phase Conception II*. Niigata, Japan: Hakushindo, 1989.
Koplos, Janet. "Arts." *Asahi Evening News*, June 14, 1985.
———. "Arts." *Asahi Evening News*, November 13, 1987.
———. "Leaf and Relief." *Asahi Evening News*, November 20, 1987.
———. "States." *Asahi Evening News*, October 7, 1988.
Sekine, Nobuo, and Yoshifumi Hayashi. *Phase Conception*. Tokyo: Environment Art Studio, 1987.
Ueda, Makoto, ed. *Nobuo Sekine, 1968–1978*. Tokyo: Julia Pempel Atelier, 1978.

CHIEO SENZAKI

Koplos, Janet. "Arts." *Asahi Evening News*, October 3, 1986.
———. "Groups and Individuals." *Asahi Evening News*, September 2, 1988.
Mollenkof, Peter. "Works of Three Young Artists." *Japan Times*, September 28, 1986.
O'Brien, Rodney. "Art without a Capital A: Chieo Senzaki." *PHP Intersect* (Tokyo), November 1985.
Rohrig, Johannes, and Georg M. Roers. *Chieo Senzaki: Installationen*. Cologne, Germany: Kunst-Station Sankt Peter Koln, 1990.
Tani, Arata. "Activation of Polyphonic Visuality and Meaning." In *Funakoshi/Kondo/Senzaki*. Tokyo: Nishimura Gallery, 1986.

TAMOTSU SHIIHARA

Koplos, Janet. "Connection and Elaboration." *Asahi Evening News*, July 15, 1988.

HISAYUKI SHIMA

Koplos, Janet. "Arts." *Asahi Evening News*, July 10, 1987.

USHIO SHINOHARA

Castile, Rand. "Absorbing the Shock of the West." *Artnews* 80 (September 1981).
——— and Yoshiaki Tono. *Ushio Shinohara*. New York: Japan Society, 1982.
Glueck, Grace. "Art: Shinohara's Headlong Collision with American Culture." *New York Times*, October 1, 1982.
Hamill, Pete, and Michiko Miyamoto. "The Japanning of New York." *New York*, August 17, 1981.
Koplos, Janet. "N.Y. Nightmares and Tokyo Traditions." *Asahi Evening News*, September 18, 1987.
———. "Shinohara's Exuberant Vulgarity." In *Ushio Shinohara*. Tokyo: Gallery Yamaguchi, 1988.
Levin, Gail. *Homage to Edward Hopper: Quoting the American Realist*. New York: Baruch College Gallery, 1988.
Mazo, Norma. "Notes from Tokyo." *Art in America* 48 (Fall 1960).
Nadelman, Cynthia. "Ushio Shinohara." *Artnews* 82 (February 1983).
O'Brien, Rodney. "A Tattoo of Steam and Scream: Ushio Shinohara." *PHP Intersect* (Tokyo), March 1986.
Sato, Hiroaki. Interview with Shinohara. *Mainichi Daily News*, January 7, January 21, February 4, 1985.
Tono, Yoshiaki. "New Talent in Tokyo." *Art in America* 54 (January–February 1966).
———. "Japan." *Artforum* 5 (January 1967).

SATORU SHOJI

Hugo, Joan. "Reductive Form and Limited Color." *Artweek*, May 16, 1981.
Love, Joseph. "The 10th Tokyo Biennale of Contemporary Art." *Art International* 14 (Summer 1970).
Nakamura, Hideki, et al. *Tomoharu Murakami/Satoru Shoji*. Los Angeles: Los Angeles Institute of Contemporary Art, 1981.

KISHIO SUGA

Chiba, Shigeo. "On Kishio Suga: Toward a Radicalism of Seeing." In *Kishio Suga*. Tokyo: Kaneko Art Gallery, 1980.
———. "Modern Art from a Japanese Viewpoint." *Artforum* 23 (October 1984).
Fry, Edward F. *Contemporary Japanese Art*. New York: Solomon R. Guggenheim Foundation, 1970.
Haryu, Ichiro. "Kishio Suga." *Japan Ushimado Fourth International Art Festival*. Ushimado, Japan: Japan Ushimado International Art Festival, 1988.
Hinatsu, Tsuyuhiko. *22d Artists Today Exhibition*. Yokohama, Japan: Yokohama Citizens Gallery, 1986.
Koplos, Janet. "Matter-of-Fact Mysteries." *Asahi Evening News*, September 18, 1987.
Minemura, Toshiaki. "The (Face) Moves." In *Kishio Suga*. Tokyo: Tokyo Gallery, 1981.
Nakahara, Yusuke. "Koji Enokura and Kishio Suga." *La Biennale di Venezia 1978: Giappone*. Tokyo: Japan Foundation, 1978.
Silva, Arturo. "Kishio Suga at Kaneko." *Daily Yomiuri*, September 14, 1989.
Suga, Kishio. *Kishio Suga, 1988–1968*. Tokyo: Self-published, 1988.
Tanigawa, Gan, Yasuo Kobayashi, and Kishio Suga. *Kishio Suga*. Tokyo: Touko Museum of Contemporary Art, 1990.

WAKIRO SUMI

Koplos, Janet. "Arts." *Asahi Evening News*, September 15, 1988.
———. "Japan: Wakiro Sumi." *Sculpture* 9 (March–April 1990).

HISAO SUZUKI

Koplos, Janet. "A Poised Universe." *Asahi Evening News*, March 20, 1987.

RYOJI SUZUKI

"Experiment in Material 20," "Azabu Edge," "An 'Archipolitique' of Architecture," "Experiment in Material 22," "Commercial Building A." *JA (Japan Architect)*, October 1987.
"Kinjin Building." *JA*, May 1976.
Koplos, Janet. "Altering the Familiar." *Asahi Evening News*, December 11, 1987.
Perron, Joel. "Ryoji Suzuki: Sculptures Paving the Road to Art and Architecture." *Japan Times*, May 14, 1989.
"S Residence." *JA*, June 1977.
Suzuki Ryoji. "Message from Tokyo: Experience in Material 17." *JA*, November–December 1986.
Trucco, Terry. "Getting the Most out of Interiors." *PHP Intersect* (Tokyo), June 1985.
"The Uchida Arms Building." *JA*, June 1980.
Ueda Makoto. *Japanese Houses in Ferroconcrete*. Tokyo: Graphic-sha, 1988.

YOICHI TAKADA

Art for Touching. Tokyo: Seibu Museum of Art, 1988.
International Paper Art Exhibition in Japan '89. Kyoto, Japan: Japan Paper Academy, 1989.
Joseph, Lawrence E. "Tradition vs. HighTech." *Artnews* 84 (November 1985).

Koplos, Janet. "The Material Is the Message." *Asahi Evening News*, May 31, 1985.
———. "Sketches and Embellishments." *Asahi Evening News*, December 23, 1988.

HIDEHO TAKASU

"Architecture as Objet d'Art." *JA* (Japan Architect), February 1, 1985.
Kauza, Simone. "Metro Mosaic: Jack-of-All-Trades Juggles New Works to Forefront." *Japan Times*, December 26, 1987.
Koplos, Janet. "Sculpture Meets Painting." *Asahi Evening News*, February 21, 1986.
Mimura, Kyoko. "A Sculptured Shopping Center." *Mainichi Daily News*, October 12, 1987.

NOBORU TAKAYAMA

Clarke, Anthony. "Shark for Japanese Art's Sake." *Griffin 1 Arts Review 1* (Australia), July 20, 1981.
Kobata, Kazue. "Kitakyushu: International Iron Sculpture Symposium." *Artforum 26* (March 1988).
Koplos, Janet. "Noboru Takayama." *Artcoast* (Los Angeles) 1 (March–April 1989).
Love, Joseph. "Letter from Japan." *Arts International* 17 (Summer 1973) and 19 (November 1975).
McCullough, T. G. *Ideas from Japan*. Australia: Gryphon Gallery, 1981.
Takayama, Noboru. *Noboru Takayama, 1968–1988*. Tokyo: Gallery 21 + Yo, 1988.

YASUHIRO TAKEDA

Hayami, Takashi. "The Logic of the Ambiguous Objects." In *Takeda Yasuhiro*. Tokyo: Hillside Gallery, 1988.
Koplos, Janet. "Arts." *Asahi Evening News*, August 8, 1986.
———. "Roundup." *Asahi Evening News*, November 6, 1987.
Mollenkof, Peter. "Arts." *Japan Times*, November 1, 1987.
———. "Reviews: Japan." *Artnews 87* (February 1988).

SADAO TAKIMOTO

Koplos, Janet. "Sadao Takimoto." *Sculpture* 8 (January–February 1989).
———. "See This Show!" *Asahi Evening News*, March 10, 1989.

HIDEHO TANAKA

The Fiberarts Design Book I. Asheville, N.C.: Lark, 1980.
4th Triennale Fiber Artists and Designers. Lodz, Poland: Polish Artist Union, Lodz Centre, 1981.
Freudenheim, Betty. "Sculpture in Wood, Ceramics and Paper." *New York Times*, July 18, 1985.
Michoacan International Exhibition of Miniature Textiles. Michoacan, Mexico: Casa de la Cultura, 1982.
Saint-Gilles, Amaury. "Hideho Tanaka." In *12th International Biennial of Tapestry*. Lausanne, Switzerland: Musée Cantonal des Beaux-Arts, 1985.
Seelig, Warren. "Classic Turn: The 13th Lausanne Biennial of Tapestry." *American Craft 47* (October–November 1987).
Silva, Arturo. "There Are No Secrets." *Daily Yomiuri*, September 5, 1985.
———. "Tighten Up: The Blur Clarified." *Daily Yomiuri*, June 19, 1986.
———. "Hideho Tanaka." In *13th International Biennial of Tapestry*. Lausanne, Switzerland: Musée Cantonal des Beaux-Arts, 1987.
———. "Quiet Artists." *Nadir* (Japan), Fall–Winter 1988.
Slivka, Rose. "From the Studio." *East Hampton Star*, July 24, 1986.

Today's Art Festival '74. Tokyo: Japan Art Festival Association, 1974.
Trends in Today's Japanese Art '75. Tokyo: Japan Art Festival Association, 1975.
Vallombrosa, Jean-Paul. "Fire as Art." *Tokyo Journal*, January 1987.

ISAO TANAKA

Koplos, Janet. "Arts." *Asahi Evening News*, January 17, 1986.
Ogawa, Masataka. "Contemporary Artists in Japan." *Japan Quarterly 27* (January–March 1980).

GAHO TANIGUCHI

Callender, Judith. "Environmental Sculptures." *Japan Times*, April 12, 1987.
Japan Times Weekly, April 18, 1987.
Koplos, Janet. "Vulgar Substances." *Asahi Evening News*, April 24, 1987.
———. "Japan: To the Depth." *Sculpture* 6 (September–October 1987).
———. "In Kichijoji." *Asahi Evening News*, December 16, 1988.
Minamishima, Hiroshi. "Towards a Final Destination." In *To the Depth*. Tokyo: Spiral Garden, Wacoal Art Center, 1987.
O'Brien, Rodney. "In the Ikebana World, New Offshoots Are Blooming." *Japan Times*, March 12, 1989.
Tani, Arata. "Cross-Modal Transfer." In *Tatsuo Gocho/Gaho Taniguchi*. Tokyo: Gallery AlphaM, 1988.
Weisenfeld, Gennifer. "Reviews: Gaho Taniguchi." *Artcoast* (Los Angeles) 1 (May–June 1989).

SHIGEO TOYA

Fendrick, Julia. "Out of the Woods: Shigeo Toya." *Tokyo Journal*, January 1989.
Kondo, Yukio. "Shigeo Toya." *Artcoast* (Los Angeles) 1 (May–June 1989).
Koplos, Janet. "Japan—Shigeo Toya." *Sculpture* 7 (March–April 1988).
Minemura, Toshiaki. "Leaving Woods to Create 'Woods.'" In *Toya Shigeo, 1984–1987*. Tokyo: Satani Gallery, 1987.
———. "Resurrection at Pompeii." *Toya Shigeo, 1979–1984*. Tokyo: Satani Gallery, 1988.
Obigane, Akio. "Reviews: Shigeo Toya." *Flash Art 138* (January–February 1988).
O'Brien, Rodney. "Invisible Sculpture: Shigeo Toya." *PHP Intersect* (Tokyo), March 1984.
Sakai, Tadayasu. "A Symbiotic Relationship with Forests." In *La Biennale di Venezia 1988: Giappone*. Tokyo: Japan Foundation, 1988.
Toya, Shigeo. "Artist's Message: 'Woods.'" In *La Biennale di Venezia 1988: Giappone*. Tokyo: Japan Foundation, 1988.
———. *Toya Shigeo: Selected Works, 1984–1990*. Tokyo: Hakushindo Co., 1990.

TAKESHI TSUCHITANI

Harris, Timothy. "Three Sculptors." *Asahi Evening News*, July 7, 1978.
Koplos, Janet. "Nature and Universals." *Asahi Evening News*, November 29, 1985.
Miki, Tamon. *17th Bienal de São Paulo: Japão*. Tokyo: Japan Foundation, 1983.
Tatehata, Kakuzo. *Japanese Sculpture—Ancient and Modern*. Vol. 23. Tokyo: Mainichi Newspapers, 1971.

KIMIO TSUCHIYA

Burn, Guy. "Japanese Contemporary Prints and Drawings." *Arts Review*, June 18, 1982.

Cameron, Nigel. "Master the Medium: Message to Artists." *South China Morning Post*, August 14, 1980.

Haryu, Ichiro. "For the Hara Annual VII." In *Hara Annual VII*. Tokyo: Hara Museum of Contemporary Art, 1987.

"Kimio Tsuchiya." *Hara Museum Review*, Winter 1989.

Middendorp, Jan. "Belgium." *Contemporanea* 11 (October 1989).

Sakurai, Takeshi, and Junichi Shiota. *Kimio Tsuchiya—Sculpture 1984–88*. Tokyo: Moris Gallery, 1988.

Silva, Arturo. "Flesh, Mind and No-Mind at the Hara." *Daily Yomiuri*, March 27, 1987.

Vallombrosa, Jean-Paul. "Hara VII." *Tokyo Journal*, April 1987.

KOJI TSUJI

Hara Annual IV. Tokyo: Hara Museum of Contemporary Art, February 1984.

Koplos, Janet. "Constructions." *Asahi Evening News*, March 13, 1987.

———. "Connection and Elaboration." *Asahi Evening News*, July 15, 1988.

FUSAKO TSUZUKI

Koplos, Janet. "Primal Images." *Asahi Evening News*, April 5, 1985.

———. "Arts." *Asahi Evening News*, May 20, 1988.

KEIJI UEMATSU

Koplos, Janet. "A Poised Universe." *Asahi Evening News*, March 20, 1987.

———. "Surfeit." *Asahi Evening News*, March 24, 1989.

———. "Osaka: Keiji Uematsu." *Art in America* 77 (July 1989).

Nakahara, Yusuke. *Press and Pull*. Rotterdam, the Netherlands: Centrum Beeldende Kunst, 1984.

———. *Structures—Cloth/Branch*. Rotterdam, the Netherlands: Centrum Beeldende Kunst, 1984.

Sakai, Tadayasu. *La Biennale di Venezia 1988: Giappone*. Tokyo: Japan Foundation, 1988.

KEIJI UJIIE

Koplos, Janet. "Four Shows, Three Dimensions." *Asahi Evening News*, June 27, 1986.

ISAMU WAKABAYASHI

Abramowicz, Janet. "The Importance of Format." *Asahi Evening News*, November 23, 1979.

Castile, Rand. "Absorbing the Shock of the West." *Artnews* 80 (September 1981).

Ichikawa, Masanori. "Knowing a Beginning." In *Isamu Wakabayashi*. Tokyo: National Museum of Modern Art, 1987.

Koplos, Janet. "Wrong Medium." *Asahi Evening News*, October 16, 1987.

———. "Post-Industrial Landscape." *Asahi Evening News*, January 27, 1989.

Love, Joseph. "The Week in Art." *Japan Times*, February 2, 1975.

Minamishima, Hiroshi. "Japan: Isamu Wakabayashi." *Flash Art* 147 (Summer 1989).

Okada, Takahiko. *La Biennale di Venezia 1980: Giappone*. Tokyo: Japan Foundation, 1980.

Sakai, Tadayasu. *La Biennale di Venezia 1986: Giappone*. Tokyo: Japan Foundation, 1986.

———. "Venice and Venice Biennale." *Japan Foundation Newsletter* 14 (November 3, 1986).

Takahashi, Koji. "On Iron, the Human Image, Rooms, and Nature: The Work of Isamu Wakabayashi as Anti-Sculpture." In *Isamu Wakabayashi*. Tokyo: National Museum of Modern Art, 1987.

AKIRA WATANABE

Koplos, Janet. "Moving." *Asahi Evening News*, April 29, 1988.

———. "Japan: Akira Watanabe." *Sculpture* 7 (September–October 1988).

KEIKO YAMADA

Koplos, Janet. "Truths Perceived." *Asahi Evening News*, September 25, 1987.

———. "Spiffed Up." *Asahi Evening News*, April 7, 1989.

Mitsuyama, Kiyoko. "The Hara Annual IX: Towards the 1990s." In *Hara Annual IX*. Tokyo: Hara Museum of Contemporary Art, 1989.

KO YAMANE

Koplos, Janet. "Speaking Acquaintance." *Asahi Evening News*, September 20, 1985.

MICHIKO YANO

Callas, Peter. "Discussion with Michiko Yano." *Art Network* (Australia), October 1984.

Koplos, Janet. "Nature and Universals." *Asahi Evening News*, November 29, 1985.

———. "Constructions and Compositions." *Asahi Evening News*, November 4, 1988.

Minemura, Toshiaki. *5th Biennale of Sydney*. Sydney, Australia, May 1984.

Tono, Yoshiaki. *Bienal de São Paulo: Japão*. Tokyo: Japan Foundation, 1985.

———. "Imagineering." *Artforum* 24 (January 1986).

KAN YASUDA

Aramaki, Yoshio. "The Sculpture of Kan Yasuda: A Link between Heaven and Earth: Its Structural Depth in Japanese Myth." In *Ishinki*. Tokyo: Gallery Ueda, 1986.

Koplos, Janet. "Arts." *Asahi Evening News*, November 1, 1985.

Murray, Peter. *Sculptural Carving from Carrara Massa and Pietrasanta*. West Bretton, England: Yorkshire Sculpture Park, 1988.

Noguchi, Isamu. *Kan Yasuda*. Tokyo: Gallery Ueda Warehouse, 1985.

MASAO YOSHIMURA

Chu, Li. *Tat Tvam Asi*. Bali, Indonesia: Club Med First Asian Arts Festival, 1987.

Koplos, Janet. "Japan as No. 1." *Asahi Evening News*, January 10, 1986.

Seelig, Warren. "Classic Turn: The 13th Lausanne Biennial of Tapestry." *American Craft* 47 (October–November 1987).

INDEX

Italic page numbers refer to illustrations.